SIMPLE GIFTS

SIMPLE GIFTS

25 Authentic Shaker Craft Projects

from the Editors of Garden Way Publishing

Foreword by June Sprigg

STOREY COMMUNICATIONS
POWNAL, VERMONT 05261

Text design and production by Andrea Gray
Cover design by Elizabeth Woll
Illustrations by Brigita Fuhrmann
Photographs by Nicholas Whitman
Edited by Gwen W. Steege
Typesetting by Accura Type & Design, Barre, Vermont
Color separations by Roanoke Color Graphics

A number of institutions and people have graciously contributed their time and expertise toward the effort of making this book. They include the following: at the Hancock Shaker Village, all who responded to our questions and requests, in particular, Beatrice M. Snyder, Director of Public Relations and Marketing, who facilitated access to the village for research and photography, and Cheryl Anderson, Coordinator of Crafts and Domestic Industries, whose advice on Shaker crafts and craftspeople helped shape the direction of the book; at the Sawyer Library, Williams College, Sarah McFarland and others in the Reference Department, who very generously opened that institution's extensive collection of Shaker materials to us; K.C. Parkinson and Douglas B. Rhodes, who read and commented upon the chapters on chair taping and on oval boxes and woodworking, respectively; Brigita Fuhrmann, who not only illustrated the book with great skill and patience, but who also drew on her own experiences as a craftsperson to make suggestions that led to greater clarity in the instructions.

Printed in the United States by Ringier America
Text color printing by Baronet Litho

First printing, June, 1990

Copyright © 1990 by Storey Communications, Inc.

The name Garden Way Publishing is licensed to Storey Communications by Garden Way, Inc.

Library of Congress Cataloging-in-Publication Data

Simple gifts : 25 authentic Shaker craft projects / foreword by June
 Sprigg.
 p. cm.
 ISBN 0-88266-581-2 :
 1. Art, Shaker — United States. 2. Shakers — United States — Social
 life and customs. I. Title: Shaker craft projects.
 TT23.S56 1990
 745.5 — dc20

89-46021
CIP

Contents

Introduction

As amateur craftspeople learn to work with wood, metal, and fiber, their appreciation for the creations and skill of the true artisan can deepen immeasurably. Person-to-person bonds are formed in subtle ways that transcend history and even levels of skill. We hope that in making the projects described in this book, you will find that the Shakers become more alive to you, that you will become increasingly aware of the splendid beauty of Shaker crafts and their modern reproductions, and that your own skill as a craftsperson will be enhanced and enlivened.

A few comments about how to use this book are in order. For each of the nine crafts included, a short introduction provides background on how that craft developed within the Shaker community in contrast to the "World" (those outside the Shaker communities). In general, the equipment needs for the various projects are fairly basic, with many tools and supplies already present in the home or workshop, or readily available from local stores or mail-order suppliers (see listing in Appendix). A summary of these needs is included in the introduction to each chapter. Many of the projects in the book can be accomplished by persons with little or no experience with that particular craft, although the chapter on handweaving assumes a knowledge of how to dress and operate a loom. Where how-to instructions mention left or right hands, the orientation is to right-handed persons, with an apology to left-handed craftspeople.

Whenever the production of the craft involves use of sharp tools, power tools, or other equipment that can prove injurious if mishandled or misunderstood, we urge that all safety precautions be taken. Both the work process and the finished object will provide greater satisfaction if you use tools properly.

Contributors

The author of each of the chapters in *Simple Gifts* is a skilled craftsperson and an experienced interpreter of Shaker crafts in particular. Each has contributed to this project not only his or her own specialized knowledge but also an enthusiasm for Shaker crafts, both as they were practiced by the Shakers a century or so ago and by contemporary craftspeople who keep the traditions alive.

CHERYL P. ANDERSON (Handweaving) is Coordinator of Crafts and Domestic Industries at the Hancock Shaker Village, where she directs a program that includes crafts demonstrations, exhibits, and festivals; Cheryl is also a self-employed spinner and weaver, and has written articles on Shaker textiles for *Threads* magazine.

GALEN BEALE (Poplarware and Herbs) worked at the Canterbury Shaker Village for seven years, serving at various times as Herbalist and Craft Coordinator. She has researched and produced Shaker baskets and brooms, as well as poplarware, a Victorian craft learned from the Canterbury Shakers. She is currently a partner in the poplarware business, Beale & Gibbs (see Appendix for address). She has written articles on Shaker crafts for *The Shaker Messenger*.

DANA MARTIN BATORY (Miniature Furniture) is a woodworker and cabinet builder, as well as a freelance writer and photographer. He has written numerous articles for magazines specializing in miniature furniture, as well as for *Popular Woodworking*, *The Journal of the Antique Woodworking Power Tool Association* (Associate Editor for over three years), and *The Shaker Messenger*.

CHARLES A. HARTWELL (Tinware) studied tinsmithing at Eastfield Village, in East Nassau, New York. He taught courses in tinsmithing at Eastfield Village, had such museum and historic society clients as the Winterthur Museum, the National Park Service, and the Conner Prairie Museum, and served as tinsmith at the Hancock Shaker Village and the Pioneer Arizona Living History Museum.

GERRIE KENNEDY (Basketry) is the Resident Basketmaker at Hancock Shaker Village. She has taught courses in basketmaking at various schools and museums throughout the East Coast. She is also a self-employed basketweaver.

D. CLIFFORD MYERS (Oval Boxes) has been the Resident Oval Boxmaker at the Hancock Shaker Village for nearly ten years, during which he has served as both interpreter and teacher. He is also a self-employed oval boxmaker.

SETH M. REED (Woodworking) is the Resident Cabinetmaker at the Hancock Shaker Village. He studied his craft at both the Hancock Village and Old Sturbridge Village. He is also a self-employed cabinetmaker.

DANIEL B. SOULES (Tape Weaving) is a self-employed cabinetmaker and owner of Shaker Accents, a cabinet shop devoted to the manufacture of reproduction (principally Shaker) furniture, in Lee, Massachusetts (see Appendix). He was an interpreter, cabinetmaker, and workshop teacher at the Hancock Shaker Village for six years.

Foreword

I work as a curator at Hancock Shaker Village, a restored Shaker community in Massachusetts. My colleagues and I spend our time preserving the property — twenty historic buildings and a large collection — and interpreting Shaker life to visitors.

The Hancock Shakers are long gone, and we, of course, are not Shakers ourselves. But we are here because something about this place and its heritage suits us deeply. At least in practical concerns, we are much like a Shaker society in miniature. Each of us has a place and a responsibility that mirrors something the Shakers did.

To guide the village overall, the Shakers had Elders and Eldresses; we have a director. I am like the Deacons and Deaconesses, who took care of the buildings and communal possessions. Our business office does for us what the Shaker Trustees did for their community. Our farmers, gardeners, carpenters, housekeepers, and cooks each do their part.

Of all the people who work here, however, I think it is our craftspeople who give visitors the most vivid glimpse of what Shaker life was like. Our weavers, boxmaker, cabinetmakers, and basketmakers work in the same rooms as their Shaker predecessors, are surrounded by the same equipment, and use the same materials and methods to create the same kinds of products. Hearing a shuttle pass back and forth on the loom, watching narrow ash splints snake in and out over a wooden basket mold, smelling sawdust or the oddly sweet scent of lanolin in freshly carded wool, I feel the hard edge between "now" and "then" blur. When I look at just the craftspeople's hands, the edge can dissolve completely.

Much is made of the sacrifices that the Shakers made to pursue their life of idealism. They gave up marriage and family, private property, selfish desires, and most worldly concerns for personal salvation and the good of all. But the vast majority of ordinary members also gave up the need to think, ever, about rent or income or taxes or insurance, or about getting the laundry done or putting a meal on the table or shopping for food or raising children. They did not even have to think about getting supplies or selling what they made. The Deacons and Trustees bought supplies, collected orders, handled shipping, paid bills, and advertised. I do not wonder that Shaker artisans made simple and beautiful things. Their minds and spirits were freed from the distractions that are inescapable for those of us who live in the world.

The craftspeople whose contributions appear in this book are not freed from these concerns. Most of them have made considerable

sacrifices of their own to pursue the mastery of their craft. Not only do these people make beautiful things, but they have taught me most of what I know about the products of the Shakers and how and why they look as they do. Their hands-on knowledge of how a thing is made allows them to "read" information in an object that the rest of us cannot see; their willingness to share those insights has given us all a richer understanding of the Shakers and their works. With affection and respect and gratitude for the lives and work of these craftspeople, it is a privilege for me to add this small contribution to their book.

— June Sprigg
Curator of Collections
Hancock Shaker Village

OVAL WOODEN BOXES

D. Clifford Myers

*All things made for sale ought to be well done,
and suitable for their use.*

JOSEPH MEACHAM, *WAY-MARKS*, C. 1790

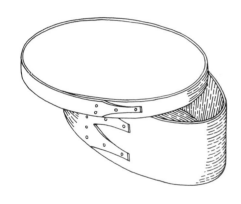

Out of the hundreds of different products that the American Shakers made for sale to the outside world, the one item that is instantly recognizable to most people as "Shaker" is the oval wooden box. The unique design of this box, coupled with the fact that the Shakers sold several hundred thousand of them throughout the United States, makes it the leading symbol of Shaker life to us, the "World's People."

The Shakers started producing oval wooden boxes in the New Lebanon, New York, community about 1798, less than a quarter of a century after they came to New York from England. Boxmaking was one of the first, one of the longest lasting, and certainly one of the most lucrative of their businesses. Although most of their community-owned activities were originally divided along the usual eighteenth-century definitions of "men's" and "women's" work, the oval box-makers were an even more tightly delineated group. According to Gerry Grant, a master boxmaker and Assistant Director for Collections at the Shaker Museum at Old Chatham, New York, in almost every case not only were the Shaker boxmakers men, but for some unknown reason they were Elders, the religious leaders of the community.

Much has been made of the deep religious significance of the oval shape and the artistic brilliance of the Shakers in having come up with the design of these boxes. In fact, nothing could be further from the truth. The so-called Shaker oval box was being produced in Europe well over one hundred years before the Shakers existed. Their contribution to the box design was a gradual refining process that came with time and experience. The distinctive oval shape evolved from the earlier, more rounded oval form, and the swallowtail projections on the face of the box (usually, and incorrectly, referred to as fingers or

lappers) became less angular, more elongated, and more numerous. These, in particular, add to the visual flow so characteristic of the later Shaker-made boxes. In addition, none of the comments in the journals left by the old Shaker boxmakers indicates that the boxes were anything other than what they appear to be — simple, dry-storage containers. In essence, the boxes were the Tupperware canisters of the early nineteenth century.

While the Shaker boxes were expensive, they offered one of the few decorative, lightweight storage containers of the period. The cheap, painted tin canister sets that came along later were not generally available in 1834 when the Shaker oval box business was at its zenith. And, although a common, heavy, round, oak pantry box was suitable for storing twenty-five pounds of dried beans in a pantry or under a table, the Shaker oval wooden box was attractive enough to be left on the table or counter where it was readily available. The box was thus not only useful, it also made the room look nice.

The lovely stack of seven or eight oval boxes in graduated sizes featured in today's designer "country kitchens" would most likely have been an unthought-of luxury for nineteenth-century housewives. The Shakers did sell nests of boxes at a discount over the price of the individual boxes, but even the smallest box (size 11, which was 2¾ inches long) was in 1834 a full day's pay for a woman working in a factory ten hours a day — that little box cost a stunning twenty-five cents! The largest box available on a production basis (size 1) was a full day's pay for a factory supervisor. These prices restricted most people to buying only a few boxes to fill their daily needs. A large box, for instance, was a reasonable storage container for ten or fifteen pounds of flour. Even though the box was expensive, it fitted the housewife's needs, and the workmanship and quality materials that went into Shaker-made boxes assured her that she could amortize its high cost over her entire life. And, just maybe, she could pause for a moment as she prepared one of the three heavy meals a day for her family of ten, look at her box, and enjoy the feeling that comes from owning something beautiful.

By the 1840s, the Shaker box business was already in decline because of foreign competition. English factories began to export tinplate canister sets that sold for less than the price of a small wooden box. Even though the Shakers had mechanized virtually every aspect of the boxmaking business by 1835, they still couldn't compete with the mass-produced tinplate containers that poured out of the steam-powered punch presses in the English factories. By the 1850s, American factories such as the Dover Stamping Company added to the flow of cheap storage containers. Box manufacture began to disappear in the Shaker communities.

By the late 1800s, however, the Shakers found an entirely new market for their oval boxes. With the addition of a bail handle and a fancy silk lining, the no-longer popular, utilitarian wooden canister

could be transformed into a fancy, top-of-the-line sewing box — a premium item that continued to be sold well into the twentieth century. After the Brothers made the boxes, the Sisters carefully lined them with silk brocade. The lining was held in place with matching silk ribbons, which passed from the inside to the outside through paired holes drilled into the side of the box, where they were tied into a fancy bow. The ribbons created four loops on the inside of the box, to which were fastened a cake of beeswax, a poplar-cloth needlecase, a tomato pincushion (see pages 99-105), and an emery. In most cases, the pincushion and the emery were made out of the same material as the lining. The result was an elegant-looking product.

The Shakers continued to produce oval boxes until 1960. Most of these later boxes were made in the form of carriers — lidless boxes fitted with handles, which were the boxmaker's version of a basket. Brother Delmer Wilson of the Sabbathday Lake Shakers produced over 1,000 of these carriers during one long Maine winter — a feat that most modern boxmakers would not like to repeat!

With Brother Delmer's death in 1960, 162 years of Shaker box-making tradition drew to a close. The craft, however, did not die with him, for more than two dozen full-time professional craftspeople now continue to turn out reproduction Shaker work, and hundreds of amateur makers lovingly craft boxes as gifts for lucky friends and neighbors.

Getting Started

There is nothing mystical about the making of a Shaker oval box. As with any craft, it is a simple, logical, step-by-step process that is within the grasp of almost anyone, even children. The difference between an acceptable beginner's effort and Shaker craftsmanship is a matter of practice and an awareness of what a truly superb box should be.

Most people who visit a modern boxmaker's shop go away bewildered by the production process that they have seen. Everywhere are stacks of drying forms. Each and every nook and cranny is filled with cutting boards, bending jigs, and complicated molds. Swallow-tail templates hang from beams like icicles from a house eave on a late winter's day. Stacks of lumber and scores of parts litter every horizontal surface, from benches and shelves to the floor itself. The production boxmaker collects all of this equipment over a period of time, allowing him or her to make boxes by the hundreds or thousands as quickly and efficiently as possible — exactly as the Shaker boxmakers did.

Making a few boxes as a hobby, however, needn't be complicated or expensive. There is no reason why the average person can't make an acceptable box with a minimum of tools and equipment. The three

projects that follow are described in increasing order of difficulty, but even the third project — a complete oval box — should be an easy project for any do-it-yourselfer.

What Kind of Wood?

Shaker boxes were routinely constructed with quartersawn sugar maple for the sides of the boxes and lids, and quartersawn white pine for the tops and the bottoms (which the Shakers called *heading*). Any local hardwood, however, can form a perfectly satisfactory side for the projects in this chapter. The New England Shakers probably chose maple because, of the hardwoods found in the area, it offers the best balance of properties for the side of a box to be used as a food-storage container.

Pine was used for the heading because hardwoods like maple expand too much during humid weather. Held tightly inside the maple sides, the expanding lids often bow up and out in the middle, pulling a part of the lid rim with them and destroying the box. Softwoods, on the other hand, don't expand as much as hardwoods, and they have much more give. Even in muggy weather, pine tops stay put. Common throughout New England, pine was readily available to the Shakers in the wide widths needed to make the bigger boxes. There is no reason, besides tradition, however, why other softwoods can't be used in its place. The only fixed rule is to use a hardwood for the box sides and a softwood for the tops and bottoms.

Quartersawn wood is a bit of a nuisance to find, particularly in small quantities. Quartersawn simply means that the board was cut so that the growth rings in the tree are perpendicular to the face of the board. Shakers preferred quartersawn stock because it is much less likely to warp when cut in thin pieces for the side of a box. Furthermore, it expands and contracts less with changes in relative humidity, so that the box lids are much less likely to stick every time it rains. Thousands of reproduction boxes are made every year from plainsawn stock, however, and the choice is, finally, a matter of aesthetics.

Both hardwoods and softwoods can be bought from lumber dealers. Examine a stack of 12-inch no. 2 pine shelving at your local lumberyard. The boards that have the little bull's-eye in the center of the end grain were cut at the center of the tree. If you rip the bull's-eye out of the center of the board, you will have two pieces of quartersawn wood. The no. 2 shelving costs a fraction of clear pine, even if you have to discard parts of it because of knots. The Shakers generally used ¼-inch thick boards for the heading of boxes up to 9- or 10 inches long, and 5/16-inch thick boards for larger boxes.

If you have a table saw or band saw, you can easily resaw 1-inch boards into box sides and tops. Alternatively, you can have the pieces cut by a local cabinet shop, or buy ready-cut strips from one of the specialty wood dealers included in the List of Suppliers on page 128.

EQUIPMENT LIST

No. 2 pencil or 0.5 mm mechanical
 pencil
Utility knife
Scissors
Combination square
Coping saw
Block plane
Hand drill with no. 54 bit
Wood chisel
Iron pipe (or other anvil)
Clamp
Tack hammer
File
Scraper

Optional:
Table saw
Band saw
Jointer
Planer or thickness sander
Disc or belt sander
Drill press
¼-sheet palm sander

FIGURE 1

Making Patterns

To make long-lasting patterns, photocopy or trace the patterns on pages 119-21. Glue the copies to a thin piece of cardboard or posterboard with rubber cement, and then cut out the patterns with a pair of heavy scissors or tin snips. Coat both sides of the patterns with shellac. With a piece of fine sandpaper, sand smooth any cutting irregularities on the edges. (The shellac will help prevent fuzzing while sanding and extend the useful life of the patterns.) Be sure to drill or punch all tack holes in the patterns.

The Tools You Will Need

You can make any of the projects included in this chapter with a fairly short list of commonly available tools. I prefer a 0.5 mm pencil over a no. 2, because the mechanical pencil gives a very clear, sharp line. The Stanley no. 199 utility knife with heavy-duty blades is particularly appropriate for cutting the swallowtails on box sides because it is one of the few utility knives with only one boss (bump) molded into the handle where the blade is held. The blade extends further than it does on other models, thus making it more flexible, a particular advantage when you are cutting the swallowtails. As you gain experience, you will find that this added flexibility allows you to cut much more smoothly. Although hand tools will allow you to do a perfectly adequate job, some power equipment makes certain tasks easier.

Selecting and Applying the Finish

Shaker boxmakers left all of the sanding and finishing to helpers. If you have to do the sanding yourself, modern ¼-sheet palm sanders make the final sanding fast and relatively easy. When the tray or box is completed, set it aside for a day or two to let it dry thoroughly before sanding. (You can also dry it in your kitchen oven on the warm setting for a couple of hours.) Don't try to sand a damp box; you will end up with a fuzzy mess that is just about impossible to finish properly. If the sandpaper leaves a clean, smooth surface, it is dry enough to finish.

Sand every square inch of the box thoroughly with 150-grit sandpaper. A piece of sandpaper folded as shown in Figure 1 makes an effective, non-slip tool. Wipe the box clean with a soft rag, and then resand it with 220-grit paper. Regardless of the finish that you use, the box won't be any smoother than the sanded wood that you start with. Do not machine-sand over the crisp, carved edges of the swallowtails, or you will end up with amorphous blobs instead of sharply defined swallowtails. Lightly sand the swallowtails and the space between them by hand. Shakers left the edges of the boxes fairly square, doing no more than gently breaking the edges as they sanded. Al-

though a harsh edge is therefore more authentic, I think the box feels better with the square edges all gently rounded.

Early boxes were painted in solid colors, most commonly barn red, oranges, yellows, blues, and greens; characteristically, only the outsides, never the insides or bottoms, were painted. Modern reproduction colors may be obtained from one of the mail-order suppliers listed on page 128.

In the 1840s and 1850s, the boxes were often given a wash coat of yellow or red paint, or stained yellow or red. Washing or staining in the color allowed some of the character of the wood to come through, yet the Shakers could still use traditional colors. By the 1860s, boxes were generally varnished with white lead/linseed oil varnish, and by the turn of the century, they were finished with commercial varnish right out of the can.

You can use any finish that you like, but keep in mind what you are going to use the object for when you pick the finish. Spar varnish or exterior enamel finishes can be wiped clean with a damp sponge, whereas finishes like shellac won't stand the moisture. Commercial oil finishes, like Waterlox or Watco, are ideal, because you can slosh a coat on both sides at once, let it soak in, and then buff it dry with a rag.

The problem with varnish or oil-based paints is that months after the box is finished, the inside still smells of paint. Shellac is a fast, easy option that allows a wooden box to smell like a wooden box. Clear, 3-pound shellac works fine, as long as the expiration date printed on the can has not passed. No matter how carefully you have sanded the box, the first coat of shellac will raise the grain. To get a smooth final finish, therefore, you will have to resand with 320-grit sandpaper after the first coat. Make sure that you wipe off all of the sanding dust before you put on the next coat. For a uniform texture, apply a third coat (without sanding again) as soon as the second coat is dry to the touch — usually within an hour. Set the box aside to dry overnight.

After you have applied the finish of your choice, rub the tray with no. 0000 steel wool dipped in paste wax. The fine steel wool cuts off any dust particles or minor lumps and bumps in the finish, and the paste wax lubricates the surface and keeps the dust from clogging the steel wool. When you have thoroughly rubbed out the finish, wipe off any excess wax with a clean cloth, and allow the tray to dry. To bring out the full shine, buff the tray with a standard shoe brush — an especially good tool for getting down around the edges of the swallowtail. Whenever the tray gets dirty from use, a simple rewaxing will restore the tray to like-new condition.

Shaker-Style Tray

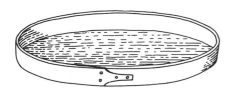

9½" wide x 13½" long x 1⅜" high

SUPPLIES

1 hardwood strip, ⅛" x 1½" x 46" (final trimmed length will be 43"
1 softwood board (such as clear pine), ⅜" x 9½" x 13½"
No. 2 copper tacks
No. 18 ½" escutcheon pins, or no. 14 copper wire
Finish (see page 6)

Although the Shakers didn't sell them as such, the lids of large boxes make handy trays to store trinkets and other odd bits that tend to clutter the tops of dressers. These Shaker-style trays are an ideal beginner's project for anyone who would like to get the feel of Shaker boxmaking with a minimum of time and equipment. No jigs or forms are necessary, because the side is narrow enough simply to be bent around the bottom.

PREPARING THE TRAY BOTTOM

1. To transfer the pattern for the tray bottom (page 120) to the pine board, align the center line of the pattern with the grain on the face of the board, and trace around the edge of the pattern with a sharp pencil. If the grain of the board doesn't follow the length of the lid, the box will look lopsided, so take special care to align the pattern correctly.

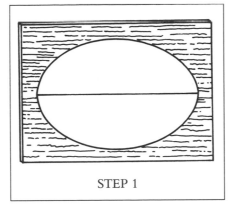

STEP 1

2. Using a coping saw with a fine-tooth blade, cut just *outside* of the line, using the technique described in Step 3, page 22. Take care not to overcut the line. (A band saw makes this step much easier.)

3. Sand the side of the bottom smooth, right up to the pencil line, so that you have a smooth ellipse against which to fit the side neatly and tightly. You can do this by machine (see page 8) or make a sanding block by gluing 80-grit sandpaper onto the edge of a block of wood. Raise the piece you are sanding up off the work surface by placing it on a thin board, and push the sanding block back and forth along the table with a curving motion. Using the block makes it easy to keep the edge of the ellipse at 90 degrees to its face. It is important that the edge of the ellipse doesn't have any flat spots. If you sand over the line slightly, don't panic; the maple rim is flexible enough to follow any slight changes in the curve — it just can't bend abruptly when it comes to a flat spot.

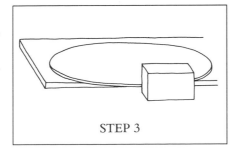

STEP 3

4. Sand the two faces of the bottom very smooth, using a sanding block to avoid rounding the edges. Double check both faces for any remaining scratches or pencil marks, and make sure that you sand them off now — they are real bears to get rid of once the side of the tray is nailed to the bottom.

5. Lay the pattern over the bottom, and with a pencil, mark the center line on one long edge of the bottom. Set the tray bottom aside in a safe place.

TAPERING THE FEATHEREDGE

6. Before the rim is bent, the rim ends must be tapered, or the double thickness where they overlap for joining will create a lump and the curve will not be uniform. The end that will be on the inside of the overlap — the featheredge — must be planed down until it is paper thin, and the tip of the swallowtail must be planed down to one-half to one-third of its original thickness. The resulting overlap is almost as thin throughout its length as the rest of the rim.

Take a careful look at the grain direction in the rim. If you plane the wood with the plane iron cutting *against* the grain, it will quickly catch and tear chunks of wood off the face of the rim. Since the grain line is not always visible on the side of the rim, you may start to plane the featheredge on the wrong side and find that the plane iron starts to dig in. Note that the rim measurement given in the supply list is a few inches longer than necessary in order to give you some insurance, in case you have to shorten the rim to correct such a mistake.

Usually, the grain of the wood is straight on one end of the rim and

slightly off on the other. Save the straight end for cutting the swallowtails. Because the straight grain makes for easier cutting (the utility knife tends to follow the grain), you are less likely to slip and cut off the tip of a swallowtail. With a pencil, lightly mark an ST (for swallowtail) on the straight-grained end.

Lay the other end of the rim on a pine board. Line the rim up with the edge of the board, and line the edge of the board up with the edge of a sturdy work table. Clamp the rim and the board to the table, with a small wood scrap between the clamp and the rim so that the clamp won't leave an unsightly mark on the rim. The clamp should be placed toward the swallowtail end of the rim. Planing will be easier if you allow the pine board to extend several inches further than the rim end that you are planing.

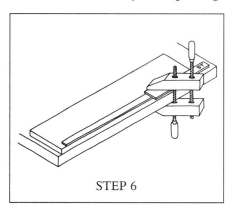

STEP 6

7. To indicate the length of the taper, make a mark 4½ inches from the end you will be planing; then make marks every ¼ inch from there to the end. Plane the rim on the ¼-inch section closest to the end until the plane doesn't cut any more. Move the plane back and plane from the second section to the end of the rim, again until the plane no longer cuts. Continue in this manner until you have planed all of the feather-edge. Each time you move the plane back and plane a new section for the first time, you are also replaning the

MACHINE SANDING

A fast, easy method is to machine sand the piece with a disc sander, or a 10-inch steel sanding disc designed to replace the blade in a standard table saw or radial arm saw. A few basic principles will help you achieve a smooth curve:

○ Sanding should always be done on the side of the sanding disc that is rotating downward into the table, so that the rotating disc pushes the wood down onto the table as it sands. If you try to sand on the other side, you will find that the wood is picked up off the table and thrown out of your hands.

○ Start sanding near the center of the sanding disc; you will have much more control over the amount you remove. If you try to sand near the outer edge of the sanding disc, where the disc cuts away much more quickly, you will find it doesn't take long for the edge of your piece to disappear.

○ You are less likely to get unwanted flat spots if you start your sanding on the end grain, for the disc does not cut as quickly there as it does on the side of the piece.

○ Always keep the wood moving in a smooth, circular motion. Place the tip of your right index finger on the wood about an inch away from the sanding disc, and let your finger serve as a pivot point while with your left hand you push the wood around as required. When you have turned the wood as far as you can with your left hand, switch the position of your hands, using your left index finger as the pivot and your right hand to keep the piece moving.

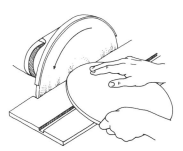

If you try to sand right down to the pencil line on the first pass around, you will end up with lumps and flat spots. Concentrate instead on first sanding the worst irregularities from the saw cut; then sand around the entire edge of the bottom several times, removing a little more excess wood with each pass until you are finally sanding right up to the pencil line and have created a smooth, uniform ellipse.

Note: Attach a shop vac or a dust collector to your equipment, or it will rapidly disappear in a cloud of sanding dust! Whether you are using a hand sander or a machine sander with a dust collection system, it is a smart idea to wear a suitable particle mask or respirator; inhaling wood dust has been shown to increase the likelihood of getting some forms of respiratory tract cancers. Equally important, make it a habit to use safety glasses or shop goggles to protect your eyes.

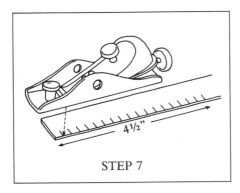

other sections. By the time you finish the last section, the first section will have been planed fifteen or twenty times, and you will have your paper-thin taper.

If you plane one side of the feather-edge more than the other, you may plane off one of the corners. Because Shaker originals usually have nice crisp, square edges, a missing corner is obviously unacceptable. To correct this situation, slide a combination square against the edge of the rim just behind the mistake, and *lightly* run a utility knife across the rim along the edge of the square. Make a series of light cuts along the same line until the end is completely cut off of the rim. The result is a nice square edge, and nobody will ever know you made a mistake.

8. Scrape the rim smooth. First, sharpen your scraper (for in-structions, see page 115). Hold the scraper at the forward two corners so that your fingers are on the top face, your thumbs are on the bottom, and the rear corners rest on your palms. Place the forward edge of the scraper at a 30- or 40-degree angle to the length of the box side. Move the top edge of the scraper down until your thumbs rest on the box side. Pull the scraper toward you to make the cut. Heavier cuts may be made either by pushing down harder on the scraper or by pushing outward with your thumbs to bend the scraper into a slight arc. Make repeated cuts until the surface is flat and smooth.

9. With the rim still clamped in place, make a mark at the unplaned end 43 inches from the planed end. Place a combination square against the edge of the rim at the pencil mark, and lightly score across the rim with the utility knife, cutting at least *halfway* through the rim. Unclamp the rim from the board, and hold it with the knife cut facing you and with a thumb on both edges of the knife cut. With a quick, confident motion, flex the rim so that you are closing up the knife cut. The rim should snap in two, leaving a clean, square edge with a minimum of splinters.

THE SWALLOWTAIL END

10. It is important to trace (and cut) the swallowtail on the *same side* that you planed the feather-edge, as the other side of this end must also be planed after the swal-lowtail is cut. Use the pattern on page 121 to trace the swallowtail. Because cutting swallowtails is usually the most frustrating part of boxmaking for beginners, I suggest that you practice on a scrap piece of rim before you cut your ultimate masterpiece —the swallowtail on your first tray rim.

Clamp a pine board to your work surface. Clamp the swallowtail end of the rim — with the tracing line facing up — to the edge of the pine board. The tip of the swallowtail should be flush with the end of the board, and the side of the rim should be flush with the edge of the board.

11. Hold the knife as if you were going to stab someone. The blade end should extend from the bottom of your fist, and, for the best control, the cutting edge should face you and almost touch the fleshy part of your hand. Grab the hand holding the knife with your other hand. Be sure to keep your elbows down when you are cutting, so that your fore-arms will strike your chest long before the blade does. Done properly, this cutting technique is much safer than one-handed cutting styles. Cut sitting down, and keep your knees spread well apart, so that your legs are out of harm's way.

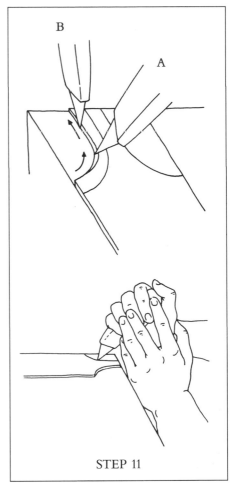

Place the fleshy edge of the hand holding the knife on the end of the cutting board and use it as a pivot point. Place the tip of the knife blade just outside the pencil line at the base of the swallowtail and just below the bottom side of the rim, so that it will cut the whole way through the rim but not get hung up in the cutting board. Roll your hand, slanting it toward the center line of the swal-lowtail at about a 60-degree angle (A in illustration). As you pull the knife

toward you to make the cut, slowly roll your hand outward, away from the center line, so that the blade is vertical when it reaches the tip of the swallowtail (B in illustration). Make a series of cuts, no wider than 1/16 inch, getting closer to the pencil line with each cut. Don't try to cut all of the waste wood off in one Herculean cut. If you do, you will very likely cut the end off the swallowtail — or break the tip off your knife blade.

To avoid forming notches on the bevelled edge where you reposition the knife to start new cuts, first put the knife point against the edge of the last cut, where the cut touches the pencil line. Allow the point to cut slightly into the pine board. Push sideways on the knife handle and flex the knife blade so that it bends to meet the existing bevel. When you feel the bending of the blade stop, the cutting edge is at exactly the same angle that it was when it made the last cut. Now pull forward; the blade won't begin cutting until it reaches the spot where the last cut left the pencil line. Repeat this technique until all of the waste wood outside of the pencil line is cut away. Remember always to roll the knife to change the bevel as you cut. Cut the outside of the swallowtail in precisely the same manner.

12. While the swallowtail end of the box side is still clamped to the cutting board, drill the tack holes (as indicated on the pattern) with a no. 54 drill bit. Predrilling is a precaution against splitting the wood when you tack the ends together. Hold the drill bit between the fingertips and thumb of your right hand, with the drill tip even with the bottom edge of your ring finger. If you then rest the little finger of your right hand on the swallowtail, the drill can be positioned accurately without breaking the bit. Slight

bumps will result from the drill's being pushed through the wood, but these will be planed off when you taper the back of the swallowtail.

13. To make a guide for tapering the swallowtail tip to between ½ to ⅓ of its original thickness, hold a pencil between your thumb and middle finger, with the tip of the pencil near the tip of your index finger; push against the edge of the swallowtail tip with your index finger so that the pencil point is aligned halfway between the top and the bottom of the swallowtail, and draw a line across the tip.

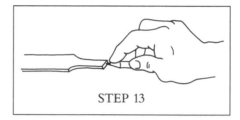

STEP 13

14. Unclamp the rim, turn it over and clamp it back onto the work surface. Plane the tip of the swallowtail down to the pencil line, extending the taper over 5½ inches. (When the ends are overlapped, the swallowtail taper on Shaker boxes usually extends from the swallowtail tip to a point halfway between the base of the swallowtail and the thin edge of the featheredge taper.) Divide the section to be tapered into 1-inch sections and plane each section once, as you did for the featheredge. Check the swallowtail tip for thickness after each cut; the tips disappear very quickly. If the tip is getting too thin before you have planed over the entire length of the swallowtail, keep planing, but lift the plane before you get to the end of the tip.

15. To cut a 45-degree bevel on the tip of the swallowtail with a sharp chisel, first mark a pencil line across the top of the swallowtail tip at a distance from the end equal

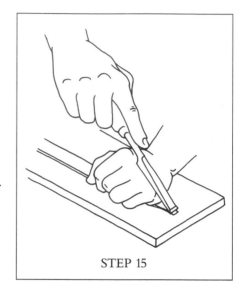

STEP 15

to the thickness of the tip. Place your left hand or clenched fist an inch or so behind the tip. Hold a sharp chisel in your right hand, and place the cutting edge of the chisel on the pencil line, parallel with the end of the tip. Roll your left and right hands as a unit until the chisel is aligned at 45 degrees from the horizontal. Push down on the chisel to cut a clean, smooth bevel on the end of the swallowtail. If the bevel does not extend through the entire thickness of the swallowtail, repeat the cut a little further back until it does.

BENDING THE RIM

16. To soften the rim for bending, soak it in your bathtub in an inch or two of warm water and a couple of capfuls of fabric softener. (Fabric softener drastically reduces the soaking time and significantly improves the flexibility of the rim.) Hold the rim under the surface with a couple of stainless steel table knives. Try flexing the rim before you put it into the water and again every fifteen minutes or so while it is soaking. When you can bend the rim easily, it is ready — usually within an hour. Before you bend the rim around the

bottom, dry the rim with a paper towel so that it doesn't drip.

17. Place the tray on the work surface, with the pencilled center line facing away from you. Hold the bottom by its edge, near the pencil mark. Place the back side of the swallowtail against the edge you are holding, with the two holes of the back tack line directly over the center line. Clamp the swallowtail tightly against the bottom with your left hand and make sure that the swallowtail is pointing to your left. Then, with your right thumb on the top of the tray bottom and your right index finger on the bottom, push the rim in against the tray edge and slide your right hand along the tray bottom to bend the rim around the outside edge until you can't move your hand any further. Push the tray against your stomach near your right hand to keep the rim in place. Now use your right hand to clamp the swallowtail to the bottom, and, beginning at the point where you are bracing the rim against your stomach, use your left hand to continue bending the rim around the bottom. (If you are a beginner, you may find it easier to have someone else hold the tray bottom securely in place for this operation. Your helper should stand

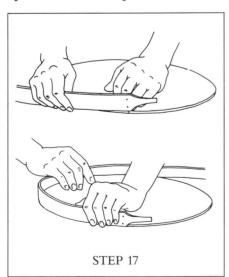
STEP 17

on the opposite side of the work table and hold the bottom firmly while you bend the rim around the tray.)

18. At this point, the rim is fully bent, but the featheredge is on top of the swallowtail. Keep the tray firmly pressed against your stomach because the last thing you want is for the rim to slip. Carefully slide your two hands away from each other along the edge of the rim until the tip of the swallowtail bends outward far enough away from the edge to allow it to move out from under the featheredge. Push the featheredge back against the bottom and push the swallowtail over the featheredge.

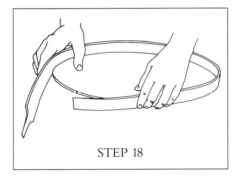
STEP 18

The bottom is ready for tacking. (A helper could hold the rim against the bottom at the short ends, while you first hold the overlap together and then free the ends to get the swallowtail over the featheredge.)

19. Check to make sure that the rim is still tightly wrapped around the bottom at all points. If it isn't, rebend the rim until it fits snugly. Make a pencil line on the rim to mark placement of the tip of the swallowtail, and then allow the rim

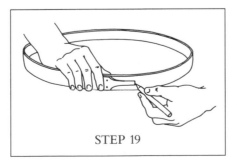
STEP 19

to slip and loosen enough to take it off the bottom. Hold the overlap firmly together with your thumb and index finger, and carefully remove the rim.

20. Slide the tip of the swallowtail along the featheredge end of the rim until it is again touching the pencil mark. To compensate for the fact that, as it dries, the rim will shrink away from the bottom of the tray and fit too loosely, make the rim slightly smaller by sliding the tip of the swallowtail about 1/16 inch past the pencil line.

21. To tack the rim joint together, you will need to place the overlap against a metal anvil, such as a small shop anvil or a short length of galvanized pipe clamped over the edge of a table. First, check to be sure

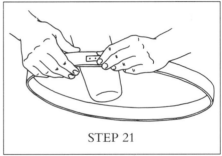
STEP 21

that the ends line up along their length. Hold the rim near the tip of the swallowtail, and pinch the overlap together between your thumb and index finger; then push the edge against the work surface to align the edges. Next, place the rim over the anvil, and push the point of a tack into one of the predrilled holes along the main tack line (*not* the hole at the tip), and drive the tack through the overlap. Hammer in each tack head until it is flush with the surface of the wood. Don't hammer so vigorously that you mash the end of the swallowtail.

22. The rim is now ready to be attached permanently to the bottom. Hold the rim with your left

hand, pinching the overlap between your thumb and index finger, with the swallowtail pointing away from you. Place the tray bottom on the work surface with the long axis running away from you and with the center line to your left. Reach across the bottom and pick it up by the long end furthest away from you. Your fingertips should be on the bottom surface and your thumb and palm on the top surface of the tray bottom. Hold the end of the rim nearest to you against your stomach and insert the long end of the bottom nearest to you into the part of the rim between your left hand and stomach. Make sure that the bottom does not go into the rim more than 1/8 inch or you will have difficulty getting the rest of the bottom into the rim. Be careful not to catch the edge of the feather-edge and tear it. Push the bottom against the rim, while sliding the bottom around the rim until the center line is aligned with the back tack line of the swallowtail. Without letting go of the bottom with your right hand, slip the tips of your right fingers out from under the bottom and use them to press the edge of the bottom into the rim and against your stomach and clamp the bottom and the rim together. Slide your left hand up against your right hand and then slide the tip of your left thumb onto the edge of the bottom. Pull against the inside of the rim with your left fingertips and push against the

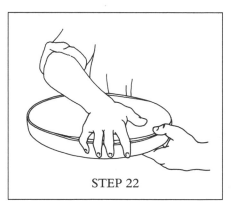

STEP 22

bottom with your left thumb to stretch the rim up onto the bottom. Slide the fingertips of your right hand over the end of the rim and curl them around into the inside of the tray, pinching the bottom between them and the palm of your right hand. Then, slide your right hand a few inches along the rim in a clockwise direction and again slide your left hand over to your right hand. Maintain the pressure on the fingertips and thumb of your left hand, so that the rim will be lifted over the edge of the bottom. Repeat these motions until the rim has been pulled over the edge around the entire bottom. (If you have a helper, he or she should hold the bottom firmly on the work surface, while you use both hands to slide the rim over the upper edge of the bottom.)

23. When the last bit of rim is over the edge, place the tray bottom-side down on a work surface, and beginning at the feather-edge, press down on the top edge of the rim with the palm of your hand, so that the rim slides a little further down onto the bottom with each push. Keep moving around the tray until the entire rim touches the table all around the tray. Don't try to get the rim the whole way down with the first push; you will need to move around the tray several times, inching the rim further into position with each circuit around.

24. Mark the nail locations around the bottom edge of the rim (as indicated on the pattern) with a vertical pencil line about 1/4 inch long. Lay an ordinary lead pencil on the work surface next to the tray, and without lifting the pencil or the box from the table, make a short horizontal line across each of the vertical marks: The marks for the nails should all be at exactly the same height above the bottom (about 1/8 inch).

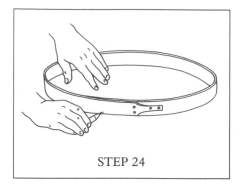

STEP 24

25. To avoid splitting the rim when you attach it to the bottom, predrill all nail holes with a no. 54 drill bit. (If you have a drill press, push the bottom of the tray against a vertical fence.) To drill the holes by hand, hold the rim between your knees, and drill with care. Mark the drill bit with a piece of masking tape 1/4 inch from its point so that you drill no more than that into the wood. If you drill the holes as close to perpendicular to the rim as possible, it will be easier to drive the nails.

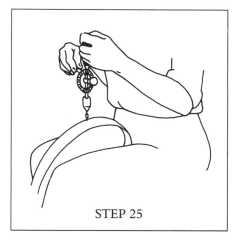

STEP 25

26. Put one of the escutcheon pins into a nail hole, and drive it into the bottom until the underside of the head fits snugly against the rim; don't drive the head down into the rim. Continue in this manner until all the nails are in place.

27. Set the tray aside to dry. As the rim dries, the wood will shrink away from the tack heads, leaving them sticking out from the

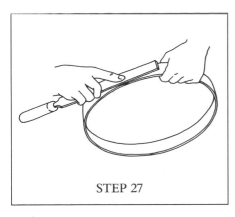

STEP 27

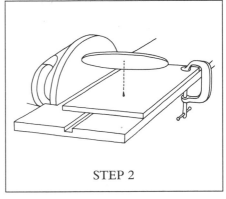

STEP 2

surface. When the tray is fully dry, slip the overlap back onto the anvil, and reset the tacks by lightly tapping them in flush with the surface. To complete the job, the tack heads should be filed to completely smooth the surface. Brother Delmer used to say that you filed the tack heads "so that the ladies didn't catch their dresses on them."

28. Finish the tray as suggested on pages 5-6.

Spit Box

9¾" diameter x 3½" high

SUPPLIES

1 softwood board (such as pine),
³/8" x 9½" x 9½"

1 hardwood board (such as maple),
1/8" x 3½" x 41¾" (final
trimmed length will be 38¾")

1 hardwood board (such as maple),
1/8" x 7/16" x 38" (final
trimmed length will be 35")

No. 2 copper tacks

No. 18 ½" brass escutcheon pins

Finish (see page 6)

Although the Shakers made round boxes as well as oval ones, few of their round boxes had swallowtail fasteners. One style of Shaker-made box that consistently did, however, is the spit box. Although the originals were used exactly as their name suggests, reproductions are popular as fancy serving containers for rolls or muffins. As with the oval tray, spit boxes can be bent directly around their circular bases, with no need of a custom-made form.

Spit box construction is similar to that of the oval tray. Because the sides of the box are wider, however, the Shakers used three swallowtails instead of one. One or even two swallowtails on a box this size would be entirely out of proportion with the size of the box. Since the box doesn't have a lid and was designed to be banged on its thin upper edge for emptying, its construction also calls for a reinforcing rim around the top.

1. Using a compass, draw a 9½-inch diameter circle directly on the wood for the box bottom. Following the technique described in Step 2, page 7, rough cut the circle to within 1/8 inch of the pencil line.

2. Because the bottom of the spit box is circular, it is a little more difficult to sand accurately than the oval bottom of the tray. The human eye can detect even the slightest irregularity in the shape of a circle, and, unless you are very careful and very good, you will find that your box bottom will look awful. The solution to this problem is to do what the Shakers did — cheat! To get a perfect circle every time, make a sanding jig in the following manner: Drive a small finish nail completely through a thin board so that the nail head is flush with the surface of the board. Clamp this jig onto the table of your sander with the nail point up to act as a pivot point. Clamp the jig loosely to the sander table in a posi-

tion that allows you to push the center mark on the box bottom (which you made with the compass pivot point) down onto the jig pivot nail. Be sure that the nail and the mark are exactly aligned. Turn the sander on and push the rough-cut bottom into the disc so that you are sanding to within 1/16 inch of the pencil line. Tighten the clamp to keep the pivot point stationary. Turn the bottom around and around until the edge is perfectly round and the sander doesn't cut any more. Then, carefully loosen the clamp and move the bottom into the disc until you are sanding right down to the line. Retighten the clamp, and finish sanding the bottom to its finished size. Make sure that you shut off the sander before you try to remove the finished bottom. It is virtually impossible to remove the bottom without bumping into the disc and grinding away a significant chunk of the edge. (To hand sand, see Step 3, page 7.)

3. You now have a perfect circle, pleasing to the eye except for the nail hole smack in its center. Split a sliver from the scrap wood left after cutting the bottom. Whittle it into a dowel slightly larger than the pivot hole. Cut a short, sharp point on the dowel, dip it in glue, and push it securely into the hole. Don't try to drive it through the board! Let the glue dry for a half hour. Trim the dowel off flush with the face of the

STEP 3

bottom by pushing the flat of a chisel against the bottom and paring the dowel off with a slicing motion. Do not push too hard or the dowel may snap off, leaving a jagged edge poking out of the nail hole. Sand the two faces of the bottom as described in Step 4, page 7.

4. Using the 3½-inch wide piece of maple, plane a featheredge taper 5 inches long as described in Steps 6 and 7, pages 7-9.

5. Scrape the side smooth as described in Step 8, page 9.

6. With the featheredge still clamped to the work surface, make a mark at the unplaned end 38¾ inches from the planed end, and cut the side to length as described in Step 9, page 9.

7. Using the pattern on page 121, trace the swallowtails on the same side that you planed the featheredge, and clamp the swallowtail end to the work surface as described in Step 10, page 9.

8. Cutting the swallowtails is complicated by the fact that you have to cut *between* swallowtails in addition to cutting just the outsides as for the tray rim. One simple, constant reminder to yourself will make this task much easier: "Don't push down."

Cut the *spaces* between the swallowtails first. The outer, uncut top and bottom edges will make the inner edges of the swallowtails more rigid and easier to cut, because you

don't have to compensate for their bending while you cut.

First, open the V between the swallowtails by making a straight cut, starting about ¼ inch from the base of the V. During this first cut, the knife must compress the wood, as well as cut it, to make room for its own passage through the wood. Consequently, it takes significantly more pressure to cut the whole way through the rim. Since you are pushing harder, it is much easier for the knife to slip out of the cut and skid diagonally across the rim, leaving a deep cut across the ends of one or two of the swallowtails and ruining the rim. It is also easier to slip and cut yourself, so be sure to keep your elbows against your chest and your legs spread wide apart, out of harm's way. Hold the knife as described in Step 11, page 9, but hold it at a 90-degree angle to the wood — the angle it would have at the end of a normal cut. At this angle, the knife is less likely to skid to the side.

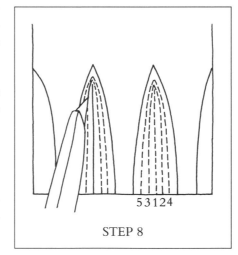

5 3 1 2 4

STEP 8

9. Begin the second cut with the knife at its normal 60-degree cutting angle. Place the fleshy part of the hand holding the knife on the end of the rim, and from this pivot point, carefully place the tip of the blade on the beginning of the first cut. Pull

back toward yourself, rotating your wrists as you pull, so that the knife is at a 90-degree angle to the rim when you reach the tip of the swallowtail. Remember: Don't push down! Your arms are heavy enough and the knife is sharp enough that the blade will cut down into the wood without any pushing. At the end of the cut, a thin chip should pop out of the rim. Make a third cut in the same way, but with the knife held at a 60-degree angle in the opposite direction. Again, a chip should pop out easily. The cuts from the left and right should run together toward the center line of the space between the swallowtails, leaving a clean, smooth notch at the base where the swallowtails meet.

10. Open the V further by making the next two cuts about ⅛ inch closer to the base of the swallowtails, again alternating by cutting first on the left and then on the right. Continue to make new pairs of cuts until the cuts begin on the pencil lines. You will find that the last two cuts follow the pencil lines for at least ¼ inch as you cut toward the tips. Don't go back and try to start the next pair of cuts at the base of the V or you will ruin the clean V you have created. Instead, start these cuts, and all subsequent cuts, as described in Step 11, pages 9-10. Repeat this process until all of the waste wood is cut away.

11. Cut the second V in the same manner.

12. Cut the outside edges of the top and bottom swallowtails the same way you cut the edges of the swallowtail on the tray. Any slight irregularities on the edge of the swallowtails can be very carefully sanded out by turning the swallowtail edge so that the outside of the rim is facing away from you and sanding the bumps off with 150-grit sandpaper.

Reach up from the underside of the swallowtails and press the sandpaper against the work with your index finger; be careful that you don't sand the sharp edge of the swallowtail —just sand the bevel.

13. Drill the tack holes with the end still clamped to the work surface (see Step 12, page 10). Be sure to center the holes within the swallowtails when you drill them.

14. Taper the back side of the swallowtails for 5 inches (see Steps 13 and 14, page 10).

15. Cut a 45-degree bevel on the tip of each swallowtail (see Step 15, page 10).

16. The side of the spit box is bent and fit to the bottom exactly as described in Steps 16-27, pages 10-13, but because the side is much wider, there are a few extra things to be aware of. First, and most critical: Always push on all three swallowtails at the same time. If you don't, the side will cheerfully split right down the grain line, and you will end up with two or three smaller box sides. The easiest way to control the swallowtails when bending is to put the fleshy part of your fingers across all of them as you bend. (If you make a very large Shaker-style box, you must use a stick for this procedure because your fingers are not long enough to reach across the entire width. Because sticks are likely to slip, it helps to glue a strip of coarse sandpaper on the face of the stick, but this is no substitute for careful work on your part.)

17. Because of its width, the box side is likely to distort along the top edge after it is pushed onto the bottom. To hold box sides in shape as they dried, Shaker boxmakers used a drying form called a follower, which was a thin, oval-shaped wooden cork with vent holes drilled through it. The sides of the follower

were tapered slightly, so that they would easily slide down into the boxes and so that they contacted the box sides as little as possible. The vent holes allowed air to circulate into and out of the box, thus drying the inside, as well as the outside, into the desired shape.

The spit box needs one follower, cut the same size and in the same way that you cut the bottom, but with a tapered edge. To provide the taper, tilt the *outer* edge of the sander table down a few degrees, so that the follower won't slide down into the sanding disc. The follower will fit snugly into the box if you sand down just short of the pencil line. Before trying the fit, drill several neat vent holes in the follower, or you may not be able to get it back out of the box.

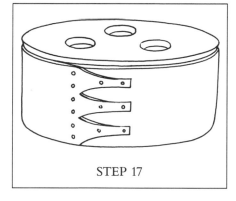

STEP 17

If the follower doesn't quite fit, remount it on the pivot nail and sand off just a hair. You will be surprised at just how little you have to sand off of the edge to make the follower fit. A few thousandths of an inch — the thickness of one of these book pages — is often enough to make the difference between a follower that fits and one that is too small or too large. Ideally, the follower should fit down into the box to a depth of about half of its thickness when it is pressed firmly. Don't push the follower into the box too forcefully or it will cause the edge of the box to flare outward. When positioning the follower,

always place it against the feather-edge of the box first.

18. With the follower in place, let the box side dry for a few days before you fit the rim, so that it will not shrink further after the rim is fitted.

19. The reinforcing rim is made from the 7/16-inch wide hardwood, following similar procedures to those for the side. Taper the featheredge, making the tip the same thickness as the base of the swallowtail on the box so that the rim will lie flush with the swallowtail. Next, cut the featheredge so that it will fit into the three-dimensional curve of the outside of the top swallowtail on the box side. (Use the template to trace the swallowtail on the featheredge end of the rim, but when you cut, *cut away* the swallowtail portion of the rim and *leave* what would normally be the waste portion.)

20. Cut the rim to the proper length. You may leave the overlapping end of the rim plain or cut a swallowtail into it — some Shaker rims had swallowtails but most didn't. If you cut a swallowtail on your rim, take care to keep it in proportion with those on the side of the box. After you have cut the end as desired, drill holes for tacks and taper the end.

21. Soak the rim until it is flexible. Butt the trimmed featheredge tightly against the swallowtail on the box side. Clamp on a

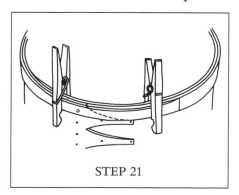

STEP 21

spring clothespin every inch or so to hold the rim against the side of the box as you bend; this will keep the rim from slipping as you work, and assure a nice, tight fit.

22. Mark the tip of the rim swallowtail with a pencil, remove the rim from the box, and tack the rim together.

23. Before you slip the rim back onto the box, make sure that the featheredge and the swallowtail are in exactly the right position. It is virtually impossible to slide them into alignment after you put the rim onto the box.

24. Push the rim into place all around its edge. Turn the box over and press it down on the table to push the rim the rest of the way onto the box. Keep pushing until the outside edges of the rim and the box are aligned.

25. To drill nail holes around the rim, clamp a scrap of pine board so that it projects out over the edge of your work surface, and slide the box over the end of the board. (Although you may wish to lay the holes out with a pencil before you drill, the Shakers usually "eye-balled" the spacing.) With a no. 54 drill bit, drill holes every couple of inches around the rim. Use the scrap board as a support to drive brass escutcheon pins into the holes until the heads are firmly seated on the rim; don't drive them into the surface.

26. Using a pair of diagonal cutting pliers, cut the points of the escutcheon pins off flush with the inside of the box. File the cut ends smooth with a half-round file.

27. Put the follower back into the box, and allow the rim to dry before sanding and finishing it (see pages 5–6). Most Shaker spit boxes were finished on both the inside and outside, generally with either a wash coat of yellow paint or a clear varnish. Oil finishes are much easier to apply, however, because you can do the inside and the outside at the same time. Furthermore, these finishes do not sag or run. Two or three coats should do it.

Oval Box

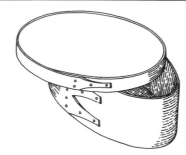

4⅝" wide x 7¼" long x 2⅝" high

SUPPLIES
2 softwood boards (such as pine), ¼" x 4¾" x 7½"
1 hardwood board (such as maple), ¹/₁₆" x 2⅝" x 27" (final trimmed length will be 24")
1 hardwood board (such as maple), ¹/₁₆" x ¾" x 27⅜" (final trimmed length will be 24⅜")
No. 1 ½ copper tacks
Finish (see page 6)

If you have built the tray and the spit box, the oval box should be very easy to do. The technique is the same as for the first two projects, with two important exceptions: First, you will bend the oval box side around a solid plug form instead of around the box bottom (it's actually much easier to bend it around a form), and, second, there is no pattern for the bottom; instead, it is custom-made for each box by tracing the inside of the bent, dried side.

To make the plug mold, trace the pattern on page 121 onto a piece of 6" x 6" softwood, and cut it out with a band saw. Unless you are very good with a band saw, rough-cut the piece, and then do the final shaping with the disc sander. Set the sander table so that you are sanding a 1- or 2-degree bevel on the side of the form. (Test it out first on a scrap piece of wood.) This slight taper will make it much easier to get the box side off the form, yet it doesn't interfere with the bending process. Sand the form the same way that the follower is sanded (Step 17, page 15). Keep the block moving when you are sanding, so that the curve of the oval will be smooth and consistent. With a combination square, mark the center line on the side of the form.

1. Using the 2⅝-inch wide piece of maple, taper the featheredge for 3 inches, scrape the side, trim the side to 24 inches, cut the swallowtails (see pattern, page 119), drill the tack holes, taper the swallowtail end for 3¾ inches, and cut the bevel on the tips of the swallowtails, as described in Steps 6–15, pages 7–10.

2. Soften the side as described in Step 16, page 10.

3. Place the box side onto the form so that the main tack line of the side is on the center line of the form. Wrap the side around the form, and mark the placement of the swallowtail tips.

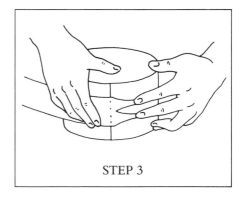

STEP 3

4. Tack the side ends together with the tips of the swallowtails *on* the pencil line (not past it, as in the other projects).

5. Slide the side down onto the form.

6. Taper the featheredge of the lid rim for 3 1/8 inches, trim the rim to 24 3/8 inches, and cut (see pattern, page 119) and taper the swallowtail for 3 7/8 inches, as described in Steps 6-15, pages 7-10.

7. The lid rim is fitted around the box side while it is on the form. Soften the rim as described in Step 16, page 10. Align the back tack line of the rim with the back tack line of the box, and wrap the lid rim around the top of the box side. Mark the tip of the swallowtail. Tack the rim together with the tip of the swallowtail about 1/32 inch *beyond* the pencil line. (As the box side and the lid rim dry, the fit between the two will get looser; this extra snugness will compensate for that to give a firm fit. Don't go so far that you can't get the lid rim off the box. With practice you will be able to fit lid rims perfectly.)

8. Place the rim over the box side on the form, and allow them to dry for several days. Slide them off the form to fit the tops and the bottoms.

9. Taking care to align the long axis with the grain of the pine heading, place the dried box side on the heading, and carefully trace around the inside of the box side with a pencil. Slide the lid rim about halfway off the box. Turn the box upside-down and place the lid rim on the heading, aligned as before with the grain, and trace around the inside of the lid rim. Mark the base of the swallowtails on the top and bottom with a pencil mark. The box side and lid rim are generally not quite symmetrical and the top and bottom will thus not fit as well if you reverse them when they are being fitted. Mark the bottom lightly with a B and the top with a T.

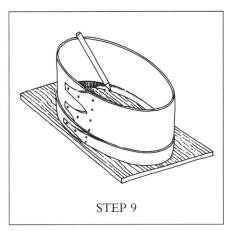

STEP 9

10. Cut and sand the bottom and top following the procedures described in Steps 2-4, page 7. If you would like a particularly tight-fitting lid, sand the top of the box so that it is a little longer than indicated by the pencil tracing, and sand the sides down beyond the pencil marks. When the lid is placed on the box, the ends will stretch and the sides will draw in and rub against the sides of the box.

11. Fit the tops and bottoms to the side and rim, following the procedures described in Steps 22-27, pages 11-13.

12. If the lid rim is too tight, don't panic until you have done the finish sanding on the inside and outside of the box and the lid. If it is still too tight, turn the box upside down and analyze the fit. Usually, the lid is tight in just a few places, not the whole way around. Pencil mark on the box the tight places, remove the lid, and scrape pencil lines off with your scraper. Repeat until the lid fits snugly without sticking.

13. For suggestions for finishing, see pages 5-6.

WOODWORKING

Seth M. Reed

*All work done...ought to be faithfully and well done,
but plain and without superfluity.*

<div align="right">

JOSEPH MEACHAM, *WAY-MARKS*, C. 1790

</div>

The respected position that Shaker furniture now holds in the world of American popular design is a fairly recent development. Whereas other traditional styles have enjoyed instant and continuous popularity, Shaker furniture went unrecognized until about twenty years ago. The reasons for this are many. Unlike the Worldly styles contemporaneous to it, the individual elements that make up Shaker style were never seen as uniquely new or fresh from a design perspective. Contrasted with Queen Anne furniture, for example, which took mid-eighteenth-century America by storm with its gracefully flowing S-curves, or late eighteenth-century Hepplewhite furniture, which was elegantly lean, but formal and uniquely different from the styles that preceded it, Shaker design had no distinctive line that set it apart from other contemporary styles.

Of the several explanations for the current popularity of Shaker furniture, one relates to the prevalent mystique surrounding both the Shakers and their furniture. Many factors have contributed to this mystique, but probably none so heavily as the Shakers' religious beliefs and lifestyle, both of which have been perceived as unusual and somewhat mysterious. The public is generally slow to accept, and even slower to understand, unusual religious factions. This lack of understanding breeds curiosity, which in turn leads to intrigue and fascination. In the case of the Shakers, fascination led to the birth of a popular style. The lifespan of a style born in this manner is generally determined by its ability to hold its fascination for a large audience. Although the popularity of Shaker style is relatively new-found, it does show promise for continued acceptance.

The wide appeal of Shaker furniture relates as well to another tendency of human nature: Furniture styles (like styles in architecture, clothing, or any other aspect of material culture) are often adopted first by those who enjoy a certain degree of status, before being recognized by a broader segment of society. When Shaker furniture became popular, originals tended to become more expensive, but the style also received greater publicity, making it more widely known and appreciated.

Mystique and fashion thus in part explain the current popularity of Shaker design, but a more serious evaluation of the style should be based, first, on its design merits and, second, on an understanding of how and why the style evolved into its classic forms.

One of the most important things we can say about both the merits of Shaker design and the relationship of that design with Shaker culture, is that Shaker furniture is probably the earliest example of furniture designed for large-scale, institutional use in this, or any other country. In the early nineteenth century, few, if any, settings other than Shaker communities required somewhat standardized furniture that could be quickly, easily, and economically produced to serve the needs of up to several hundred community members. I often compare Shaker retiring rooms (bedrooms) to twentieth-century college dormitory rooms, an initially somewhat jarring comparison, which upon closer examination stands up well. Both are set up as efficiently as possible, with furnishings that are generally identical in each room down the hall. The dormitory room may have a one-piece dresser-desk-bed unit, standardized enough to allow its use in any one of 100 similar rooms; similarly, Shaker retiring rooms were generally fitted with built-in drawers and cupboards, which were often designed as a standard unit in order to speed production and installation, as well as to make more efficient the enormous task of cleaning the large dwelling houses. This similarity between nineteenth-century Shaker and modern institutional arrangements is evident in all Shaker communities, and it demonstrates an important aspect of their lifestyle.

When we study how the style evolved into its classic forms, it helps to note that, although the Shakers were heavily influenced by what was going on in the World, they were, at the same time, a singular group of people — a microcosm of the larger society — who did their own thing in their own way. As the Shaker communities developed and separated themselves from the mainstream, they retained or adapted the various styles that converts brought with them in ways that best suited Shaker communal life and beliefs. Yet, at the same time that they were separate from society, they also had many things in common with the World's people. Unfortunately, many written histories distance us, as people, from people of the past, and that distancing is often the main obstacle we face in trying to understand past

cultures. Recognizing the similarities between the World's people (including ourselves) and the Shakers often provides answers for many commonly asked questions about Shaker design. Their cabinetmakers, for example, drew their design inspiration from the designs that were typically being made elsewhere at the time, just as modern cabinetmakers do. Similarly, the levels of skill of Shaker cabinetmakers were varied, just as the skill levels of today's cabinetmakers are — technically, some pieces are rather amateur and others rank with the best of the best. And even the masters had both good days and bad days. A valid study of Shaker furniture thus examines individual pieces as well as the total body of work.

On Tools and the Workshop

Workshops tend to be as varied as the workers who use them and the work done there. Shaker woodworking tools were no different from those used by Worldly carpenters, and the Shakers seldom designed or made their own tools. Although a woodworker's shop and tools will have some bearing on the quality of his or her work, a tremendous amount of space and every power tool known to man are not essential to producing quality pieces. All too often, both putterers and professional woodworkers blame the shortcomings of their work on their shop and/or their tools. Yet some of the finest furniture that this world has ever seen was made in past centuries in small shops, using tools that ran off muscle and finesse rather than 220-volt current. When I am asked how the Shakers did such nice work using such primitive tools, I answer that there is no such thing as primitive tools — only primitive tool users. The key to making a "minimalist" shop work lies in having a handful of good, basic tools and, more than anything else, knowing how to maintain and use them.

Although power tools do make certain jobs easier, most of the projects included in this chapter can be constructed with the hand tools indicated on the accompanying list. A perfectly adequate workbench can be made of common framing lumber, nailed together and equipped with a working vise and holes for bench dogs. You will need bench chisels in four or five sizes from ¼ to 1 inch — preferably bevel-edged, paring chisels. A block plane is a small, one-handed, low-angle plane used for fine planing and end-grain planing. A smoothing plane is a 9- or 10-inch plane used for final, smooth planing. A jack plane is a 14- to 16-inch fork plane used for rough stock removal. A mortise gauge has two cutting points rather than one as on a marking gauge; it is especially useful for such projects as the end table (pages 26-31). The cutting points are set to scribe out the sides of both the mortise

EQUIPMENT LIST

Workbench
Hammers, screwdrivers
Bench chisels
Block plane
Smoothing plane
Jack plane
Cabinet scraper
Combination square
Marking gauge
Mortise gauge
Wooden mallet
Rubber mallet
Rip saw
Crosscut saw
Dovetail saw
Coping saw
Brace and bits
Eggbeater drill
Cork block
Wooden spokeshave
Bench hook

FIGURE 2

and tenon to be cut (see Step 10, page 28). A dovetail saw is a fine-toothed backsaw. A cork block, available through many catalogs, provides a firm, though not hard, backing for sandpaper. A bench hook is made by screwing a cleat to each end, but on opposite sides, of a piece of scrap wood (Figure 2); to use, lay the hook on your bench with the underside cleat toward you, so that it butts against the edge of the bench, and lay the workpiece against the top cleat, which keeps it firmly in place.

To make the post-and-rung stool (pages 23–26), you will also need a lathe and turning tools, such as skews, gouges, parting tools, and calipers. The lathe is one of the oldest woodworking machines. Early lathes, including those used by the Shakers, were driven by foot treadles or water power.

The Projects

The three projects included here are as enjoyable to make as they are useful. The first — a wall shelf — is the smallest and simplest, but even beginning woodworkers should have no trouble completing the slightly larger and more complex projects, provided that adequate time and care are taken. The shelves and end table can be made by those who have few or no power tools, for the joinery techniques that I describe focus on hand methods. However, these techniques can readily be adapted to machine work if you prefer. For the post-and-rung stool, you will need a lathe.

Your biggest problem may be to get your stock planed to the proper thickness. If you have neither the equipment nor the knowledge to accomplish this, ask a friend or neighbor to mill your stock for you (offer a favor in return!), or seek out a local cabinetmaker or mill-work shop to prepare your stock for you for a fee.

You may use any one of a number of finishes on these pieces. Until the 1840s, the Shakers were likely to have used a painted finish —usually red, blue, or yellow, which were cheap and readily available; green was also sometimes used. After 1840, they also began using oil, varnish, or shellac. (For paint sources, see under Oval Boxes in the List of Suppliers, page 128.)

Once you've finished a project, don't forget to stand back for a few minutes to admire it. Unfortunately, our eyes are always drawn to the imperfections of our own work. This is good, so long as we also feel a sense of accomplishment from the perfections of the same piece. In other words, while it's important to your development as a craftsperson to be conscious of what needs to be done better, you should also feel good about what you have achieved.

Wall Shelf

11" wide x 5¾" deep x 8¼" high

5" wide x 4¼" deep x 11½" high

SUPPLIES

Shelf A: Pine board (or other wood), ¼" x 11" x 25"

Shelf B: Pine board (or other wood), 5/16" x 11" x 18"

¾-inch, cut finishing nails (see List of Suppliers, page 128)

Yellow glue (such as Titebond, or Elmer's Carpenter's Wood Glue)

Finish (see Step 9, page 23)

Wall shelves were made by both the Shakers and the Worldly people in literally hundreds of styles throughout the eighteenth and nineteenth centuries. Their primary traditional purpose was for holding various lighting devices, although their modern uses are unlimited. Most of the originals were made of clear pine, but nearly any native wood will work well. Two variations are described here. The originals are at the Hancock Shaker Village.

PREPARING THE PARTS

1. Hand plane the stock to remove all traces of machine work.

2. Enlarge the patterns on page 126, cut out your enlargements, lay them on the wood, and trace them in pencil. Be careful to arrange the patterns so that the wood grain runs vertically on the vertical parts (sides and back) and horizontally on the bottom.

3. Cut out the parts. If you use a coping saw for this step, clamp a bird's-mouth board (a scrap board with a V-shaped notch cut in one end) to your bench. Position the wood so that the cutting line falls over the notch; the wood on both sides of your cut will thus be supported and prevented from breaking off. Drill the holes for hanging.

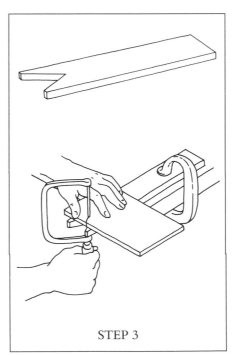

STEP 3

4. Finish the edges of the cut-out parts using a spokeshave, block plane, or chisels, and sandpaper. If you wish to have rounded or beveled edges, clamp the piece in a vise and use a spokeshave.

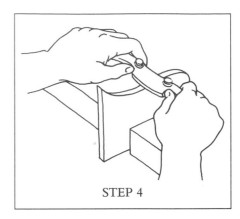

STEP 4

5. Do all of your final sanding with 300-grit (or finer) sandpaper before beginning assembly.

ASSEMBLY

6. Set up all the pieces as they will look when assembled, and check for fit and accuracy.

7. Contrary to common belief, both nails and glue are extremely common in Shaker, as well as non-Shaker, furniture made in the past. These fastenings are excellent, provided that they are used properly and appropriately, such as for these small shelves. The Shakers used hide glue, but yellow glues such as Titebond or Elmer's Carpenter's Wood Glue are quite good for this purpose. For a nice accurate touch in reproduction

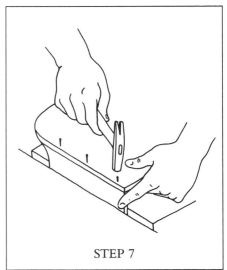

STEP 7

work, I use cut finishing nails of essentially the same type commonly used for fine trim work during the nineteenth century. These nails also hold better than wire nails. For stock of this thickness, the ¾-inch length works best.

The first pieces to join are the back and sides. To avoid splitting the wood and get the nail started straight, prepare for nailing by drilling ⅛-inch pilot holes through the shelf back. Place the first nail hole about ¾ inch from the top edge; space other nails about 1½ inches apart. Align the rectangular nail head along the grain of the wood; this looks better and also prevents splitting. Apply a small amount of yellow glue wherever the face grain on the back meets the face grain on the sides. With the side panel held in a bench vise, align the back, and, using a small hammer and light, even taps, nail the pieces together. Don't try to clobber the tiny nail in place with one or two strokes from a larger hammer.

8. Because the porous end grain of the back and sides would quickly absorb glue, making the glue ineffective, the bottom is nailed to the top without gluing. Fit the top unit to the bottom to check for squareness. Adjust the parts with light hand pressure, if necessary, before the glue on the top portion sets. When all is well, nail it together.

THE FINISH

9. The main key to any good finish, especially an oil finish, is to realize that your final surface won't be any better than the wood surface that you started with. If your wood surface is rough, uneven, or full of sanding marks, your finished surface will be also. Smooth your surface until you're absolutely positive that it's perfect — and then smooth it some more. When you are working with a finishing material that you're not familiar with, make several tests on scrap pieces first. For this project, nearly any finish is suitable, either with or without a stain (see page 21). Because of the inside corners, however, an oil finish is probably the easiest to apply; varnish or shellac is a little trickier to get onto inside surfaces. For reasonably good durability, make a simple oil finish of 1 part tung oil and 1 part turpentine. Rub on one coat and let it stand for twenty-four hours before rubbing with no. 0000 steel wool. Repeat these steps three or four more times. An application of paste wax, rubbed out with a cloth will produce an attractive, satiny final finish.

Post-and-Rung Stool

11½" wide x 14½" long x 9¾" high

SUPPLIES

Wood:
 4 posts, 1½" x 1½" x 12"
 4 short stretchers, 1" x 1" x 12"
 4 long stretchers, 1" x 1" x 15"
Yellow glue (such as Titebond, or Elmer's Carpenter's Wood Glue)
Finish (see page 21)
Weaving materials for seat

Note: Stock for turning should be checked carefully to be certain that there are no visible checks or cracks, which can cause chunks of wood to fly off when turning. If in doubt, throw it out. Knot-free wood with straight grain not only is stronger and more attractive, but also is a whole lot easier to turn.

This small stool, which uses post-and-rung construction, and thus requires a lathe to produce, is both useful and pleasing to look at. Because its production involves practicing many of the major cuts that woodturners use on a daily basis, it serves as a good introduction to woodturning in general, and chairbuilding in particular.

The Shakers made these stools in a variety of shapes and styles, the most common of which provides our pattern. The smaller size is intended primarily as a footstool, while a larger one could serve as a sort of backless chair. No matter what size you make, the steps are identical. After the stool has been assembled and finished, you can weave an appropriate seat of splint, rush, or woven tape (see pages 61–68), all of which were used by the Shakers.

I generally use either cherry or maple for this type of work. All around, maple probably makes the best chair wood, but cherry is nearly as strong and looks a bit nicer.

TURNING THE POSTS

1. To mark the centers of the stock and provide a notch for the drive center to engage in, stand the stock vertically in a vise and make two saw cuts, each running diagonally across the end from one corner to its opposite.

2. Mount one of the post pieces on the lathe. Set the tool rest by positioning it even with the lathe's centers; there should be about ⅛-inch clearance between the rest and the workpiece. Turn the stock

around manually several times to ensure that it won't hit the rest.

3. The *roughing cut* (first cut) reduces the entire stock to its maximum finished dimension. Use a large gouge, ground straight across. Aim the blade slightly to the right, with the tool handle angled toward the floor. Slowly raise the handle with one hand until the gouge contacts the wood and begins to cut. Once the shavings start to fly, slowly move the entire tool the full length of the wood, taking only a light cut per pass. Continue to cut (moving the gouge either back and forth or from left to right repeatedly) until the stock is completely round. Check for roundness by laying the back of the gouge on the spinning workpiece. When it no longer makes a ticking sound, the rough cut is complete.

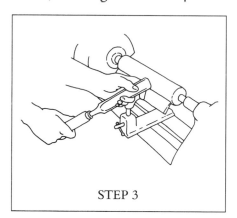

STEP 3

4. Set your calipers to slightly over 1¼ inch, the maximum diameter for this post. Using a parting tool, gradually make a cut about an inch from the right end of the stock. At the same time, lightly set the calipers into the cut; when the workpiece has been cut to 1¼ inch, the calipers will slip over it. Make a series of such cuts along the entire workpiece, spacing them every 2 inches or so. Being careful not to cut beneath the required dimension, remove the excess material between these cuts

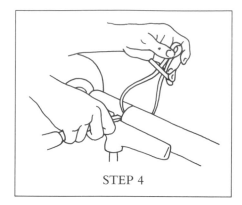

STEP 4

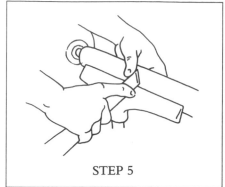

STEP 5

with your large gouge. You should now have a rough cylinder, just slightly over 1¼ inch diameter.

5. Use a ½-inch wide skew for smoothing. Skew chisels have three different cutting surfaces: the long point, the short point, and the middle edge. For this planing cut, use only the middle edge. Working at an angle to the workpiece, lay the tool on the work with only the edge of the bevel closest to you on the wood. Slowly raise the handle until the tool begins to cut. Move the tool slowly from left to right. If at first you aren't able to produce a smooth, clear cut, don't get frustrated — this type of cut requires a great deal of practice to master.

6. On a piece of scrap wood make a drawing of one vertical half of the finished piece; include all dimensions, both linear and diameter from the patterns on page 127. Transfer these dimensions to the workpiece by holding the drawing against the workpiece and carrying each mark over from the drawing to the workpiece.

7. Start the lathe again, and using a parting tool, cut in at both ends of the turning, at the two outside end marks.

8. Using calipers set to ⅞ inch and the parting tool, turn to the dimensions of the base of the post.

9. Rough cut the taper at the base with a gouge, and then clean it

TIPS FOR GETTING AN EVEN DIMENSION WHEN SMOOTHING A POST

○ Young, thin stock tends to chatter during turning. To prevent this, with your right hand take a one-handed grip on the blade of the tool, while gently supporting the work from behind with your left. If your right hand heats up, it may be a sign that you are holding on too tightly and using too much force — to compensate for a dull tool. (See Appendix for advice on how to sharpen tools.)

○ Butt your right hand against the tool rest, using it as a fence to keep your skew even with the rotating work.

○ Rest both sides of the hollow-ground bevel on the work, whether you are using a skew or a gouge. If only the cutting edge is contacting the wood, it will dig in. *The direction that your bevel is pointing is the direction that your cut will go.*

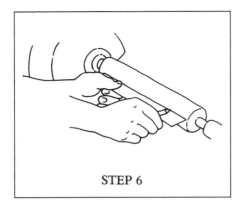

STEP 6

up with the skew, always working from larger diameter to smaller diameter.

10. The rounding at the top of the post is done with the skew, using the long point *only*. It takes three or four passes to create this round shape. Start with the tool angled slightly to the right. Be sure that only the long point contacts the wood; if any other part of the blade contacts the wood, it will grab and do terribly unpleasant things to the

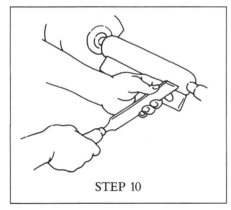

STEP 10

wood. Approaching the wood with your tool at an angle, slowly begin to cut, sweeping the tool handle to the right and raising it slightly. If you've never used this technique, you may want to practice on scraps. Do this rounding in several passes, as only a thin slice can be taken in a single pass. Using this method, you can turn this section down to about ³/16 inch, which reduces your trimming time after your lathe work is done.

11. To mark the location of the stretcher mortises, *lightly* touch the moving spindle with the long point of the skew at the points indicated on your diagram. A very faint scribe is all that is necessary.

12. Using a fine-grit sandpaper, sand with the grain, with the lathe off in order to avoid crossgrain sanding marks.

13. Remove the post from the lathe, saw off the excess on either end, and smooth the ends with a bench chisel and fine sandpaper.

TURNING THE STRETCHERS

14. Turning the stretchers involves basically the same operations as turning the posts, except that the stretchers have a *tenon* on each end. I usually cut these tenons to size with a parting tool. To ensure proper sizing of the tenons, set your calipers *exactly* to fit the same ½-inch drill bit that you plan to use to drill the mortises. Check the size of the turned tenon by drilling a ½-inch hole in a scrap of maple and fitting the tenon into it. It should be snug enough to require a mallet to tap it home, without using brute force. If your tenon is too loose, throw it out and start over; if too tight, gradually trim it down until it fits. This small stool has eight stretchers all together, four long and four short. I generally don't completely smooth the four top stretchers that will make up the seat rails, as leaving them slightly rough will keep the cloth tape (listing) from sliding around after the seat is woven. Following the same techniques as you used for the posts, turn all eight of the stretchers and trim the ends.

JOINING THE PIECES

15. You may drill the round mortises for the stretchers by hand or by power. With a ½-inch drill bit, drill holes ¾ inch deep (the length of the tenons). For a depth stop, simply place a piece of masking tape ¾ inch from the end of the bit.

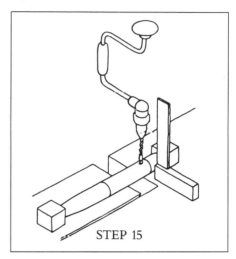

STEP 15

To drill the mortises, securely clamp one of the posts either between two bench dogs or in a face vise. As a guide for centering both mortises, draw a pencil line down the center of the post. Place the edge of the bit so that it just touches the *lower* edge of one of the scribe lines. Set a square on the workbench, and using it as a guide, begin drilling a hole perpendicular to the post. Continue until the depth stop touches the wood. Repeat this step beneath the other scribe line. In the same manner, drill two holes in each of the other posts.

16. To glue the long stretchers in place, apply a thin coating of glue with a small paintbrush to the inside of the first mortise and a thinner coat to the outside of the tenon. Set the stretcher in place, and slowly tap it home with a wooden mallet. Take another long stretcher and set it into the other hole on this post in the same manner.

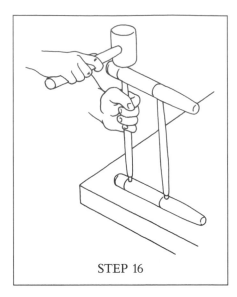

STEP 16

Note: If you have left four stretchers rough for the seat, be sure to place them in the top holes.

With the first two in place, apply glue to the other ends of these stretchers and to the mortises on another post. Lay the post on top of the stretchers and tap the whole assembly together, using a rubber mallet to avoid scarring the surface of the wood. Assemble the other end section in the same manner.

17. Clamp each section between bench dogs and drill the mortises for the short stretchers as described in Step 15, *except* this time,

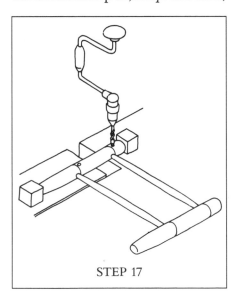

STEP 17

place the edge of the bit against the *top* edge of the scribe lines. Use a square to assure that the holes are perpendicular to the posts.

18. Glue four short stretchers into one of the end sections. Glue the other end section into place.

19. Check to see that the stool is square by measuring the diagonals with a ruler or tape measure. If it is out of square, you can generally correct it by squeezing it diagonally with your hands or a bar clamp. Unfortunately, only experience will show how far you can squeeze. If in doubt, stop. You may also have to level the stool so that all four feet squarely contact a flat surface. There are two ways to level it — the first of which *sometimes* works; the second of which *always* does. The first is what I call "the chairmaker's slam-dunk." Set your stool on a hard, flat surface, and holding it by the top stretchers, rap it down briskly (but not savagely). This sometimes corrects a slightly twisted stretcher that is causing the stool to be unlevel. The main drawback is that if there is bad grain in your wood or you rap it too forcefully, your stool will collapse like a breakaway chair in the Western movies. Go easy, or try the second option instead: With a sharp chisel, trim off the bottoms of the too-long legs until the stool is level.

FINISHING

20. Most original stools seem to have been oiled or varnished, but almost any finish would be suitable. If you are making more than one stool, and you would like to save time, you may want to use an oil finish on the parts *before* assembly, since it is more difficult and time-consuming to put a finish on after the stool is assembled.

End Table

23" wide x 15³/8" deep x 27¾" high

SUPPLIES
Wood:
Top, ¾" x 15½" x 23"
4 legs, 1¼" x 1¼" x 27"
2 side skirts, ¾" x 4" x 12½"
2 skirts (front and back), ¾" x 4" x 19½"
2 cleats, ¾" x ¾" x 11"
16 ³/16-inch birch dowels, cut to ¾" long
Wood screws
Yellow glue (such as Titebond or Elmer's Carpenter's Wood Glue
Finish (see page 21)

The small end table described here is based on one from the Hancock Community. This table, traditionally referred to as a stand, is only one of hundreds of similar designs made by the Shakers throughout the nineteenth century. Although stands of this type are very often considered a classic Shaker form, a great many were also made by Worldly cabinetmakers, not only because they were attractive, but also because their straightforward design was economical to produce.

In a project of this kind, absolute accuracy in laying out your joinery and cutting mortises and tenons is critical. Not only is the quality of your joinery readily visible

on the finished piece, but it is also one of the main factors that affects the life expectancy of your furniture. Even a joint that doesn't show at all needs to be completely neat, clean, and, most important, properly fitted. The key factors that are involved in proper joinery are

o *understanding what joint you are making and why*

o *allowing as much time as it takes to do it right*

o *measuring and dimensioning with absolute accuracy*

If you ignore any of these elements, it will show up sooner or later in your work. When you are first learning joinery, practice good working habits and do the job right — it will most definitely pay off in the long run.

The choice of wood for this project is entirely a matter of personal preference. Although the vast majority of original stands are made of hardwoods, many are also made entirely of common softwoods, such as pine or poplar. My version of this stand (shown on page 71) is of butternut, a very soft, deciduous wood frequently used by Shakers in the Northeast.

I used Eastern white pine for drawer sides and bottoms, not only because pine is easy to work with, but also because early cabinetmakers most often chose it for these purposes. The instructions below do not call for a drawer.

1. Rough cut all pieces to their nearly finished sizes. Before beginning any joinery, hand plane each piece on all of its faces with either a smoothing plane or a block plane to remove any marks left on them by machinery. These marks all need to come off at some point, and now is the easiest time to do it.

TAPERING THE LEGS

2. I always begin by shaping the legs. With a pencil, draw the taper on each leg. The taper begins 4¼ inches from the top and tapers down to the foot, which is ¾ inch square. Nearly all of the legs on the Shaker tables are tapered on the two inside surfaces only. This lightens the table, without making it appear top-heavy, as a four-sided taper would.

STEP 2

3. Although the actual cutting can be very quickly done with a taper jig on a table saw, hand tapering is a useful skill to learn. Clamp one leg between bench dogs or in a face vise with one of the sides to be tapered facing up, and the foot end facing away from you. Using a well-honed smoothing plane, take a fairly heavy cut, starting about 4 or 5 inches from the foot. (I do the first planing on the foot end, because that is where the most material needs to come off.) After taking five or six good passes, begin your cuts a little higher up the leg, again taking five or six passes from there to the foot. You should now begin to see a bit of taper starting. Continue in this manner, keeping a careful eye on the pencil line so that you don't plane beneath it. It's also a good idea to use a combination square to check your stock periodically for squareness.

4. When you reach your pencil line, turn your work 90 degrees and cut the second taper in the same manner.

5. Check the completed taper for squareness from top to bottom and make any adjustments that may be necessary.

6. Repeat Steps 2-5 on the remaining three legs.

LAYING OUT THE JOINERY

7. Lay out all legs and skirts, and number each piece systematically to ensure that each tenon will be fitted and assembled to its proper mortise. I number each leg, 1 through 4, and each end of each skirt to correspond. I place these numbers on the tops of the pieces, which gives the added advantage of being able to see at a glance which surface is the top. I also consistently number the parts in the same order (for example, front left is always 1; front right is 2; and so on).

STEP 7

8. Scribe a line on each end of the skirts to mark the length of the tenons, which should be ¾ inch. Set your marking gauge to ¾ inch, and scribe a line around all sides of the end of each skirt.

9. Since the skirts are ¾ inch thick, the tenon will be ¼ inch thick, or one-third the skirt thickness. With a ruler, adjust the cutting points of the mortising gauge so that they are ¼ inch apart, and move the gauge's fence ¼ inch from the adjustable point. Test for accuracy by scribing the end grain of one of the skirts first from one face and then from the other. If the scribe lines don't match up perfectly, adjust the fence setting until they do.

10. From the scribe made in Step 8, scribe a double line on top of the skirt, down the end grain, and stop at the scribe line on the bottom of the skirt. Repeat this operation on both ends of each of the skirts. I suggest that you always begin the scribe on the outside face of the skirt, so that if there is any inconsistency in the thickness of the stock, your tenons will always be properly spaced from the outside surface of the skirt.

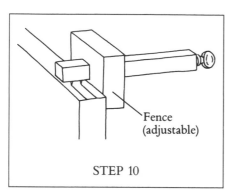

Fence (adjustable)

STEP 10

11. Scribe the sides of the mortises on the legs. Once again, be consistent and begin scribing from the outside face of each leg. Start scribing from the top of the leg, making lines just under 4 inches long. (Since the skirts are 4 inches wide, longer lines would be visible on the finished leg.)

12. Scribe yet another set of lines to mark the shoulders (steps on the edges) of the mortises and tenons. The main purpose of shoulders is to provide two additional bearing surfaces for the joint, thus adding more strength to an already strong joint. In the case of the bottom of the skirt, shoulders have the additional advantage of overlapping the edge of the mortise. This gives a neat appearance in case the bottom edge of the mortise is a hair uneven. Scribe these lines with a mortising gauge, marking one line ¼ inch from the top of the skirt, and the other 3¾ inches from the same point. Do this on each

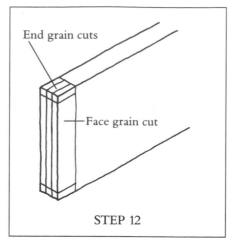

End grain cuts

Face grain cut

STEP 12

skirt end, and then on each of the leg mortises.

13. Before cutting, once more lay out your pieces to check that the joints to be cut are properly located. This final check ensures that you don't wind up with such a mishap as mortises cut in opposite sides of a leg. Believe me — it's been done!

CUTTING YOUR JOINERY

14. Different workers cut out mortises in slightly varying ways. I often start by drilling out most of the waste, either with a drill

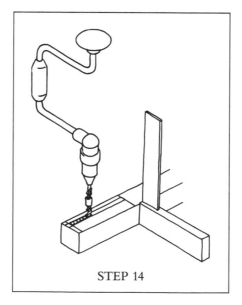

STEP 14

press or by hand. To do this by hand with a brace and bit, use a masking-tape depth stop as described on page 25, Step 15. The holes should be ¾ inch deep (the length of the tenon). Use a 3/16-inch bit, which will leave you room to tidy up the mortise sides afterwards. Drill a series of holes the whole length of the mortise, with a square set next to your work on the bench as an aid to keeping the holes parallel to the face of the leg.

15. Once the bulk of the waste has been removed by drilling, the slot can be cleaned out with chisels. With a wide (¾- or 1-inch) chisel, begin paring down the sides (or cheeks) of the mortise. On the last cut, you should be able to set the chisel directly into your scribe line.

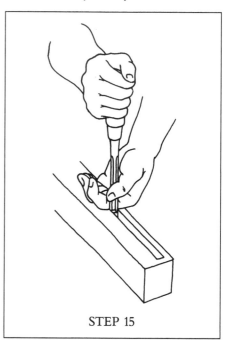

STEP 15

16. Finish the mortises by using a ¼-inch chisel to square up the ends. Again use light paring cuts, directed with hand pressure; at each cut, remove less than 1/16 inch of stock. The keys to cutting good mortises are to take your time while trimming and to pay close attention to squareness.

17. With the skirt clamped vertically in a bench vise, rough cut the tenons with a fine backsaw. Make your first saw cuts on the end grain surface of the stock. Since the end grain scribe lines denote the *finished* edges of the tenon, keep your saw cuts slightly *outside* of these lines, and be careful to stop your cuts before you get to the line marked on the face of the stock. Since each tenon has four faces, you'll be making four cuts on each end of each skirt.

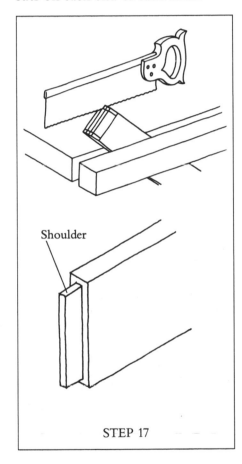

Shoulder

STEP 17

18. Finish removing the bulk of the waste by making the face grain cuts. Lay one of the skirts up against the top cleat of a bench hook (see page 21). Being careful to stay just outside of your scribe lines, make the face cuts on all pieces. Saw down until the cut intersects with your previous cuts and dislodges chunks of waste wood.

TRIMMING AND FITTING

19. Most of the work of trimming and fitting the tenons involves using a perfectly sharp, ¾-or 1-inch chisel. Make light, accurate paring cuts. I start with tenon "1" on the front skirt and work my way around the table in order. To trim the shoulders, butt the end of the skirt up against the bench hook. Slowly pare down vertically toward the tenon, using your scribe line as a guide for the last of your cuts. Trim all of the shoulders in this way; then lay the stock with its long face against the bench hook cleat in order to trim the faces. Lay your chisel with its back flat against the face of the tenon, and begin making light, paring cuts across the entire face of the tenon. Do this careful trimming on all four sides of each tenon, stopping *just short* of the dimension lines scribed on the end grain of the piece.

STEP 19

20. Test-fit the tenons by holding each tenon up to its corresponding mortise to see how closely they align. Continue to trim slowly until the parts begin to fit; at the same time, with a combination square, check that the faces of the tenon are square. Bear in mind that a perfect fit requires only a fairly light tap of a mallet to drive the tenon home — experience alone will teach you when that point is reached. If you have to put too much power into the procedure, the tenon fits too

tightly and will split out the leg mortise when forced into place. One last tip: Lightly ease all of the sharp corners of the tenon by using a chisel or block plane to put a light chamfer (less than 1/16 inch wide) on each corner. As a final check, dry-fit the leg and skirt by tapping the parts into place with a wooden mallet. To disassemble, clamp the leg between bench dogs or in a vise, and wiggle the skirt gently left to right while pulling it upward. Fit each tenon in the same manner.

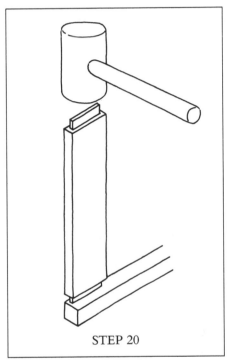

STEP 20

FINAL ASSEMBLY

21. Final assembly is best done in two separate stages: First, glue front and back skirts to their respective legs and, second, join these front and back units together by gluing in the side skirts. Begin by clamping the first leg for the front section in a vise. I usually apply glue with a very small paintbrush, coating the inside of the mortise quite liberally and giving the tenon a very light

coat. Since most all of the glue that squeezes out of the assembled joint will have come off the tenon, applying only a light coat here will give you less cleaning up to do afterwards. With glue applied to both surfaces, gently tap the joint home. For this type of assembly, I always use a wooden mallet onto which I have glued a leather face that prevents the marring of the surface. (Be aware that even a protected mallet can cause dents if used too forcefully.) In the same manner, complete the assembly of the other leg on the front section. Next, clamp the unit snugly together with a bar clamp, padding the jaws of the clamp with scraps of softwood to prevent clamp dents on the finished work. Check the unit again for square. If it is out of square at this point, you can generally correct it by adjusting the pulling direction of the clamp until the unit is true. Glue the back section in the same way. Set both units aside until the glue sets.

22. Join the front and back sections together by gluing in the side skirts. Clamp the whole thing together and test the base one last time for squareness — this will be your last chance to right any wrongs. Put the completed base aside until the glue has set thoroughly before removing the clamps.

23. Finish your joinery by pegging the base together. This pegging elevates an already strong glued joint into an incredibly strong mechanical joint. On the *sides* of the legs, mark the position for the pegs; note that there are two pegs set into each joint. With a 3/16-inch drill bit, drill all peg holes to a depth of 3/4 inch. Precut sixteen pegs from 3/16-inch birch dowels, and with a chisel, make slight points on one end of each. Dip the pointed ends in glue (further reinforcement), and tap them into place.

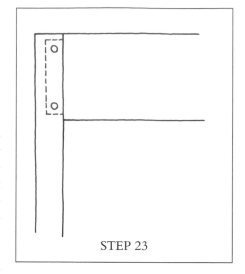

STEP 23

24. Note that not only do the pegs protrude at this point, but some of the skirt-leg surfaces are also not completely smooth. Begin your final trimming by sawing off the excess pegs. Next, with a razor-sharp chisel, clean up the joints one at a time. With your chisel flat on its backside, pare off any excess, whether it be from the skirt or the leg. Do your final smoothing with fine-grit sandpaper wrapped around a cork block.

THE TOP

25. Due to the size of this top, as well as the size lumber that is most often available, you will probably need to glue two boards together to achieve the necessary dimensions. With a power jointer you can easily plane the edges for a glue joint of this type. If you don't have this equipment, the joint can be made just as well (though with a bit more skill) with a hand plane. The two boards should be of the same thickness, but they should be a little longer and wider than the final required dimensions. Clamp both of these boards in your bench vise face to face with their top edges as flush

as possible to each other. Traditionally, a long, 24- to 36-inch jointer is used; if you don't have one that long, use your longest plane. Begin by making passes on the two edges clamped together, working slowly and checking them often for square. You should also check for straightness — which is highly critical — by both sighting down the edge and comparing it against a straight edge. For greatest success, bear down slightly on the front of the plane at the beginning of each pass and then on the rear of the plane at the end of each cut.

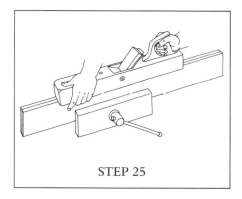

STEP 25

26. Unclamp the boards and lay them edge to edge on your bench. You should see no gaps, cracks, or voids. If the pieces don't mate perfectly, put them back in the vise and plane some more until they do. Modern glues are wonderful, but they neither fill gaps nor provide any strength unless there is exact wood-to-wood fit.

27. To join the two pieces, apply a thin coat of glue to each edge, and then clamp them together with fairly heavy bar clamps and good, tight pressure. Many people use a lot of dowels when joining the pieces, but I feel that if the edges are properly jointed and glued, they will stay together, and if the edges are not properly jointed and glued, they will not. In other words, dowels will do nothing for an ill-fitting butt joint,

except to make it more time-consuming to produce. Allow the glue to set overnight.

28. Remove the clamps. Cut the top to its finished dimensions (15 3/8" x 23"). Lightly replane its faces to remove any irregularities that may have occurred during gluing.

29. If you look at Shaker tables, you will often see that the undersides of their edges are either rounded over or chamfered lightly. This easing of the edge significantly lightens the appearance of the table. If you choose to profile the edge, do it now with a block plane or a router.

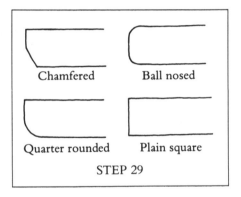

Chamfered Ball nosed

Quarter rounded Plain square

STEP 29

30. Finish smoothing the entire top with a thorough scraping and sanding.

MOUNTING THE TOP

31. The following method for attaching tops is but one of many traditional methods, but one I often use on tables of this type. It involves using two blocks of wood (cleats) to which both the top and base are screwed to form a single unit. I generally make these cleats of maple, mainly because its rigidity helps to stabilize the top during humid spells. Cut two cleats, about 3/4 inch square, of a length appropriate to fit between the legs on the end skirts of the table. You will need to

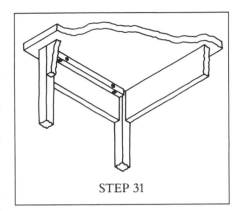

STEP 31

drill two sets of holes in each cleat, one set on each of two adjoining faces. Because in humid air the top always expands across the grain (widthwise), the holes for the top screws should be slots. This allows the top and its securing screws to slide back and forth as the wood expands and contracts. Use a small, round file to file the drilled hole into an oval, parallel to the grain of the cleat, roughly 1/4 inch long.

32. To predetermine what length screw you need (if you choose one too long, you will have a set of screw points protruding through the top of your table), add together the thickness of the top and the cleat, and subtract 1/8 inch. This is the longest length screw that you can safely use. (Example: 3/4" + 3/4" = 1 1/2"; 1 1/2" − 1/8" = 1 3/8"). In this case, use more common 1 1/4-inch screws, and countersink your holes a little deeper. For extra insurance, place your left hand on the table top above the screw as you are driving it in; if the point should happen to go too far, you will feel it before it breaks the surface. In that case, take it out and use shorter screws.

THE FINISH

33. Since entire volumes have been written on wood finishing, I offer here only a few sug-

gestions about some of the more common finishes. (See also page 21.) Probably the main consideration affecting your choice of finishes is the function of the piece in question. End tables such as this one are likely to have wet things set on them on a daily basis; therefore, shellac — which is a beautiful finish, but which offers little protection from water and alcohol — is not a good choice. Lacquer is also a nice finish, but many woodworkers consider it a nightmare to apply. Although paint is also a fine finish, most people make furniture out of wood because they want to see the natural wood. That leaves oils and varnishes, both of which are relatively resistant to water and alcohol (varnish is more so), and relatively easy to apply.

If you are using a finish that you've never used before, do as many test pieces as possible to get an idea both of how the finish handles and how the wood takes it. Whatever finish you use, to achieve a decent surface you must rub it down *completely* between *each* coat with either no. 0000 steel wool or 400-grit (or finer) sandpaper. If you are using an oil finish, apply it with a rag, as most manufacturers suggest. The label directions on many oil finishes suggest applying only two coats, however, and this is not sufficient. I apply a minimum of four coats, and sometimes as many as six or seven to table tops. As you experiment, you will eventually get the results that you are looking for, but don't ever settle for less. After the last coat of finish has hardened for several days, rub it down again and, with a soft cloth, apply a coat of paste wax. Allow the wax to stiffen for ten or fifteen minutes, and then buff with a soft cloth. If you prefer a lower gloss, wax again, buffing this time with no. 0000 steel wool instead of a soft rag.

MINIATURE SHAKER FURNITURE

Dana Martin Batory

Trifles make perfection, but perfection itself is no trifle.

SHAKER ADAGE

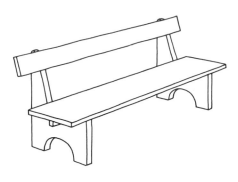

If you appreciate the craftsmanship and proportions of Shaker furniture, yet high prices or limited space prohibits you from collecting full-size pieces, you may wish to try making miniatures. With its clean, sharp lines and straightforward construction, Shaker furniture readily lends itself to being duplicated in small scale. Simple, yet elegant, such pieces exhibit enough complexity and beauty to satisfy any craftsperson, no matter what scale he or she normally works in.

Materials and Equipment

You may purchase wood for your projects, or you may become interested, as I have, in collecting old woods. Over the past several years I have created many of my own Shaker miniatures from wood salvaged from a 140-year-old farmhouse in Richland County, Ohio. Red beech, chestnut, and black walnut woods, buried beneath several generations of lead paint and yellowed varnish, have been transformed into miniature-sized, classically proportioned Shaker furniture that is truly unique. If you are observant, and lucky, you may be able to collect materials for your miniatures from an old barn or house that is being destroyed, and thus save a bit of local history, at the same time that you preserve Shaker traditions of workmanship. Although, as far as I have been able to discover, the Shakers did not themselves build miniature furniture, I like to think that making furniture from reclaimed wood is something they would have approved of.

For their own furniture, Shakers selected the best trees in their lumber tracts, and sawed and carefully air-dried the wood before skill-

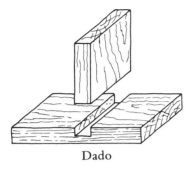

Dado

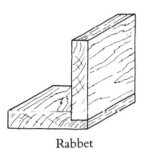

Rabbet

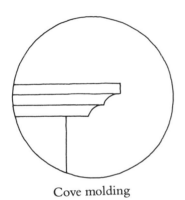

Cove molding

Butt-glued joints

fully completing a project. Their appreciation of fine craftsmanship demanded that the original wood be unconcealed. No inlay or veneer was allowed — just honest, solid wood. They left cherry and walnut with a natural finish, but sometimes gave a coat of red or blue paint to poplar and pine. I recommend following these basic principles when you are deciding on appropriate woods and finishes for your own Shaker miniatures.

Although stationary power tools such as a table saw, a jigsaw, and a drill press will allow you to build the following projects more quickly and precisely, the pieces can also be made using only such hand tools as an X-Acto miter box, a jeweler's saw, and a pin vise.

General Instructions

The patterns in this chapter are intended to be used full size. Your completed pieces will be on a scale of 1 inch equals 12 inches. If you intend to make more than one of each project, you will find that patterns cut from thin sheet metal (brass or aluminum, for example) will last indefinitely.

If you have a band saw, you can cut your own wood to the desired thickness. For the projects illustrated here, saw the wood slightly thicker than 1/8 inch, and then use a belt sander to sand the piece down to a 1/8-inch thickness. If you do not have your own equipment, you can obtain 1/8-inch thick wood from hobby shops or mail-order suppliers (see page 128 for List of Suppliers).

For the greatest authenticity, you should rout *dadoes* (joints at right angles to the wood grain) for the dustboards, *rabbets* (joints parallel to the wood grain) for the case backs, and *cove moldings* (concave moldings). If you are unfamiliar with how to operate a router, however, you can *butt glue* the dustboards and back directly to the case sides, using small pieces of 1/2-inch, 5/8-inch, and 3/4-inch plywood as temporary spacers. Cove moldings can be made using round files and/or X-Acto carving tools.

When working in small scale, splintering is difficult to control and greatly magnified. To avoid this problem, it is important to use the finest-toothed circular carbide blade available. Before cutting, make sure the wood is square. One edge should run straight along the grain, and crossgrain cuts should be made at right angles to that edge. Make cuts using any of the following three techniques: (1) Begin by using the saw blade to nick one edge on the cutting line. Then, flip the piece over and complete the cut by sawing from the other edge to the nick. (2) Place a piece of scrap wood behind the piece you are cutting, and then complete the cut. Or, (3) cut the width about 1/8 inch wider than the desired finished width. Next, cut the piece to exact length, and then remove the rough edges of the width by cutting about 1/16 inch off each side, bringing the piece down to the exact desired width.

Make the dadoes *before* sawing to exact width, so that you won't have to take special precautions against splintering the ends. Splintering should not be a problem when making rabbets.

Because varnish will not properly cover wood smeared with glue (the glue acts as a sealer against the varnish), sand and varnish the pieces before assembling them. To sand, use first 240-grit, then 320-grit sandpaper; finish by rubbing them with no. 0000 steel wool. To varnish, carefully leave bare those surfaces that will be glued; wood glue will not adhere properly to varnished wood. Apply three coats of finish, allow each coat to dry thoroughly, and rub with steel wool between coats. Assemble pieces, but do not glue them into place until you double check on fit and squareness. Miniature scale magnifies these kinds of mistakes also. When you are sure everything is correct, glue pieces in place with a wood glue such as Titebond Wood Glue or Elmer's Carpenter's Glue. Do not use hide glue or tinted glues. During assembly, if any excess glue squeezes out, wipe it off with a damp cloth, or wait until it dries, then scrape it away or pop it off with a chisel. After assembly, apply a final coat of varnish and a coat of paste wax.

If you are painting, rather than varnishing, your work, apply paint after the piece is assembled.

A Note on Drawer Assembly

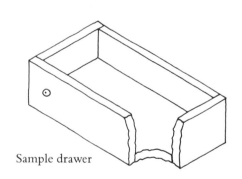

Sample drawer

Exact drawer dimensions are not given in the cutting lists, because each must be custom fitted into the frame. Rough cut the pieces following the patterns for each project (see page 125), but making them a bit larger than the required dimensions to allow for fitting. Before gluing the drawer fronts to their cases, mount the hardware by marking the handle locations while holding the fronts in their proper position. At the mark, drill a hole, slightly smaller than a sequin pin, nearly all the way through the drawer front. Slip a seed bead on the point, tap it through from the front, and bend it over on the back side. Butt glue sides and backs. Glue the drawer front to the sides, and check the fit again after the glue has set up. Cut and fit the drawer bottom, and glue it into place. Apply a final coat of varnish. Polish the drawer sides and bottoms with paste wax to make them work more smoothly.

Settee

6" wide x 1½" deep x 2¾" high

SUPPLIES

Wood:
 1 back (A), 1/8" x 3/8" x 6"
 1 seat (B), 1/8" x 1¼" x 6"
 1 brace (C), 1/8" x ¼" x 5½"
 2 sides (D), 1/8" x 1½" x 2¾"
Yellow glue
Finish (see page 33)

This simply designed bench would have seen service in a Shaker schoolroom. The original is in a private collection.

1. Cut settee parts following dimensions in cutting list. Use the pattern on page 122 to cut the sides (D). You will need a jigsaw or a jeweler's saw to cut the arc at the bottom.

2. Use a table saw and miter gauge, or an X-Acto miter saw and a square file to cut the 1/8" x 1/8" mortises (notches) in the brace (C) and sides as indicated on the pattern on page 122. To assure that the pieces are identical, clamp the two sides together and cut both at one time.

3. Fit (but do not glue) the brace and sides together. You may need to file the mortises a bit to make the top of the brace flush with the top of the sides. If the brace does not fit snugly, the seat will wobble.

4. Sand well, and apply three coats of finish (one coat will be adequate for hidden surfaces), rubbing with steel wool between coats.

5. Glue and clamp the brace to the sides. Glue down the seat (B). Glue on the back (A).

7. Apply a final coat of varnish, followed by a coat of paste wax.

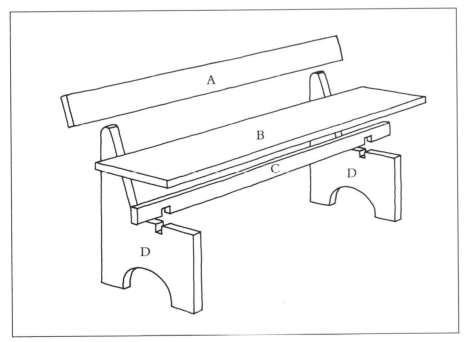

Counter

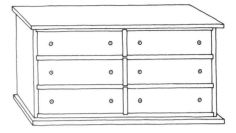

5¾" wide x 1⅝" deep x 3" high

SUPPLIES

Wood:
 1 top (A), 1/8" x 1⅝" x 5¾"
 1 base (B), 1/8" x 1⅝" x 5¾"
 2 sides (C), 1/8" x 1½" x 2¾"
 1 back (D)★, 1/8" x 2¾" x 5⅜"
 4 dustboards (E)★, 1/8" x 1⅜" x 5⅜"
 3 dividers (F)★, 1/8" x 13/16" x 1⅜"
Yellow glue
Finish (see page 33)
1 package ½-inch, gold sequin pins
1 package 1/16-inch white seed beads

★If pieces will be butt glued, rather than routed and glued, use the following measurements instead:

 1 back (D), 1/8" x 2¾" x 5¼"
 4 dustboards (E), 1/8" x 1⅜" x 5¼"
 3 dividers (F), 1/8" x ¾" x 1⅜"

This pine counter, the original of which is in a private collection, was used in a weave room in the Sisters' shop at the New Lebanon, New York, community. It is painted red.

1. Saw pieces to dimensions given in cutting list. Make the back slightly oversize, in both length and width, to allow for custom fitting.

2. With a router, make 1/8" x 1/16" dadoes and rabbets in the sides (C), and 1/8" x 1/32" dadoes in the dustboards (E) as indicated on patterns on pages 122-23. (If you do not have a router, proceed to Step 3.)

3. Sand all surfaces, and apply three coats of varnish (one coat to hidden surfaces), rubbing with steel wool between coats.

4. Glue and clamp top and bottom dustboards in place, checking carefully to be certain that all angles are square. Glue remaining dustboards in place. If you did not rout sides and dustboards, butt glue these pieces in place, using plywood scraps as supports to hold the dustboards in place while the glue sets up.

5. Glue the dividers (F) in place.

6. Custom fit back (D), and glue it in place.

7. Align top (A), and glue it in place. Align base (B), and glue it in place.

8. Apply final coat of varnish, followed by a coat of paste wax.

9. Make and custom fit drawers. (For drawer assembly, see page 34.)

Western Dresser

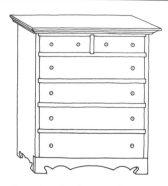

4" wide x 2" deep x 4⁹/₁₆" high

Built by Daniel Sering at Union Village, Ohio, on November 9, 1827, the Western dresser from which this miniature is copied comes from Warren County Historical Museum, Lebanon, Ohio. Although walnut, or sometimes cherry, dressers were rather unusual in New England Shaker communities, they were quite common in Ohio and Kentucky.

SUPPLIES

Wood:
 1 top (A), 3/16" x 2" x 4"
 2 sides (B), 1/8" x 1 3/4" x 4 3/8"
 1 back (C)★, 1/8" x 3 3/8" x 4 3/8"
 5 dustboards (D)★, 1/8" x 1 5/8" x 3 3/8"
 1 hidden dustboard (E)★, 1/8" x 1 1/2" x 3 3/8"
 1 front molding (F), 1/8" x 5/8" x 3 1/2"
 1 divider (G)★, 1/8" x 5/8" x 1 5/8"
Yellow glue
Finish (see page 33)
1 package 1/2-inch, gold sequin pins
1 package 1/16-inch white seed beads

★If pieces will be butt glued, rather than routed and glued, use the following measurements instead:

 1 back (C), 1/8" x 3 1/4" x 4 3/8"
 5 dustboards (D), 1/8" x 1 5/8" x 3 1/4"
 1 hidden dustboard (E), 1/8" x 1 1/2" x 3 1/4"
 1 divider (G), 1/8" x 1/2" x 1 5/8"

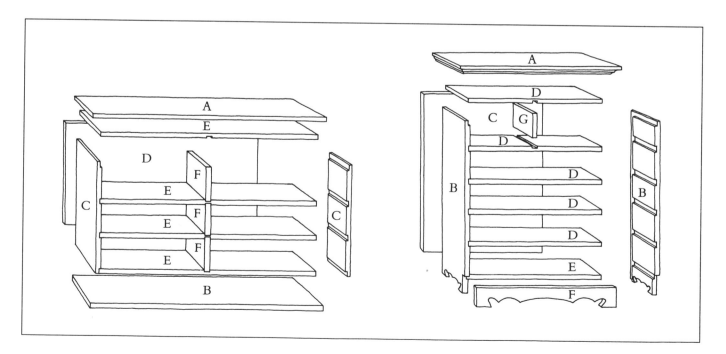

1. Saw pieces to dimensions given in cutting list. Cut the length of the front molding (F) and the length and width of the back (C) slightly oversize to allow for custom fitting.

2. With a router, make 1/8" x 1/16" dadoes in sides (B) and top two dustboards (D), and 1/8" x 1/16" rabbets in sides, as indicated on the patterns on page 122. If you do not have a router, proceed to Step 3.

3. Make the molding edge along the top (A) with a 1/8-inch veining bit fitted to your router, following the illustration on page 33. If you do not have a router, use X-Acto carving tools or a round file.

4. Following the patterns on page 122, notch sides for front molding, and cut scroll work on sides (B) and front molding (F) with a jigsaw or a jeweler's saw.

5. Sand all surfaces and apply three coats of varnish (one coat to hidden surfaces), rubbing with steel wool between coats.

6. Glue top (D) and bottom (E) dustboards in place, carefully checking all angles to be certain they are square. Glue remaining dustboards in place. If you did not rout sides and dustboards, butt glue the pieces, using plywood scraps as supports to hold the pieces in place until the glue sets up.

7. Glue divider (G) and front molding into place. Custom fit back to piece, and glue it into place. Align top and glue it to case.

8. Apply a final coat of varnish, followed by a coat of paste wax.

9. Make and custom fit drawers. (For drawer assembly, see page 34.)

TINWARE

Charles A. Hartwell

*Put your hands to work and your hearts to God,
and a blessing will attend you.*

MOTHER ANN LEE

The tinware projects in this chapter — a sconce, a pastry cutter, and a lantern — were useful, and thus popular, items in the nineteenth century. Although they were probably similar to those used and even crafted in some Shaker communities, they are not distinctively Shaker. The explanation for this is simple: The Shakers were unique in many ways, but not in the field of tinsmithing. In fact, in my eight years as tinsmith at Hancock Shaker Village, I was not able to certify that one single tinware item was clearly of Shaker manufacture. The reason for this is that the tinware items that the Shakers used were the same as those that all nineteenth-century tinsmiths made, and thus, even if made by a Shaker tinsmith, the object is not likely to be identifiable as such. Although sometimes people claim that certain features of an object, such as the shape of the lid knob on a coffeepot or the brace on the handle of a dustpan, identify them as Shaker (sometimes even from a particular community), in reality, tinsmiths everywhere used similar shapes. As far as I have seen, the only patterns that can be identified with certainty as having a Shaker origin came from the Canterbury, New Hampshire, community. These are patterns for commonly made, not unusual objects, such as matchsafes, funnels, and needlecases.

Shaker tinshops were generally small, and in my opinion and that of others who have studied the situation, served as a place where tinware could be repaired and occasionally made. An examination of journals shows that the Shakers bought a good deal of their tinware. Isaac Youngs, a member of the New Lebanon, New York, community (the largest of the Shaker communities), states that their tinshop was small and poorly equipped compared to Worldly tinshops (shops

outside the community), and that most of their tinware needs were purchased. The Watervliet, New York, journals mention a tinker stopping by and mending their old tinware, which indicates that that village didn't even have a tinshop.

The first American tinsmiths worked in New England in the early part of the eighteenth century. In the nineteenth century — particularly after the 1850s when much tinware was stamped — tinplate played the role that plastic plays in the twentieth: It was a new, miracle material, popular because the tinware made from it was light, easy to clean, and relatively inexpensive. Tinplate could be formed into a myriad of shapes, including both decorative, hand-painted household objects and countless plain, utilitarian items for the kitchen, farm, and dairy. The advent of less corrosive, more popular materials, such as aluminum, Pyrex, plastics, and stainless steel, has resulted in the decline of commercially produced tinware, but individual tinsmiths keep the craft alive.

Modern tinplate is made of a sheet of steel coated with tin; earlier tinplate used iron instead of steel. Although tin by itself is a soft, not very strong metal, with a fairly low melting point (about 450 degrees F.), the steel provides the strength, while the tin coating provides the steel with resistance to corrosion. Until shortly after World War II, the coating was accomplished by dipping the sheet of steel or iron into molten tin. Today, almost all tinplate is produced by electroplating large rolls of steel.

Until about 1850, the standard size of a sheet of tinplate was 10" x 14", with increasingly larger sizes available as time went on. Tinplate comes in several thicknesses, referred to by weight. Most old tinware was made either of 1 C (1 common or 112 pound) or of 1 X (1 cross or 135 pound). The poundage is based on the weight of 225 10" x 14" sheets. A sheet of 1 C measures .0125 inches, and a sheet of 1 X measures .0152 inches. (Tinplate is less commonly designated by gauge, and because there are at least six different gauge systems, the base weight system is preferred.) A 1 X tinplate is the most suitable for tinware projects, except for the smallest of objects, which can be formed more easily from a thinner material.

Another important characteristic of tinplate is its temper, or hardness. The harder the material, the springier; and springy material is difficult — sometimes impossible — to form into small shapes such as candle sockets, spouts, and dipper handles. Before the 1870s, all tinplate was relatively soft, as it was made from iron sheets. After steel was used for tinplate, however, its temper became important. Tinplate today carries a "T" number. The higher the number, the harder the material. The softest is T 1 D, followed by T 1, T 2, T 3, and T 4. T 4 is the hardest and most difficult with which to work. T 1 is a good, all-round temper, and I recommend its use for most projects.

Tin snips

Bar folder

Mallet

Round mandrel

Hatchet stake

The thickness of the tin coating is another specification, but it is not important for the projects in this chapter.

Prior to electroplating, all tinplate was bright and shiny. Now, a matte, or dull, surface is also produced. If you want your tinplate to be bright — which is traditional — you must specify that finish. A complete description of a good tinplate for the projects in this chapter would be the following: "Bright, 135-pound tinplate with a T 1 temper."

A word of caution about *terneplate*, a material that is intended for roofing: Terneplate is steel that is coated with a mixture of lead (about 75 percent) and tin. *The high lead content renders it unfit for any object that comes in contact with foodstuffs.* The solder that is commonly used on tinware for construction and sealing is half tin and half lead, and it also contains enough lead to be dangerous under some conditions. Lead-free solder is available, and I recommend it for most items that come in contact with food.

Tools and Techniques for Projects

A working tinshop, equipped to handle almost every project, contained many tools and a great deal of equipment: machines for folding and turning edges, for closing metal around wires, for beading and for seaming; forming rolls for changing flat pieces into cylinders or cones; stakes (mandrels) for shaping the metal into various configurations; punches, both solid and hollow, for making holes; mallets and hammers of many shapes, as well as rivet sets, pliers, and wire cutters; dished wooden blocks for forming the metal into domed shapes; tin snips in a variety of shapes and sizes; both foot-operated and large bench shears; rulers, calipers, dividers, squares, and scratch awls for laying out designs; swages for beading and creasing; and soldering coppers (commonly, but erroneously, called soldering irons), along with a method for heating them.

Although these, and other tools required for quite specific tasks, comprise a well-equipped tinshop, the tinware projects presented in this chapter can be done with a minimum of equipment, as follows:

Tin snips for these projects should be approximately 12 inches long, with straight blades. Avoid aircraft-type snips, as these leave serrated marks on the edges of the cuts. When using the snips, do not close the blades completely, except when cutting to the bottom of a notch. Straight or circular cuts are made by pushing the snips forward as the blades are opened. This allows you to keep the blades in contact with the end of the cut, thus avoiding dangerous burrs on the cut edges. Because it is much easier to remove a $1/8$ - or $3/16$ -inch edge than one that is wider, most pieces should be rough cut before the final trimming.

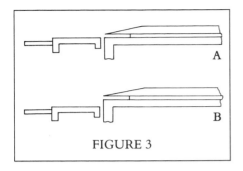

FIGURE 3

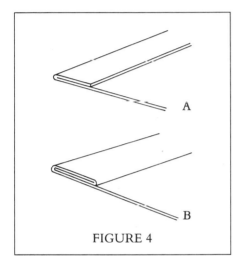

FIGURE 4

FIGURE 5

FIGURE 6

The bar folder is, in my opinion, the heart of a tinshop's equipment. Almost every tinware project calls for its use. Bar folders can be set to make two kinds of folds, sharp (Figure 3A) and rounded (Figure 3B). For the projects that follow, set the bar folder to make sharp folds. An adjustable depth stop determines how much is folded. Most bar folders will not make folds greater than 1 inch; ½-inch folds are average. To make a single hem (an edge turned back on itself, Figure 4A), first fold the piece (Figure 5A and 5B), and then place it on top of the folding blade and flatten it (Figure 5C). To make a double hem (Figure 4B), put the hemmed edge back into the bar folder and fold it again, place it on top of the folding blade, and flatten it as before. A single hem will reinforce an edge, but a double hem is stronger. If you do not have a bar folder, a brake can be used, but not as conveniently. A brake is somewhat similar to a bar folder, but without an adjustable fence. Designed to fold a piece of any length, brakes are widely used by sheet metal shops, but relatively inexpensive brakes are also available in many hobby shops. Although not as fast and convenient as a bar folder, a brake will do creditable work for the projects in this chapter. You can also fold edges by placing the tinplate on a sharp-cornered object and striking it into the desired shape with a mallet. This is painstaking, however, especially for longer pieces.

Round mandrels and mallets are used to shape the metal into a round form. For the following projects, you will need two mandrels, one approximately ¾ inch and one 2¼ inches in diameter. Tinsmiths' mandrels (stakes) consist of a horizontal portion, around which the tinplate is shaped, and a stake portion that fits into a square, tapered hole in the workbench, or into a socket in a bench plate that is bolted to the workbench top. Lengths of pipe held in a bench vise make admirable substitutes; even round pieces of hardwood will stand limited use. For best results, use a mandrel that is a bit smaller than the size of the finished object, as the metal tends to spring back toward its original shape. Mallets should be small and made of rawhide or wood; metal mallets cause scratches. To form the metal around a mandrel, use your mallet to shape the ends only (Figure 6), and apply hand pressure to shape the remainder of the piece. Don't use a mallet on the middle of a piece, as dents will result. On the other hand, you will find that no matter how much hand pressure you use, you will not be able to bend the ends without the use of a mallet. Use your mallet gently and lightly; heavy blows will cause denting and stretching of the metal.

A hatchet stake has a knife edge, and is used for making sharp bends. (You can use a square-edged mandrel for this purpose, too, but the angle will be less than 90 degrees, because of the spring-back of the metal.) Held in a bench vise, a piece of 3/16-inch or ¼-inch flat stock with one side ground off will allow you to make admirable bends

FIGURE 7

A

B

Needlecase stake

Scratch awl

Hole punches

Crimping tool (single)

Dividers

(Figure 7A). If you shape one end as shown in Figure 7B, you will be able to make multiple bends on small objects. When bending, use only finger pressure, and apply that pressure as close to the bend as possible. Never use a mallet when making bends.

A small, flat stake, such as the needlecase stake, is often used when closing a side seam, such as in the lantern top (page 46), but a piece of ½-inch to ¾-inch square stock held in a bench vise will do as well.

Scratch awls are used to mark tinplate with a light line. The point of a compass, or almost any piece of hardened steel that is brought to a sharp point, will also do the job.

Because the thinness of tinplate precludes drilling it, hole punches are essential pieces of equipment. Use a pin punch, which is solid, to punch holes up to ¼ inch; for larger holes, use a hollow punch. To punch holes in tinplate, place the piece to be punched against a block of lead or the end grain of a block of hardwood.

The Roper-Whitney 5 Jr. punch, or an imitation, is a handy item to have if you intend to make many small holes. It has interchangeable punches capable of making any size holes from $^3/_{32}$ inch to $^9/_{32}$ inch, in $^1/_{32}$-inch increments.

The hole produced by the punch will have a flared edge, which, depending on the object, can be completely or partially removed, or left as is. To remove it, place the object, flared side up, on a hard, flat surface and carefully tap the flared edge with a mallet, removing as much of the flare as you wish. For the sconce, you will need to make a $^3/_8$-inch (or smaller) hanging hole. The lantern requires $^3/_{32}$-inch, $^1/_8$-inch, ¼-inch, and ½-inch punches.

Hand crimping tools are similar to pliers, and come in two styles — one that produces a single and one that produces a double crimp. The single crimping tool forms a crimp when the single blade on one jaw and the double blade on the other come together. Double crimps are formed with a double crimping tool, which has two blades on one jaw and three on the other. Although the double tool produces more uniform crimps, the single tool is more versatile, and is therefore preferable if you are purchasing only one. I put a mark with a felt-tip marker on one of the jaws to indicate the placement of the jaws on the tinplate, so that all the crimps will be the same length. The material bends toward the V-shaped jaw.

Needle-nose or round-nose pliers or hemostats may be used to hold pieces or edges of pieces together when soldering, as well as for light-duty bending. The self-locking feature of hemostats (designed for surgical use) makes them adaptable to many tinsmithing techniques.

Dividers are similar to compasses, but dividers have points on both ends instead of a pencil on one. In tinsmithing, they are mainly used for scribing circles on metal.

Rulers should be graduated in inches and be at least 12 inches long.

A soldering copper or an electric soldering iron is another essential piece of equipment. (Electric soldering guns do not generally have enough tip surface to work well, and torches of any kind distort the metal and burn away the tin coating, leaving blue spots.) Soldering coppers are heated with either gas or charcoal. Gas heat requires a furnace, and charcoal heat requires both a furnace and a vent. Electric soldering irons are easier to use and usually cheaper to purchase than soldering coppers and the necessary furnaces. Choose one that is rated at 150 to 200 watts.

The first step in soldering is to flux the joint. *Flux* is a substance that keeps the metal from instantly oxidizing when contacted by the heat, and allows the solder to flow. Two types of flux may be used — resin or zinc chloride. Resin may be dusted onto the seam in powdered form or mixed with alcohol to form a thick liquid that is painted onto the seam. Resin leaves a brown, noncorrosive residue, which may be left in place or, if it is objectionable, removed with alcohol, acetone, or simply your fingernail. Most commercial soldering fluxes contain zinc chloride, available in both liquid and easier-to-use paste forms. Because the residue of zinc chloride is corrosive, it must be removed, but this is easily done with water. Zinc chloride seems to work better than resin, but because of its corrosive residue, some workers prefer resin. In fact, resin seems to be the historic favorite, but most of the early books mention zinc chloride as well, so take your pick!

For tinware that will not contact food, you can use the standard tinman's solder known as fifty-fifty, or half and half, consisting of half tin and half lead. Sixty-forty (60-percent tin and 40-percent lead), which I prefer, melts at a slightly lower temperature than fifty-fifty and flows a bit better. Forty-sixty (40-percent tin and 60-percent lead), which melts at a higher temperature, works best with a torch and is not suited for tinware. Use solid solder, without a flux core, in wire or bar form.

Most tips are pyramid shaped, but I prefer to modify the basic shape to one I find more versatile (Figure 8). I form this shape at room temperature by placing the tip on a heavy object, preferably an anvil or a heavy stake, and striking it with a fairly heavy hammer. My students have dubbed it the "Hartwell hook," but I am sure it is used by many whom I haven't taught. If you reshape the tip of an electric iron, remove it from the iron before shaping, so as to avoid damaging the heating element. Use the flat end of this tip for soldering such joints as candle sockets and container bottoms. It heats more than a very small area and allows smoother soldering, and its slight curve allows the end of the tip to reach inside seams easily.

When using coppers to solder, you will soon find that large, heavy ones are cumbersome and small ones, although handy, lose heat

FIGURE 8

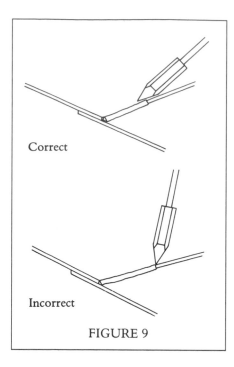

Correct

Incorrect

FIGURE 9

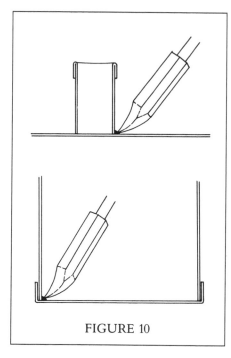

FIGURE 10

rapidly. The best size, in my opinion, is a *2*. Sold by the pair, soldering coppers are numbered according to weight per pair, in pounds; a soldering copper marked *2* therefore weighs one pound. If you use both irons in the pair, you can heat one copper while you are soldering with the other. This requires a lot of attention, however, to ensure that the one heating doesn't get too hot.

Soldering is accomplished by heating the tip enough to melt the solder readily, but not so hot that it burns the solder. Burning results in a soldering tip coated with insulation to which further solder will not adhere. Before you begin, clean the tip of the soldering device with a file or sandpaper, and coat the tip with solder. When heated to the correct temperature, the solder coating will melt and appear wet, attracting further solder. Place a drop of solder on the tip and then move it to the properly fluxed joint.

If you are soldering a flat seam, lay the flat side of the solder-laden, heated tip along the seam (Figure 9). Although the area of the seam being soldered is obscured by the tip, it is important to do it this way or the area where the pieces overlap will not be heated and solder will not be drawn into the seam. If you are soldering a 90-degree-angle seam, hold the soldering device at right angles to the seam, so that the soldering is accomplished by the end of the tip (Figure 10). For all joints, draw the tip slowly along the seam. If the solder runs out before the seam is completed, withdraw the tip, melt another drop of solder onto it, and resume soldering.

Note: It is easier and safer to move the hot tip to the solder than to move the solder to the hot tip.

Smooth soldering takes practice, so don't be discouraged if your first attempts are less than perfect. Remember, the average full-time professional tinsmith solders about two hours per day, five days a week — about five hundred hours a year. Under these circumstances, a person either gets good, or should seek a new profession! You can usually reheat a messy seam to improve its appearance, so all is not lost if it doesn't look pretty the first time around.

I strongly recommend that you make tin patterns for the following projects, especially if you plan on producing more than one of any of the objects. Metal patterns are sturdy and well worth the bother.

Pastry Cutter

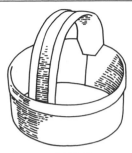

Approx. 2½" diameter

SUPPLIES

4" x 8"-sheet of tinplate (see pages 39-40)
Lead-free solder and flux

This pastry cutter is approximately 2½ inches in diameter. To make a cutter of a different dimension, calculate the body and handle lengths as follows: For body length, multiply the desired cutter diameter by 3.1416 (Pi) and add 3/16 inch for the overlap. Make the handle length (minus the soldering tabs) about one half of the body length.

1. Use patterns on pages 122 and 124 to cut the two cutter pieces.

2. Make 3/16-inch double hems on both long edges of the handle and on the shorter of the long edges of the body.

3. With the hem to the outside, form the body into a cylinder around a round mandrel.

4. Bring the two ends of the cutter together by lapping the tab end over the other end on the outside of the cutter, so that the protruding tab tucks under the hem on the other end and the two hems butt each other. Solder both sides of the seam.

5. Examine the shape of your cutter to be sure you have created a true cylinder. Forming a flat piece into a perfectly symmetrical cylinder can be a challenge. For a guide, draw a 2½-inch circle with a compass, place your cutter upon it, and study the cutter to see which portions need more bending and which portions need less.

6. With the hems to the outside, form the handle into a semi-circle.

7. Use needle-nose pliers or hemostats to fit the tabs on the handle ends to the top inside of the body, centering one of the tabs over the body seam to help reinforce it. The hems on the handle should butt against the top edge of the cutter. Solder the ends in place, using needle-nose pliers or hemostats to hold them while soldering.

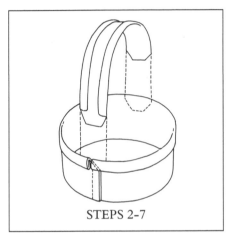

STEPS 2-7

Sconce

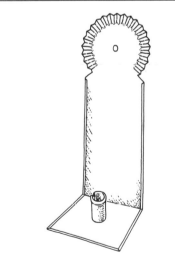

4" wide x 3¼" deep x 11½" high

SUPPLIES

7" x 15"-sheet of tinplate (see pages 39-40)
Solder and flux

1. Use patterns on pages 124 and 126 to cut the two sconce pieces.

Note: The circle at the bottom of the sconce pattern indicates placement of the socket and should *not* be punched in the sconce body (see Step 8, p. 46). If you are making tin patterns, you will find it helpful to punch the hole through the pattern so that you can trace the circle onto the sconce piece.

2. Make 1/8-inch double hems along right and left edges and bottom edges of the sconce body.

3. With a scratch awl or compass point, scribe a line across the *back* of the body, 11½ inches from the top edge and at right angles to sides of body.

4. Punch a hanging hole from front to back at the point indicated on the pattern. The hole on the original sconce was 3/8 inch, but you can use a different size, if you wish. Partially flatten the flare caused by the punch.

5. Crimp the edge of the circular portion at the top of the sconce, making the distance between the crimps as even as possible. I make about twenty-four crimps, ½ inch long, and not very deep; the number and size of crimps can be varied to suit personal preferences.

6. Make a 1/8-inch hem along the top edge of the candle socket.

7. With the hemmed edge on the outside, form the socket around a round mandrel. Leave a gap of 3/32 inch or slightly less between the ends of the candle socket. This gap allows burned-down candles to be pried easily from the socket with a sharp instrument.

8. Solder the candle socket into position at the point indicated on the pattern. Position the gap so that it will be accessible.

Note: Because it is difficult to solder the rear of the candle socket after the body is bent, it is important to solder the socket into position before the sconce body is bent.

9. Place the sconce over a hatchet stake, and bend it at a right angle on the line scribed in Step 3, p. 45; use only hand pressure to bend.

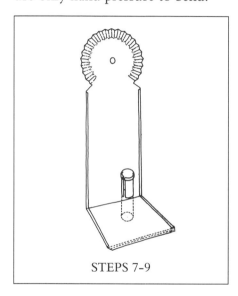

STEPS 7-9

Lantern

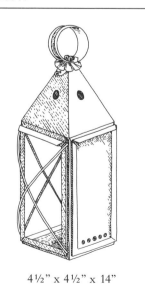

4½" x 4½" x 14"

SUPPLIES

21" x 15" sheet of tinplate (see pages 39–40)
51" 12-gauge wire
3⅝" 14-gauge wire
9½" 16-gauge wire
Solder and flux
Three 3⁹/₁₆" x 7" pieces of glass

Although for clarity the directions for forming and soldering are combined in the instructions that follow, you may find it more efficient to complete all forming before you assemble and solder the lantern.

The lantern pictured on page 74 shows a bead on both the top and the handle. Because specialized equipment is required to make this bead, it is not included in the instructions below.

1. Use patterns on pages 123–125 and 127 to cut out the various lantern pieces.

TOP

2. Punch the ½-inch holes in the top from the back side. Partially flatten the flare caused by the punch.

3. Punch the two ³/₃₂-inch holes in the top from either side. Completely remove the flare.

4. Along edge A of the top piece, make a ⅛-inch, 90-degree-angle fold toward the outside. Along edge B, make a ⅛-inch, 180-degree-angle fold toward the inside.

5. Using the three fold lines indicated on pattern as guides, make 90-degree-angle folds in the top over a knife-edge surface.

6. Join edges A and B by tucking edge A inside edge B. Place top over the flat end of a needlecase stake or a piece of square stock, and close the seam.

7. Set the bar folder for a ⁷/₁₆-inch fold. Slightly bend the bottom

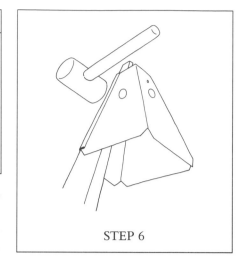

STEP 6

edges of the top so that they are pointing straight down, parallel to one another.

BOTTOM AND SOCKET

8. On bottom piece, make ½-inch, 90-degree-angle folds along all four edges.

9. Make a ⅛-inch hem along the top edge of the candle socket.

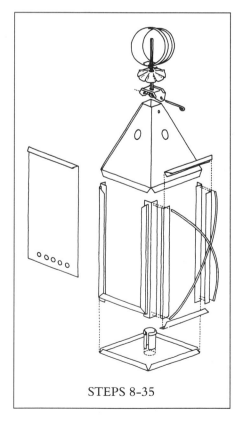

STEPS 8-35

10. With the hemmed edge on the outside, form the socket around a round mandrel. Leave a gap of 3/32 inch or slightly less between the ends of the candle socket. This gap allows burned-down candles to be pried easily from the socket with a sharp instrument.

11. Center the socket over the guideline shown on the bottom pattern piece. The gap should squarely face one of the bottom edges, which will now be designated as the back edge. Solder the socket into place.

CORNER POSTS
AND GLASS GUIDES

12. Fold each corner post lengthwise down the center, making a 90-degree-angle fold.

13. Solder the corner posts to the bottom corners, inside the folds on the bottom. Use a square to ensure accurate placement.

14. Place the top over the corner posts, with the seam in the top at the left rear corner. Solder the top to the corner posts. Seam is on the left side when viewed from the rear.

15. Make 1/8-inch, 90-degree-angle folds in the eight long, and four short glass guides. Each glass guide will have a narrow (1/8-inch) face and a wide (1/4-inch) face.

16. Solder the eight long glass guides to the corner posts, centered top to bottom on the corner posts, and with the edges of the wide faces lined up even with the inside edges of the corner posts. Use the glass pieces to hold the long glass guides in place while soldering them.

Note: It is unnecessary to solder the glass guides for their entire length: Soldering at each end and at the centers is sufficient.

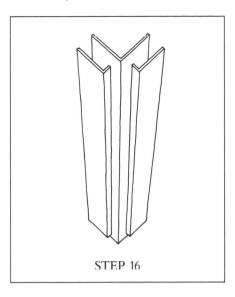

STEP 16

17. At the ends of the short glass guides, cut the wide edges at a 45-degree angle. Solder the short glass guides to the bottom of the long guides and to the bottom of the lantern. The short glass guides should fit snugly over the bottom ends of the long glass guides.

GLASS GUARDS
AND GUARD WIRES

18. Make 1/8-inch hems along edge A of the glass guards. Make 1/4-inch, 110-degree-angle folds along the unhemmed edge B of the glass guards, with the hem facing to the inside.

19. Solder the glass guards over the top ends of the long glass guides on the sides and front (*not* the back) of the lantern. The fold should line up with the top of the long glass guides.

20. Cut six, 8 1/2-inch lengths of 12-gauge wire, to be used as glass guard wires. Form each piece into a curve conforming with that on page 124.

21. Solder the glass guard wires to the corner posts and to each other where they cross.

STIRRUP, SMOKE BELL,
AND HANDLE

22. Punch a 3/32-inch hole in each end of the stirrup, as indicated on the pattern piece. Punch a 1/8-inch hole in the center of the stirrup. Remove all flare from the punching.

23. Make 1/8-inch hems on the long edges of the stirrup.

24. Make two folds in the stirrup to conform with top of lantern, with hems to the outside.

25. Using the 9½-inch piece of 16-gauge wire, form a hanging wire by wrapping the middle of the piece twice around an approximately 1/8-inch round mandrel. The unbent portions should lie side by side.

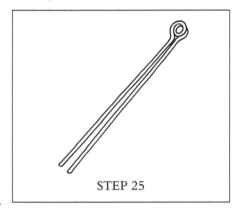

STEP 25

26. Insert both ends through the 1/8-inch hole in the center of the stirrup, from the bottom up.

27. Form the retaining wire from the 35/8-inch piece of 14-gauge wire.

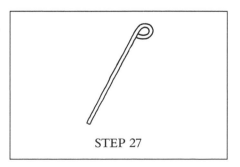

STEP 27

28. Use the retaining wire to attach the stirrup to the lantern top in the following manner: Insert the wire through one 3/32-inch hole in the stirrup, one 3/32-inch hole in the lantern top, the loop formed in the middle of the hanging wire, the 3/32-inch hole in the other side of the lantern top, and the 3/32-inch hole in the other side of the stirrup. Form the straight end of the retaining wire to match the pre-formed end.

29. Punch a 1/8-inch hole in the center of the smoke bell. Make eight, evenly spaced crimps in the bell, giving it a dome shape. Slip the bell over the two ends of the hanging wire, with its concave surface down.

30. Make 1/4-inch hems along both long edges of the handle. With hems to the outside, form the handle into a cylindrical shape around a round mandrel. (For help in achieving a symmetrical cylinder, see suggestions in Pastry Cutter directions, Step 5.)

31. Overlap the two ends 1/2 inch, and solder them on both sides.

32. Punch a 1/8-inch hole at the center of the seam. Remove all flare from the hole.

33. Slip the two ends of the hanging wire through the hole in the handle. If necessary, trim the wire ends so that they are even with the top of the handle. Using round-nose or needle-nose pliers, form each end into a spiral. (Round-nose pliers do a smoother job.) Leave about 1/8-inch play between the lantern top and the handle; a handle that

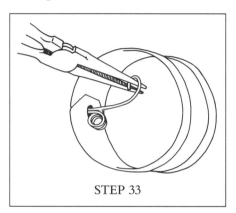

STEP 33

is joined too tightly to the lantern will get too hot.

DOOR

34. Make a 1/8-inch hem along the top edge of the door. Bend this edge down approximately 110 degrees, 3/8 inch from the hemmed edge, with the hem downward.

35. Punch the 1/4-inch ventilation holes in the bottom of the door at the points indicated on the pattern. Flatten completely all flare due to punching.

36. Slide the glass sides and the door into place.

WALL HANGER

37. Make 3/16-inch double hems along both long edges of the lantern hanger. Shape piece as shown on page 125.

38. Fasten the hanger to the wall with screws at the points indicated on the pattern.

BASKETRY

Gerrie Kennedy

*Do your work as if you had a thousand years to live,
and as if you were to die tomorrow.*

MOTHER ANN LEE

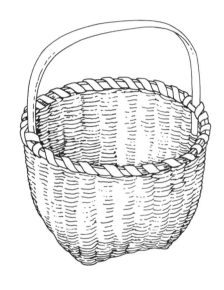

When guests visit a Shaker community or building for the first time, most go away expressing wonder at the beauty and feeling of calm surrounding them. Rooms are furnished with basic, well-proportioned furniture, and everything is in its proper place. Fine craftsmanship and a lack of ornamentation is evident throughout.

Working as the Resident Basketmaker at Hancock Shaker Village, I have had the opportunity to study and work with many original Shaker baskets and basket molds. Most are characterized by simple, graceful lines and a skillful balance of materials. Basket bodies are woven of splint that is often of a lighter weight than that used by typical New England basketmakers, yet heavy enough to ensure durability, and each is finished with a carefully carved rim and handle. Every basket reflects the same high level of craftsmanship evident in other Shaker work, craftsmanship that has elevated Shaker basketry to a highly esteemed art form.

Algonquin Indian basketmakers in all likelihood first introduced splint basketry to the Shakers, and Native American and Shaker baskets consequently show many similarities in both materials and design. The Shakers, however, adapted the Native American tools and techniques, as well as basket shapes, and refined them. As with their innovations in other craft areas, the Shakers improved and perfected their prototypes, gradually transforming them from rugged, heavy work baskets to stylized, graceful containers.

The Shakers prepared the black ash splint, as the Indians had shown them, by using a wooden mallet to pound apart the growth rings from a black ash log. The thick pieces that came away under pounding were

then lanced and halved along the grain by pulling apart each side to reveal the satiny finish of the inside wood. The splint was then scraped with a drawknife to smooth it further, cut with a knife, and woven freehand. Handles and rims were hand carved from manually split logs. The Shakers gradually developed more sophisticated tools, however, which resulted in more polished-looking baskets. Hand pounding was replaced by a trip-hammer that mechanically pounded the splint apart; planing machines smoothed the splint; cutters divided it into uniform widths; baskets were woven over molds; and handles and rims were carved on a shave horse using a drawknife. (Eventually, handles and half-round rim stock were cut on a buzz saw and machine milled.) These technological improvements allowed the Shakers to make symmetrical baskets that were consistent in size and shape, with a refinement that is distinctively Shaker.

The Shaker basket industry most likely began when the Shakers found that the baskets offered by their Algonquin neighbors failed to meet their needs. The Native American baskets tended to be light in weight and not very durable, and the Shakers needed heavy work baskets for their fields and workrooms.

Although basketmaking was a joint enterprise shared by both men and women, it was generally the Brothers who made the larger work baskets used in the community. The Sisters were responsible for weaving the finer, lightweight baskets that were sold to the outside world. These reached a high level of excellence in very feminine sewing baskets and pincushions, as well as delicate baskets for other household uses.

When Shaker communities were at their height, a large number of skilled laborers contributed various kinds of expertise to the basket industry. Workers harvested the trees, others operated the trip-hammer that pounded out the splint stock, carpenters carved or turned the basket molds and helped to steam and shape handles and rims, and skilled Sisters wove and completed the baskets.

The New Lebanon community produced the largest number of baskets, from the early 1800s right through until the early 1900s. Shortly after 1900, the Shaker basket industry declined in all villages due to a number of factors, including decreasing membership in the communities, overharvesting of the black ash trees, and, perhaps most devastating of all, serious price competition from newly emerging factories and foreign imports.

When Shaker basketmaking was at its peak, the talented hands and minds of the Shaker Brothers and Sisters created baskets of a level of excellence that few, if any, of their Worldly compatriots achieved. Shaker baskets today are regarded as some of the finest splint baskets ever made — one more example of a simple craft elevated to an art form by the Shakers.

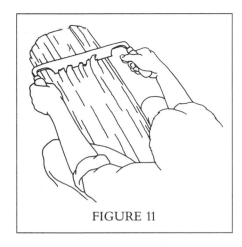

FIGURE 11

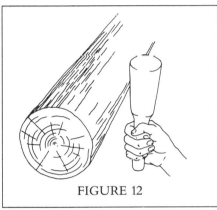

FIGURE 12

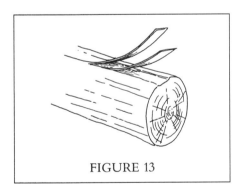

FIGURE 13

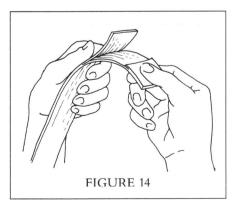

FIGURE 14

Black Ash Tree Preparation

Authentic Shaker baskets must be constructed of splint from a black ash tree (*Fraxinus nigra*), which can be obtained from local or mail-order basketry suppliers (see List of Suppliers, page 129), or, if you wish to start from scratch, from a tree that you fell. If you purchase splint (by far the simpler way), be certain that you are getting *pounded* splint, rather than planed or sawn material, which is dry, brittle, and difficult to work with. Planed and pounded splint can be quickly differentiated by observing the splint's texture: Planed splint has a smooth finish, and pounded growth rings are rough and hairy in appearance.

Black ash trees are found in northeastern North America from Newfoundland to Manitoba, south to Delaware, and west to Iowa. Look for them in wet soils bordering swamps or in lowlands where drainage is poor. Black ash resembles the larger and more common white ash, although the top branches of black ash are heavier looking. In addition, the crown of black ash typically consists of only four or five thick branches with a limited number of short, fat secondary twigs, giving it a scraggly appearance compared to white ash. The gray to gray-green bark of black ash is not as furrowed as that of white ash, and bits of it will flake or fall off when you rub it with your hand. Choose a 9- to 12-inch diameter tree that is straight and knot free; after felling it, cut the trunk into a log at least 6 feet long.

Before the growth rings can be pounded apart, you must first remove the bark from the log with a drawknife (Figure 11). After the log is free of bark, pound it with a wooden mallet or maul, beginning at one end and slowly moving to the other with overlapping blows — about fifteen to twenty per inch (Figure 12). When one year's layer begins to separate (Figure 13), pull it off and let it air dry for twenty-four hours before coiling it up and storing it for later use. It takes several days to separate all of the growth rings in this manner; keep the tree moist between pounding sessions by covering it with canvas and leaving it in the shade, or by submerging it in water.

Preparing the Splint

Both purchased and hand-pounded splints must first be divided in half lengthwise in order to expose the inner "satin" wood. The splints should first be soaked in cool water for twenty-four hours, then scored with a utility knife halfway through the thickness of the wood. Next, gently bend the scored wood until the growth ring divides in half, allowing you to get a firm grasp on both pieces (Figure 14). Applying even pressure on both halves of the splint, use your thumbs and fists to pull the two halves evenly apart with a rolling motion (Figure 15). Keep both halves as even as possible. If one side of the splint

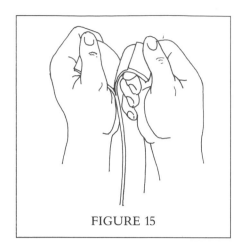

FIGURE 15

becomes thinner, pull more firmly on the opposite side to even out the thickness.

The rough side of the newly divided splints must next be cleaned. This is traditionally accomplished by placing a piece of leather over your thigh, holding one end of the splint firmly over your leg, and scraping it with a jackknife. A more efficient technique is to flatten the splint against a work surface and go over it with a 1- or 1½-inch wood scraper. You may clean it further with a piece of fine-grade sandpaper, if you wish.

Scissors are usually used to cut the splints into the desired widths (see project instructions below), but I have found that such unlikely woodworking tools as leather-cutting tools or a pasta cutter make multiple strips smoothly, evenly, and quickly. Don't be afraid to experiment with untraditional tools. Whatever you use, be sure to cut your widths as evenly as possible.

Preparing the Rim and Handle Stock

You can purchase completely prepared rims and handles, as well as stock from which to carve your own, from many local or mail-order basketry suppliers. You can also begin with raw wood. If you decide on a ready-made handle or rim, choose one that is graceful, well balanced, and finished so that it is half round on one side.

If you are making relatively small baskets, such as those illustrated in this chapter, the simplest way to make your own rim and handle stock is to use a heavy black ash growth ring that is at least ⅛ inch thick. Clean it by scraping it with a wood scraper or sharp knife, and bevel the edges so that one side is half round. Handles for larger baskets must be made of heavier stock, such as quartersawn lumber. Cut a board to the desired width, length, and thickness, and then rout or hand carve the half-round surface. The bottom ends must be tapered in order to slide between the uprights (Figure 16).

FIGURE 16

A third, more involved, approach is to split a green log of hickory, black ash, white ash, or oak. A 6- to 9-foot tree is most manageable. With an ax and wedge or a mallet and froe, split the log in half and then in quarters. Work slowly and carefully, pounding the wedge or froe down and twisting it from side to side until the wood is split the length of the log. Remove the bark, and then make further subdivisions in each pie-shaped piece until you have the size stock you need. Hand carve your rim or handle with a drawknife or jackknife.

Equipment

Much of the equipment you will need to make the Shaker basket projects illustrated here should be readily available. The dishpan is used to moisten splints. The wood scraper, or a similar tool, is used for scraping splints and cutting materials. The awl is needed for creating spaces within the rows of weaving so that handles or lacings can be

easily inserted. The scrap wood is used as a foundation for scraping splint.

EQUIPMENT LIST

Small plastic dishpan or other small
 container
Wood scraper, utility knife, or
 sharp scissors
Slender awl or long upholstery
 needle
Clothespins
Tacks
Rubber bands
Pencil
Ruler
Small scrap of wood
Basket molds

The first baskets that the Shakers made were woven freehand, in much the same style and manner as taught them by their Algonquin teachers; no molds were used to help shape the forms. These first, unrefined baskets were utilitarian, intended for use in the fields and around the buildings. As time went on, the Shakers began to improve their basketmaking skills by making more finely woven, better quality baskets. When they became aware that the commercial market had a need for a good-quality basket, they branched out and began to make baskets for sale as well as for their own use. At this point, they realized that it made sense to use molds when weaving. Not only do molds allow for increased speed, but they also produce more graceful and symmetrical containers. Moreover, baskets woven with a mold are uniform in size, and can thus be used as a standard measure — for example, a bushel basket. This uniformity in all likelihood ensured more satisfied customers, who could be certain that the no. 4 cathead basket they purchased was guaranteed to be the same size and price as baskets of that size sold elsewhere. Eventually, the Shakers used molds for almost all the baskets they wove.

Most Shaker molds were made of pine or maple. They were usually solid pieces of wood that had been turned on a lathe and hand finished, or carved and sanded by hand or with the help of a saw. For making reproduction Shaker baskets, I prefer using wooden molds, as I find plastic difficult to work on.

General Instructions

Before beginning any project, identify the smooth (satiny) side of the splints. Sand the other, rough side lightly, if necessary. The satin finish should always appear on the outside of the basket.

Before you begin to weave, use a wood scraper or jackknife to scrape one-third of the thickness off the last inch (or a length that will span about four uprights) on both ends of all weavers. This will allow you to eliminate any bumps or bulges where the ends overlap when you must add new weavers.

When you are ready to weave, quickly dip into tepid water the materials you will be working with. *Do not soak* materials in water. Whenever you begin a new weaver, it, too, should be quickly dipped into water.

To add a new weaver, cut the old weaver so that it ends *on top of* an upright, and weave it in to its end. Count back four uprights from where the old weaver ends and begin the new weaver in the following manner: With the satin side facing out, tuck the end of the new weaver under an upright *on top of* the old weaver, and continue weaving over the old weaver (Figure 17).

To make rims, measure the outside circumference of the basket rim and add 2 inches. Cut two pieces of ¼-inch cane or rim stock to this measurement. Using a utility knife or wood scraper, remove one-

FIGURE 17

third of the thickness from all overlapping ends. Use small clothespins to clip the inner rim to the inside of the basket. Clip on the outer rim in the same manner, with the false rim between, but begin and end the outer rim on the opposite side of the basket from where the inner rim begins.

Cathead Basket

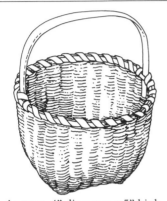

Approx. 4" diameter x 5" high

SUPPLIES

14 uprights, 3/16" x 9½"
Weavers (60 feet in all), 1/16" wide
False rim, ¼" x 14"
2 rim canes, ¼" x 14"
Lashing, 1/8" x 30"
Handle, 5/16" or ¼"
Mold, 3½" x 4"

The cathead basket was one of the most popular baskets made by the Shakers. Its name derives from the fact that when it is held upside-down, its shape resembles a cat's head — the corners being the "ears." Although the original design was borrowed from Native American baskets, it was refined by the Shakers.

The basket described here is woven on a mold measuring 4 inches wide and 3 1/2 inches high. It calls for black ash that has been split into satiny splints (see pages 51-52). By modifying the directions, you can weave it on almost any size mold. If you change the size, be sure to keep an odd number of uprights (or spokes). You can also adjust the widths of the uprights.

1. Prepare the splint as described on pages 51-52. As you weave, be sure that the satin finish is always on the outside of the basket.

2. Scrape or sand the rough side of the fourteen uprights until they are about the thickness of two pieces of construction paper.

3. Dip all materials quickly in tepid water so that they are less brittle.

4. With the satin sides facing up, lay three uprights parallel on a flat surface. Weave a fourth upright across these three, dividing them exactly in half.

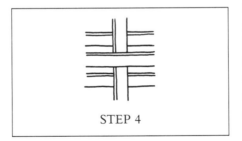

STEP 4

5. Weave in three uprights on each side of this horizontal. Adjust spokes as necessary, so that what you have woven will fit perfectly within the width of the square on the bottom of your mold.

6. Weave in the four remaining uprights vertically, adjusting to fit the mold. You now have a woven square consisting of fourteen uprights.

7. Be sure the uprights are spaced evenly within the square. Dampen the uprights around the outer perimeter of the square. Turn the square over, so that the rough side faces up. Place a ruler over the woven portion, with the edge of the ruler

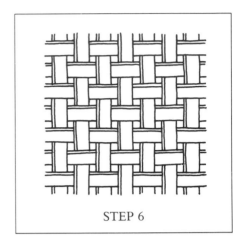

STEP 6

lined up against the edge of the weaving. Bending against the ruler, make 90-degree-angle folds in the two uprights adjacent to each corner. Follow this procedure on the other three sides, so that sixteen corner uprights are bent up. Leave the middle three uprights on each side unbent.

8. Lay the woven bottom over the base of the mold, satin side facing out. Secure the woven piece firmly against the mold with five tacks, positioned toward the center of the mold; the corners should be left free, so that they can later be pushed up to form the base — the "cat ears" — of the basket. Place the tacks *between* the spokes, to avoid damaging the splints. With a rubber band, secure the uprights against the mold. Space the uprights evenly, and push the two corner uprights toward each other. Allow to dry in a warm or sunny spot, so that when the rubber band is removed, the uprights will conform to the shape of the mold. Remove the rubber band from the mold.

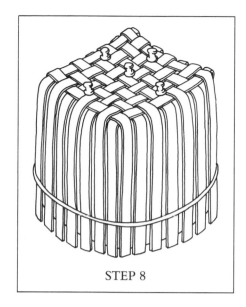

STEP 8

Continue in this manner all the way around the bottom, weaving first with one weaver and then the other, until two full rows are completed. This technique is called *chase weaving*. (Some basketmakers prefer to go all the way around the basket with one weaver, and then drop that weaver and weave around with the second weaver, instead of weaving only one side at a time.)

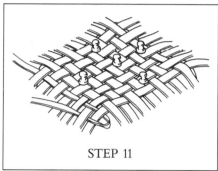

STEP 11

12. Now weave rows 3 through 7, gathering the four corner uprights together as you weave, and allowing the "ears" to push gently above the base of the mold. If necessary, pull up on the ears slightly to encourage this to happen.

Note: The positioning of uprights and the weaving tension is extremely important when you are weaving the first seven rows. Keep the weaver taut while you press the uprights against the body of the mold. When you reach a corner, push the two corner uprights toward each other as you weave around the corner, encouraging them to push up.

13. After row 7, you will no longer need to guide the ears upward. Simply weave each row snugly against the mold, remembering to space uprights evenly and to keep the corner uprights fanning slightly outward. Pack in each row as you weave.

14. Weave to the top of the mold or to the desired height.

15. Preheat an oven to 150 degrees for 10 minutes. *Turn oven off.* Remove basket from mold and allow it to dry in the oven for 1 hour. This will dry and shrink the weavers. Again pack in the rows of weavers.

16. Find the high point of the basket. Cut and taper the ends of the weavers so that they end just before this point. Stagger the two weavers so that they end close together, but not on top of one another.

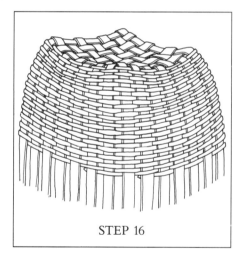

STEP 16

9. Choose a long weaver, find its center, and using scissors, taper it for 3 inches, just off center.

10. Fold the tapered weaver in half and loop it around a corner spoke, satin-side out. Take one of the ends and begin weaving over and under the uprights along one side of the mold, being certain that the satin side of the weaver is facing out.

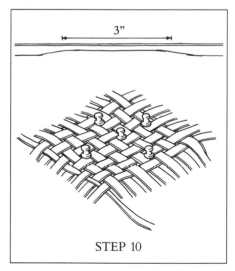

3"

STEP 10

11. Take the other half of the weaver and give it a full twist, so that its satin side is facing out. Weave with this upright in the same direction as you wove in Step 10, locking in all uprights on that side.

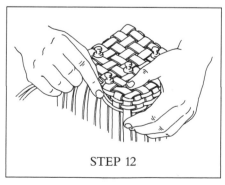

STEP 12

FALSE RIM

17. Using a weaver the same width as the rim (¼ inch), weave a *false rim* directly above the 1/16-inch weavers once around the basket. End the false rim by overlapping the two ends for a distance of three uprights, and tuck the final end under an upright.

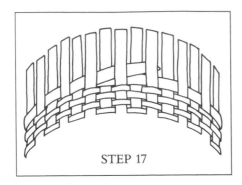

STEP 17

18. Cut the ends of the uprights that lie on the *outside* of the false rim, so that they are just long enough to bend over the false rim to the inside of the basket and tuck under three rows of weavers (about ½ inch). Dip these cut rims into water for 10 seconds. *Do not wet the false rim.* With a utility knife, score each of these uprights, and peel away one-half of the thickness.

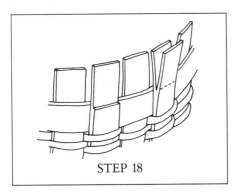

STEP 18

19. Trim the ends to points. Bend these uprights to the inside of the basket and tuck them under several rows of weavers.

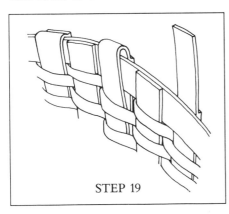

STEP 19

20. Cut off the remaining uprights (those that end *behind* the false rim, on the inside of the basket), so that they are even with the top of the rim.

HANDLE

21. Prepare handles and rims as described on page 52, or use commercially available handles and ¼-inch cane for rims.

22. Skipping the first inch of weavers, insert the tapered ends of the handle down through two lines of weavers equidistant from each other on the inside of the basket. Push the handle downward until it is at the desired height. With a pencil, mark the inside of the handle on both sides of the basket at the points where the handle touches the bottom of the false rim.

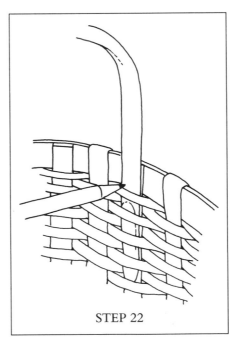

STEP 22

23. Remove the handle from the basket. Make a notch to accommodate the rim by scoring with a utility knife into ⅓ of the handle thickness on the *inside* of the handle at the pencil marks. Slice out

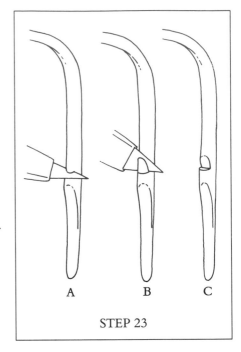

A B C

STEP 23

a wedge-shaped section beginning ¼ inch above the score and cutting down to the bottom of the score.

24. Reinsert the handle, lining up the false rim with the notch you created in Step 23.

RIM

25. Prepare the inner and outer rims and clip them onto the false rim as described on pages 53-54. Place overlapping ends of rims between the handle ends and the front of the basket.

26. Soak a piece of lightweight lashing in tepid water for 30 seconds. This basket will be single-lashed.

27. Beginning to the right of the overlapped outside rim and with the rough side of the lashing facing up, push the lashing from the top down between the inner rim and the false rim so that the lashing comes out from beneath the inside rim; cut the back end of the lashing so that it is even with the top of the rim. Lash around both rims, going from the

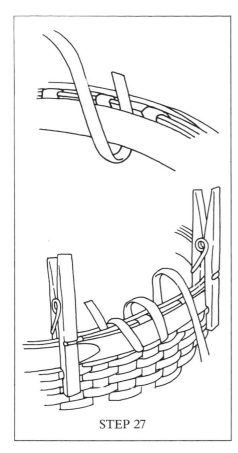

STEP 27

outside to the inside between each upright. Keep the lashing taut.

28. When you get to the handles, lash over the handle once, then come back and cross over your first lashing, forming an X on the outside of the basket.

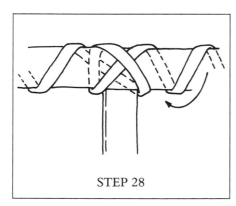

STEP 28

29. Continue in this manner around the rim until you reach the starting point. End as you began, by locking the final end between the inner and false rims.

Pincushion Basket

Approx. 2" diameter x 2½" high

SUPPLIES

8 uprights, ¼" x 6"
Weavers (2 feet in all), 1/32" wide
Weavers (9 feet in all), 1/16" wide
Binders, 3/16" x 10"
Rims, 3/16" x 12"
Lashing, 1/8" x 12"
Mold, 2" wide x 1½" high
5½" fabric circle for pinchusion cover
Heavy-duty thread
Lambs' wool or polyester fill (unwashed fleece may stain cotton fabric; be sure to wash fleece thoroughly before use)

BASKET BODY

1. Prepare the splint as described on pages 51-52. As you weave, be sure the satin finish is always on the outside of the basket.

2. Dip all materials in tepid water. *Do not soak.*

3. Mark the center of all eight uprights lightly with pencil. Trim these uprights as shown. The upright should be about 1/16 inch at its narrowest point.

STEP 3

4. Overlap the uprights in the order shown. Secure them to a piece of corkboard or cardboard by pushing a pin through all eight layers at the center.

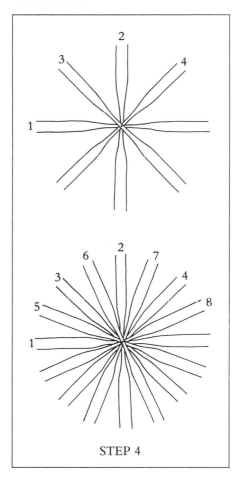

STEP 4

5. The bottom of the basket is woven with 1/32" weavers. Bend a weaver in half, loop it around one upright, and chase weave (see

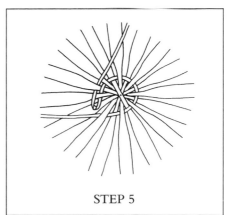

STEP 5

Step 11, page 55) in a small, tight circle. Weave around the spokes once until you are at your starting point. Pick up the second half of the weave, twist it so that the satin side is facing out and weave once around with it.

6. After you have woven two rows, pin or tack the spokes to the center of the mold. Continue to weave the bottom of the basket using 1/32" weavers and packing the rows tightly against one another.

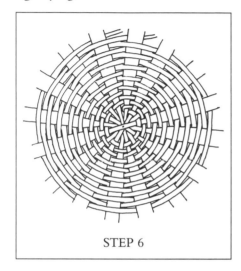

STEP 6

7. When you have finished weaving the bottom, change to 1/16" weavers. Weave to the top of the mold, and taper the last weavers to level the top of the basket (see Step 16, page 55).

8. Remove basket from the mold, and allow it to dry several days in a warm spot. You can hasten the drying process by placing the basket in an oven that has been warmed to 150 degrees F. and then turned off. Repack the weavers.

FALSE RIM AND RIMS

9. Scrape both ends of the false rim, and weave it in above the last row of regular weaving, overlapping the ends for about three uprights.

10. Dip the uprights into tepid water for 10 seconds, being careful not to wet the false rim.

11. Working now with all uprights that appear on the outside of the false rim, bend them over the rim to the inside of the basket. Score each one on the outside where it folds over the rim, and slowly peel away one-half the thickness from there to the end (see Step 18, page 56).

12. With scissors, trim the ends of the bent uprights to points. Tuck the ends down through two or three rows of weaving on the inside of the basket (see Step 19, page 56). Trim off the remaining uprights level with the false rim (see Step 20, page 56).

13. Prepare inner and outer rims and clip them over the false rim as described on pages 53-54.

14. Soak the lashing in tepid water for 1 minute. Slip the lashing down between the inside rim and the false rim, and tuck it in under several rows of weavers. Now lash firmly over the spoke that holds the short end of the lashing, around and under the rim, so that the lashing comes out on the inside of the basket. Be sure the satin side of the lashing faces out. Continue around the rim, lashing between every spoke.

15. End lashing by crossing over the top of the last spoke and slipping the end of the lashing under the outside rim. Pull the end up between the rims, and go back down on the other side of the false rim. Trim excess.

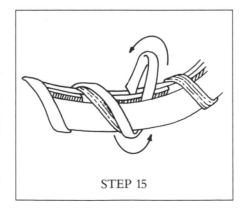

STEP 15

PINCUSHION

16. Using heavy thread, make a line of small running stitches 1/4" from the edge all the way around the fabric circle.

17. Pull up the thread until the opening is about the size of a penny. Knot the end of the thread securely. Stuff the cushion until it is firm and round.

18. Gently ease the cushion, open-side down, into the basket.

Cheese Basket

Approx. 7½" diameter x 3½" high

SUPPLIES
24 spokes, 17" x ¼"
3 weavers, 28" x ¼"
1 weaver, 28" x ³/8"
2 rims, 28" x ³/8"
1 lightweight lashing, ¼"

1. Prepare the splint as described on pages 51-52.

2. Dip spokes and weavers quickly in tepid water.

3. Take six spokes and, with pencil, lightly mark their centers.

4. Take two of the marked spokes, one in each hand, and cross the one in your right hand over the one in your left hand (at the marked centers), forming an X.

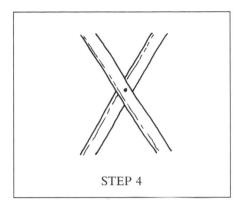

STEP 4

Note: Throughout these instructions the designations right or left spokes refer to this configuration.

5. Repeat Step 4 using two more spokes. Fit the two X's together as shown.

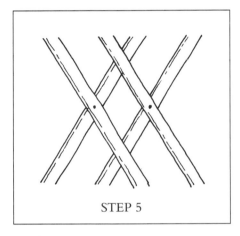

STEP 5

6. Take a fifth spoke and weave it in at the top of the two X's as follows: Beginning at the right, pass under the first spoke, over the second, under the third, and over the

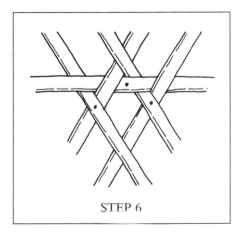

STEP 6

fourth. Lock this spoke into place at the top center by placing the right spoke over the left spoke.

7. Weave the sixth spoke in below the fifth spoke as follows: Beginning at the right, pass over the first spoke, under the second, over the third, and under the fourth. Lock this spoke into place at the bottom center by placing the left spoke over the right spoke.

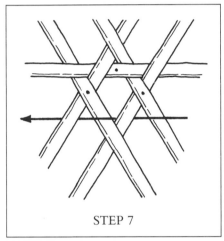

STEP 7

8. With twelve more spokes, make six X's, all with rights over lefts. Slide three of these X's in on each side of the center two X's. Lock them in as you did the first two, so that the *right* spokes of all X's above the horizontal bar are over left spokes, and the *left* spokes X's below the horizontal bar are over right spokes. You now have eight X's locking in seven hexagonal boxes. Be sure that the X's are as small as possible and that the hexagons are symmetrical.

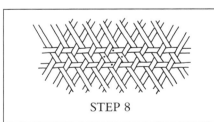

STEP 8

9. Add another horizontal bar above the seven boxes, locking in six more boxes. Add another hor-

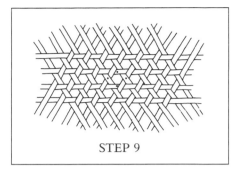

STEP 9

izontal bar below the seven boxes, locking in six more boxes. (You now have four horizontal bars.)

10. Repeat this procedure two more times, first, placing one horizontal bar above and one below the six boxes to lock in five boxes; and second, placing one horizontal bar above and one below the five boxes to lock in four boxes. All of the spokes should now have been used. Adjust so that all the X's are slanting at the same angle and all the hexagonal boxes are symmetrical and the same size.

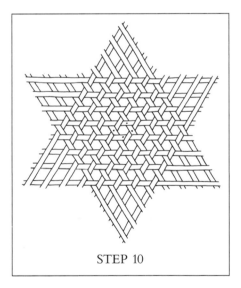

STEP 10

11. Still keeping all right spokes over left spokes, gently bend up the sides of the basket. Using a weaver, weave in a row, drawing in at the corners to form the basket into a three-dimensional shape with a hexagonal bottom. Remember to lock the weaver into place at each X

as before by crossing the right spoke over the left spoke above the weaver (see illustration below, Step 14). When one row is completed, overlap the weaver ends for a distance of four or five spokes, hiding the raw ends under the new uprights.

12. In the same manner, add two more rows to the side of the basket, starting each weaver on a different side so that the overlapping is spread less noticeably around the basket body. Keep the weavers taut, as you weave around the basket, so the the basket sides are as vertical as possible.

13. Weave in the remaining wider weaver, making four rows on the sides in all.

14. Dip the remaining portion of the uprights into water up to the last woven row, and then bend them over that row to lock it in. Bend the uprights on the outside of the basket over the last row toward the *inside*, and bend the uprights on the inside of the basket over the last row

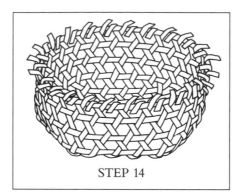

STEP 14

toward the *outside*. Trim all ends on an angle so that they are even with the bottom of the top row of weaving.

15. Prepare inner and outer rims, and use clothespins to clip them over the last row of weaving, covering the ends that were bent in Step 14 above.

16. Soak the lashing in tepid water for 1 minute. Slip the lashing down between the inside rim and the last row of weaving. Pass through the hexagon boxes and lace over the rim, going completely around the basket. Reverse direction and double back, lacing in the other direction to form X's all the way around the rim.

TAPE-WOVEN SEATS

Daniel B. Soules

We were awarded a Diploma and Medal at the Centennial Exhibition for combining in our chairs, Strength, Sprightliness, and Modest Beauty.

CATALOGUE AND PRICE LIST OF SHAKERS' CHAIRS
PITTSFIELD, MASS., C. 1870

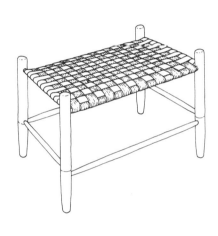

From the beginning of time, men and women have sought comfortable places to sit and rest, at first cushioning the damp, bare ground with grass, moss, leafy branches, or animal skins, and later devising padding for all sorts of seats, from common wooden stools to golden thrones. The European-style chairs used in seventeenth-century America often had natural splint or rush seats, or plank seats supplied with a cushion. Such seats continued to be popular with the less well-to-do right up to the beginning of the nineteenth century. Even the best-known eighteenth-century chair style, the Windsor, featured a plank seat, which was shaped to conform to the body and thus was more comfortable. Although as more expensive upholstered chairs became fashionable, only the wealthy could at first afford them, during the Federal and Victorian periods fabric- and leather-upholstered seats were used by wealthy and less wealthy alike. Cane seats were also quite popular in the nineteenth century.

From the time of the first Shaker communities in the 1770s, converts contributed to the common pool all of their worldly goods, from furniture to wagons and farm animals. The earliest Shaker communities were therefore furnished in the same manner as villages everywhere. Circumstances, including their desire to withdraw from the evils of the outside world, soon required that Shakers create their own furnishings, however, and as the nineteenth century wore on, they began to develop their own furniture style — a straight, pure design without embellishments, far from the fanciful pieces being constructed elsewhere. Details such as back slats and finials varied a bit from community to community, but simplicity was common to all.

One of the most common seating materials used by both Worldly people and Shakers was rush, made from the leaves of round, hollow-stemmed plants such as cattails. Cattail leaves were harvested and dried,

and then soaked, rolled, and joined together to produce a durable material that had been used for centuries. Rush had the disadvantage, however, of becoming very dry and prickly after a number of years, unless it was regularly sealed by varnishing. It had the further disadvantage of being difficult to harvest, and the harsh leaves could be a terror on the weaver's hands.

More favored by the Shakers were woven splint seats. Splint could be obtained from a variety of trees, including willow, oak, and birch bark, but the most popular splint came from brown or white ash trees, which also provided the splint for Shaker baskets. After the tree was felled, the bark was stripped and the log pounded, either by hand or with the blacksmith's trip-hammer, to separate the annual rings into layers (see also pages 51–52) that could be further cut into desirable widths for weaving over the seat frame. Like rush, splint seats had to be sealed every few years, as the splint had a tendency to dry out and split, leaving sliverlike appendages — a menace to skin and clothing alike.

During the first quarter of the nineteenth century, the Shakers developed a new material for their chair seats: woven tape. Known also as *chair listing* or *webbing*, this tape was at first usually woven of wool from the Shakers' extremely fine folds of sheep; later, wool and cotton blends, and, by the turn of the twentieth century, all-cotton tapes were principally used. The narrow tapes were woven on small looms developed for this purpose by members of the community.

To provide additional comfort to these double-thickness seats, the space between the two layers of webbing was stuffed with cloth scraps, straw, or wood shavings. A single layer of scrap material, such as old bed sheets, were first glued to the seat stretchers. A cloth cover was then stitched over this foundation on three sides, stuffed, and sewn closed. Not only did this padding cushion the user, but it provided some resiliency to the seat, which helped keep the tapes from stretching.

As with all of their endeavors, the Shakers made use of the God-given skills of their membership, as well as the gifts of God in nature around them, to produce these distinctly beautiful woven chair seats and chair backs.

Equipment and Supplies

Shaker chair seats are woven over a four-sided, turned frame, such as that shown on page 76. If you own an authentic Shaker piece, you are fortunate indeed. Excellent Shaker reproductions are available, however (see List of Suppliers on page 129), or you may wish to make your own chair or stool (see directions for Post-and-Rung Stool, pages 23–26). In fact, it is possible to weave a Shaker-style taped seat on any piece of furniture that has four round rungs (*stretchers*) for the seat, such as that intended for rush, splint, or reed seating, for instance. Be sure

to complete any necessary repairing, refinishing, or painting before you begin to weave.

As you become more confident with chair taping, you may develop your own weaving techniques. These instructions, for instance, may prove somewhat awkward for a left-handed person, or for some other reason you may be more comfortable handling your chair or stool in a different manner. There is no one correct way to accomplish the task. But if you follow the basic principles suggested in this chapter, you will be able to create an eminently useful seat that will enhance your chair.

Chair taping requires only a modest selection of equipment and a few supplies. Woven tape can be obtained from a number of mail-order suppliers (see page 129). Although the Shakers used wool, most of the tape you will find today is 100 percent cotton. Close-to-authentic colors and patterns are readily available, however, if you wish to use traditional color schemes. See pages 63-65 for instructions on calculating yardage.

Many of the other supplies indicated on the accompanying list can be purchased in stationery or hardware stores. A dull butter knife, which will not scratch the chair's finish or cut the tape, is useful to move and position tape while you are weaving. You can fashion a tape needle from a piece of sheet metal, or simply use a thin piece of wood, or even a second butter knife, to which your tape can be fastened with masking tape. To devise a needle similar to those used by Shaker Brothers and Sisters, cut a thin (1/16- to 1/8-inch thick) piece of metal about 14 to 18 inches long and ¾ to 1 inch wide, and punch slots in one or both ends, large enough to accommodate a piece of chair tape. Round off the corners and edges so that they don't catch in the fabric. Graph paper will prove convenient to plot your design. You may wish to use crayons or colored pencils to test your color scheme. An average-size chair will require approximately two dozen no. 3, 3/8" carpet tacks. If the opening you are covering is square or rectangular, rather than irregular, you will need only about eight tacks. Be sure to use the smallest size tack possible; too-large tacks may split the chair rails, particularly if the piece is old. Your tack hammer should be large enough to drive a tack readily, but small enough to fit between the stretchers of your chair or stool. The foam pad is used between the layers of webbing to cushion the seat and to take up some of the stretch in the cotton tape.

EQUIPMENT LIST

Woven tape
Butter knife
Tape needle
Graph paper
Colored pencils or crayons
No. 3, 3/8" carpet tacks
Tack hammer
Masking tape
Scissors
One-inch-thick foam pad

Calculating Tape Yardage

Because the *warp* (front to back) and *weft* (side to side) are often of different colors, yardage for each is figured separately. It is generally better to use darker colors for the warp, which covers the front stretchers; the dark color will help hide accumulated dirt and wear. You can

calculate the yardage you will need by using the following formulas, or consult with your tape supplier for advice.

When you are measuring distances, always calculate using the next number higher if the measurement is more than a whole number (for example, if the distance is 12¼", use 13").

These formulas, and the patterns that follow, may be used for chair backs or stool coverings, as well as for chair seats. For chair backs, the top to bottom should carry the warp. On rectangular stools, use the wider width for the warp.

WARP MEASUREMENT

1. Measure the distance in inches of one complete revolution around the front and back stretchers (A in Figure 18).
2. Multiply the measurement in Step 1 by the distance in inches between the front posts (B in Figure 18), and then divide by 36". The result is the number of yards of warp you will need.

Example: (29" × 16" = 464") ÷ 36" = 12.89 yards
(A" × B" = _____") ÷ 36" = Total yardage

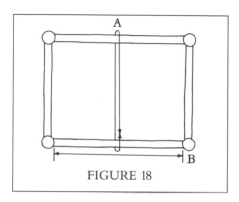

FIGURE 18

WEFT MEASUREMENT
FOR A SQUARE OR RECTANGULAR SEAT

1. Measure the distance in inches of one complete revolution around both side stretchers (A in Figure 19).
2. Multiply the answer in Step 1 by the distance in inches between the front and back posts (B in Figure 19), and then divide by 36". The result is the number of yards of weft you will need.

Example: (25" × 7" = 175") ÷ 36" = 4.9 yards
(A" × B" = _____") ÷ 36" = Total yardage

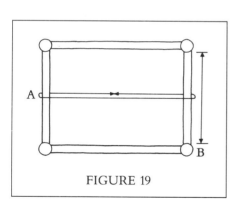

FIGURE 19

WEFT FOR TAPERED SEAT

If you are measuring an opening that is not regular — for instance, a chair with a front stretcher that is wider than the back — use the same formula for the warp as stated above, but to figure the weft you must first obtain an *average* width between side stretchers, as follows:

1. Measure the distance in inches of one complete revolution around the side stretchers, taking the measurement just in front of the back posts (A in Figure 20). Measure one complete revolution just behind the front posts (B in Figure 20). Total these measurements, and divide by 2.
2. Measure the distance in inches between the front and back posts (C in Figure 20), and multiply by the answer in Step 1. Divide by 36" for the total weft yardage.

FIGURE 20

$$(29" + 36") \div 2 = 32.5" \times 12" = 390" \div 36" = 10.83 \text{ yards}$$
$$(A" + B") \div 2 = \underline{\hspace{1cm}}" \times C") = \underline{\hspace{1cm}}" \div 36" = \text{Total yards}$$

MEASURING FOR 5/8-INCH TAPE

Most chair tape is 1 inch wide, but you can also sometimes find ½-and ⅝-inch wide tape. The smaller scale that this produces is particularly effective on small chairs and footstools, but it also works well on some standard-size chairs (see page 77). You may even occasionally see tapes of different widths combined in one weaving. Smaller sized tapes require different formulas for calculating yardage. Measure as described above, but multiply the total yardage figures by 2 for ½-inch tape or by 1.6 for ⅝-inch tape. The results will give enough tape for the project, with a little to spare.

Example: 12.89 yards × 1.6 = 20.62 yards, ⅝" wide tape
Total yardage × 1.6 = Total yardage, ⅝" wide tape

Applying the Warp to a Square or Rectangular Seat

No matter what weaving pattern you choose — from simple plain weave and twills to more intricate patterns — the warping technique is the same. You do follow slightly different procedures, however, for square or rectangular and irregular-shaped seats. Warp a square or rectangular seat (such as the stool on pages 23-26) in the following manner:

1. Reroll your tape to keep it from twisting when you wind it onto the seat.

2. *Turn the seat upside down.* Lay the beginning of the tape on the left side stretcher, with the end approximately ½ inch from the back left post. Place a tack in the center of the tape, about 1/2 inch from the end of the tape (A in illustration).

3. Pull the tape over the front stretcher. Place a second tack about ½ inch in front of the first tack

STEPS 2-5

and slightly to the right of it (B in illustration).

4. Wrap the tape over the stretchers, back to front, until they are completely covered by warp. Before tacking the end in place, check to be sure there are no twists in the tape. Don't worry if the underside of the warp appears out of square; it's supposed to look that way.

5. End the tape on the underside of the seat by tacking it ¾ inch away from the front right post on the side stretcher (C and D in illustration).

6. Slide the precut, 1-inch thick foam pad into place between the top and bottom layers of warp.

Note: To tape a chair back, face the backside of the chair toward you, begin the tape on the right post about ½ inch below the top stretcher, and place the tacks as shown at A and B in illustration. End tape, and tack as shown at C and D.

NOTE

Warping An Irregular-Shaped Seat

Most chairs are wider at the front of the seat than they are at the rear. The technique for warping them is quite similar to that for warping square or rectangular seats, chair backs, or stools, except that you begin the warping on the top of the seat and end it on the underside; in addition, you will need to add fillers to accommodate the spaces that occur toward the front.

1. Reroll your tape to keep it from twisting when you apply it to the seat.

2. Begin working with the chair right-side up. Place the end of the tape on top of the left stretcher, about ½ inch in front of the back post. Hold it in place by driving a tack into the upper left corner of the tape, about ¼ to ½ inch from the end and the left side of the tape (A in illustration).

STEPS 2-3

3. Pull the tape over, and at a right angle to, the front stretcher. Because the front stretcher is wider than the back, there will be a space between the left front post and the tape; this is correct, and will be filled in later. Apply a second tack about ½ inch in front and slightly to the right of the first tack (B in illustration).

4. Continue wrapping the tape around the back and front stretchers until *the back stretcher* is completely filled. Bring the tape once more to the front and then to the back again, ending the tape just in front of the back right post on the underside of the chair. Before tacking the end in place, be sure that there are no twists in the tape. Don't worry if the underside of the seat looks slightly out of square; it is supposed to look that way.

5. Turn the chair over. Cut the tape so that the end rests on the bottom of the right stretcher about ½ inch in front of the right back post. Use two tacks to hold it in place (A and B in illustration).

STEP 5

6. To place *fillers* in the spaces that appear next to front posts, turn the seat right-side up, and lay a piece of tape against the warp that is already in place. Use two tacks to hold it in place on the side stretcher. Wrap it around the front stretcher and carry it back to where you can tack it in place on the bottom of the side stretcher, again using two tacks. (Using four tacks for each filler decreases the likelihood of the tape's pulling loose over time.) Trim off excess tape so that the edges of the tape are even with the side stretchers. Continue placing fillers until all spaces are filled. In a balanced and pleasing pattern using 1-inch tape,

Top

Bottom

STEP 6

there will be one filler more on the right side than on the left.

7. Slide the precut, 1-inch thick foam pad into place between the top and bottom layers of warp.

Plain Weave

1. Turn the chair so that it is bottom side up with the back of the chair facing you. Weave the first row from right to left, ending the tape

STEP 1

under the first warp on the back stretcher. (Count out the warps so that you will know where to begin weaving in order to end *under* the left-hand warp.)

2. Using the butter knife, slide the warp tapes aside so that you can tack the weft in place, as at A and B in illustration. Return tapes to their original positions to hide the tacks and readjust other warp tapes as necessary.

3. Use the free end of the tape to continue weaving the seat. Weave one over, one under throughout. On the seat top, be sure to alternate warps from one row to the next, so that the warps that are covered on one row are exposed on the next. (See Weaving Tips, page 68.)

4. When the top of the seat is complete, carry the tape to the underside of the front stretcher near the front right post, and cut the weft so that the end will be hidden under the last warp tape. Tack the tape under the first and third warps (A and B in illustration) in the same way you tacked the tape to the rear stretcher. Be sure you don't cut the tape too near where it will be tacked, or the end may pull apart.

STEP 4

5. Reposition all tapes that may have become displaced when tacking, and straighten any other warp or weft tapes that are out of line.

Twill Weave

1. Turn the chair so that it is bottom-side up with the back of the chair facing you. Weave the first row from right to left — over two, under two — and ending *under* the first two warps on the back stretcher (A and B in illustration). (Count out the warps so that you will know where to begin weaving in order to end *under* the two left-hand warp tapes.)

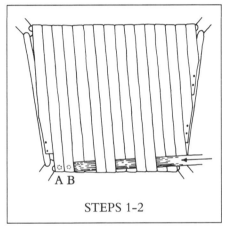

STEPS 1-2

2. Use the butter knife to slide the two warp tapes aside so that you can tack them in place as shown at A and B in illustration. Use the butter knife to slide the two warp tapes back into position and hide the tacks.

3. Using the free end of the tape, begin weaving the seat. Weave the first row on the top side of the seat by going over two warp tapes, under two warp tapes, and so on. Be

sure to cover all angle cuts on the filler tapes. (See Weaving Tips, page 68.)

4. On the second and all subsequent rows of weaving, move to the right one warp tape for each pair of warp tapes that you weave under and over. (You may also move to the left; just be sure to move in the same direction in subsequent rows so that the angle of the pattern continues in one direction.)

5. Weave the final row on the underside of the seat. Slide the last two warp tapes out of the way so that you can tack the weft tape in two places. Trim the weft so that both the end of the tape and the tacks are hidden under warp tapes.

6. Reposition all tapes that were displaced when tacking, and straighten any other warp or weft tapes that are out of line.

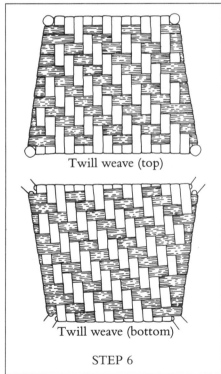

Twill weave (top)

Twill weave (bottom)

STEP 6

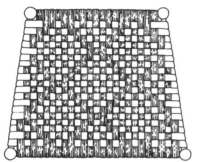

Pattern A

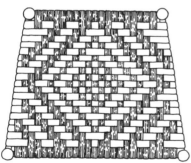

Pattern B

Pattern C

Pattern D

Weaving Tips

This chapter includes instructions for plain, or checkerboard, weave (one under, one over) and twill, or herringbone, weave (two under, two over). For various diamond patterns, see illustrations at left, and page 77.

For easier weaving, thread the tape through a homemade tape needle (see page 63), use masking tape to fasten the weft to a thin piece of wood or a butter knife, or simply fold an inch or so of the weft over the tip of a butter knife.

As you weave, leave small loops of tape extending from both sides of the seat. After every three rows, starting at the back, pull on these loops one by one to tighten the weft rows. You will find that this technique results in tauter weaving than you could achieve by trying to keep the weft tapes tight one row at a time.

In addition to keeping the weaving taut, try also to keep the weft rows straight. A common problem for beginning weavers is to allow the middle to bow out toward the front, with the result that there isn't enough room to fill in the seat completely.

When you are weaving an irregular seat, cross over fillers with the weft to hide the trimmed ends of the warp tape, even if it means going over two warps in a row. You may also have to cross over two warp tapes at the side stretchers in order to keep the pattern correct on the seat top.

More Complicated Weaves

More intricate patterns, featuring diamonds in various configurations, are not as difficult to weave as it may at first seem. Because the seats woven in these special patterns may not be as strong as those woven in plain or twill weaves, they are usually not good choices for chairs that will receive a lot of use. Plain weave is also probably the best choice for small seats, particularly if you are using 1-inch tape, as it may be difficult to define an acceptable twill, or more complicated pattern, in a small area. On occasional chairs, however, these diamond-shaped patterns will add a special touch to any room. The underside of all seats may be woven in plain or twill weave.

Use the pattern ideas shown here, or develop your own — the design possibilities are nearly limitless. Whether you use the designs in this book as your starting point, or create your own, to be certain that your design will be centered as you wish, draw it out on graph paper before you begin weaving, letting each square represent 1 inch (or 5/8 inch, if you are using narrower tape). Contrasting colors will show off your design to best advantage.

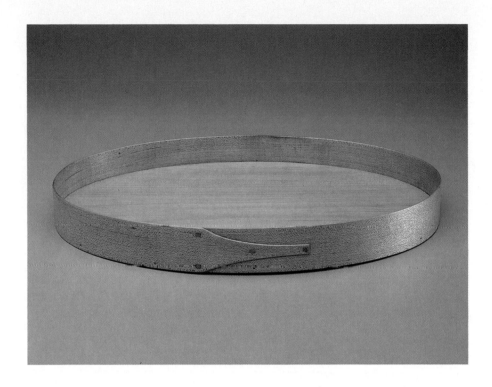

SHAKER-STYLE TRAY

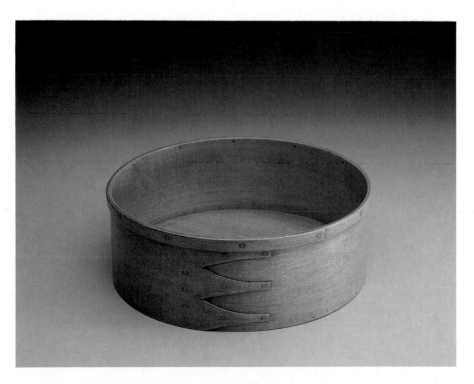

SPIT BOX

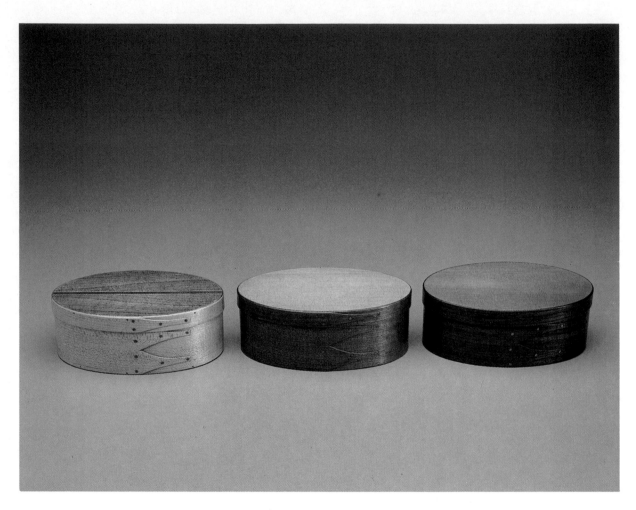

OVAL BOXES
Left to right: Maple side/butternut–maple–cherry top; cherry side/pine top; walnut side/pine top

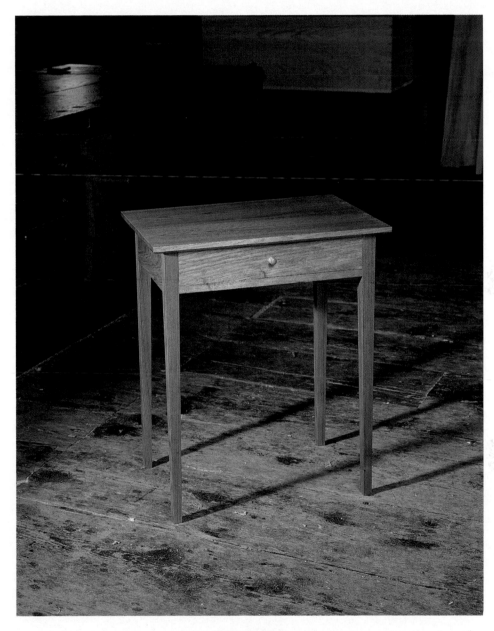

END TABLE

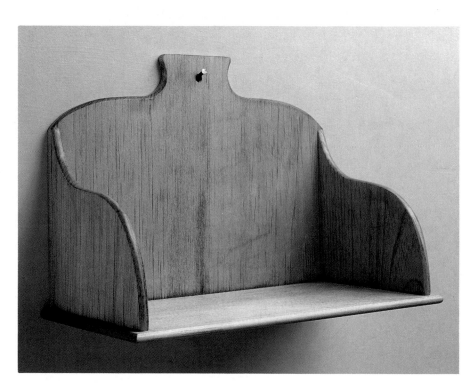

WALL SHELF A

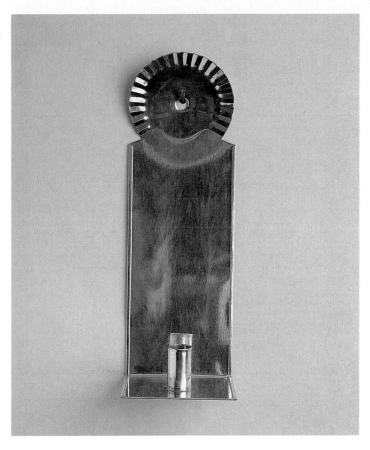

SCONCE

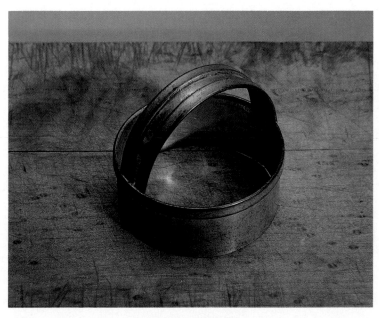

PASTRY CUTTER

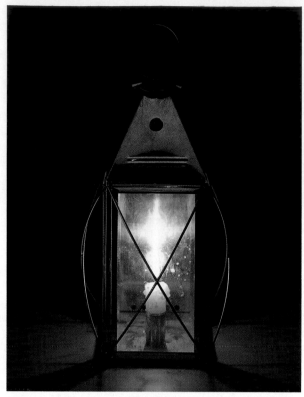

LANTERN

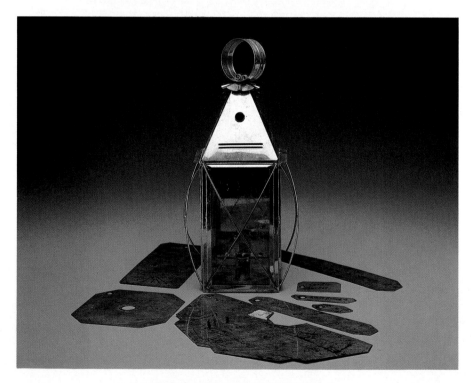

LANTERN WITH TIN PATTERNS

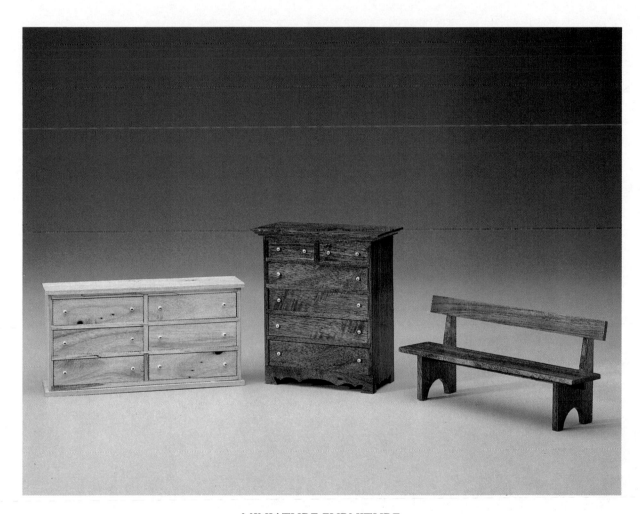

MINIATURE FURNITURE
Left to right: Counter, Western dresser, Settee

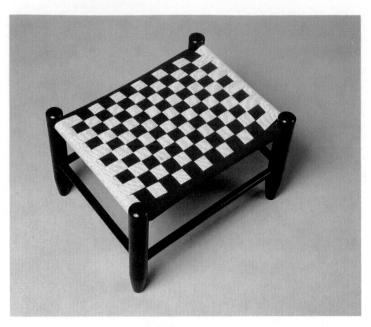

POST-AND-RUNG STOOL WITH PLAIN-WEAVE SEAT

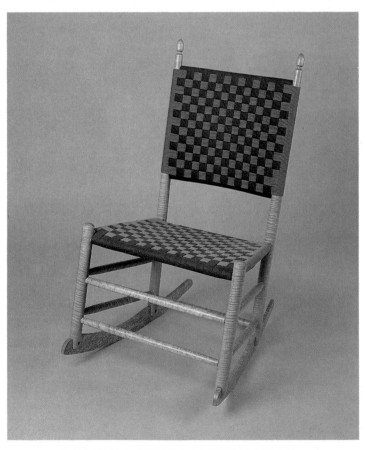

ROCKER WITH PLAIN-WEAVE SEAT

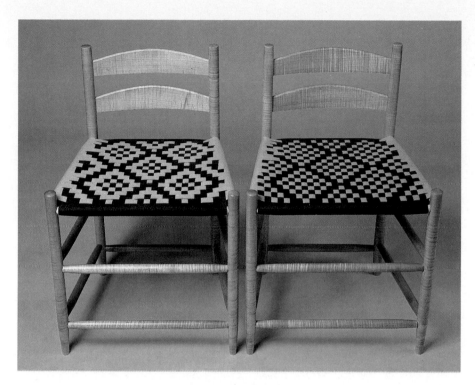

LOW-BACK CHAIRS
(Patterns A and B)

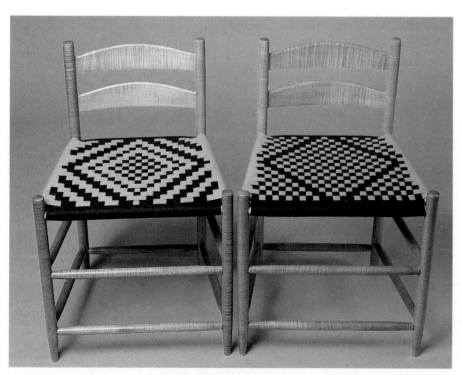

LOW-BACK CHAIRS
(Patterns C and D)

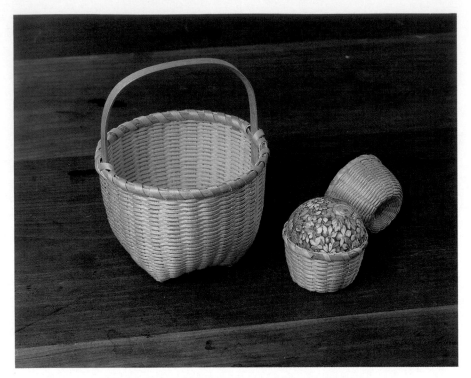

CATHEAD BASKET, PINCUSHION BASKETS

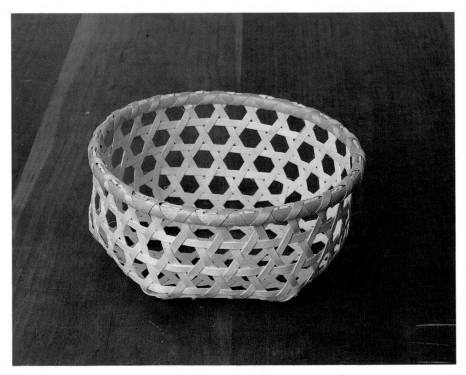

CHEESE BASKET

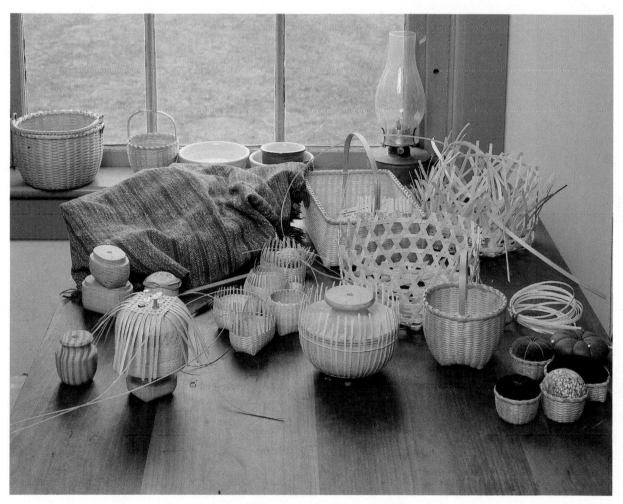

BASKETMAKING IN PROGRESS

LINEN TOWELS
Warps: linen
Wefts (left to right): natural 20/2 cotton; navy 20/2 cotton; single-ply, hand-spun linen

SHAKER ELDERS' ROOM TWISTED-WEFT RAG CARPET

TWISTED-WEFT CARPET
Detail

TWISTED-WEFT CARPET BAG

POPLAR-CLOTH NEEDLEBOOKS

TOMATO PINCUSHION IN POPLAR-CLOTH CONTAINER

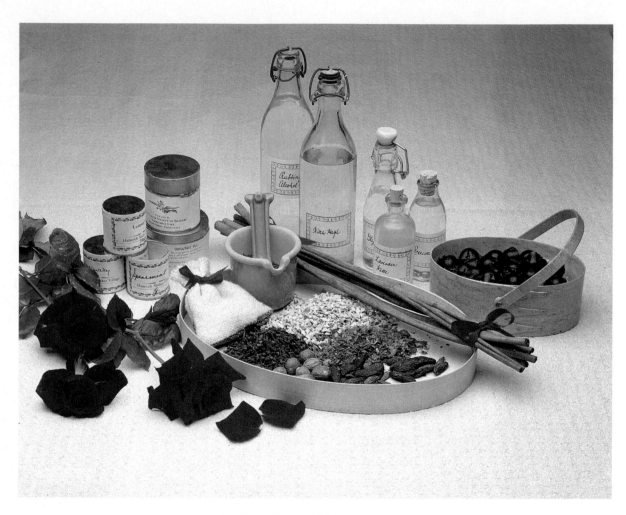

SHAKER HERBAL PROJECTS

HANDWEAVING

Cheryl P. Anderson

We used to have more looms than now, but cloth is sold so cheaply that we gradually began to buy...but our home-made cloth is much better than that we can buy.

ELDER FREDERICK EVANS, 1875

Multicolored skeins of woolen fabric strips, prepared as weft for rag carpets, hang from the peg rails and line the walls of the weave rooms at Hancock Shaker Village. "They didn't use colors like these, did they?" is often the first comment of visitors to the weave loft. In fact, the Shakers did and do use bright colors, but the popular misconception about color and the Shakers is understandable. Original paint has been stripped off early Shaker furniture, both by the Shakers themselves, when natural wood finishes began to be preferred, and by collectors who mistakenly assumed that the paint was a later addition to the piece. Original textile colors have been soiled and become faded through use, washing, and exposure to sunlight. What we see in modern collections of early Shaker artifacts, therefore, gives an incorrect impression that all that the Shakers used were plain wood and drab textiles. On closer examination of these objects, however, traces of original paint or dye that has been protected in some way from light and wear reveal a more colorful picture of Shaker interior design. For example, the rag carpet that is included in this chapter is a reproduction of one in the collection at Hancock. The stripes of red, blue, black, white, green, and gray of the Shaker original are faded and soiled to an almost uniform, drab tan color. When we reproduce this using new materials, however, we can see that the original carpet was clearly not drab in color when it was first made.

To some extent, the colors and patterns of household textiles were restricted by the Shaker doctrine of simplicity. The Shaker rules formally codified in 1840 and known as the Millennial Laws included a few guidelines for the weavers. Two rules concerning dwelling furnishings forbad checks, stripes, or flowers on bedspreads and window curtains. The only rule about carpets said that all the carpets in one room should be "as near alike as can consistently be provided."

Color itself was not considered superfluous ornamentation — it was just a normal characteristic of a thing. Nineteenth-century preference was for bright color, furthermore, and the idea of a "color scheme" or "color coordination" is modern. The large, boldly colored patterns of ingrain carpets imported from England, such as the Wilton, Brussels, or Axminster carpets, visually dominated the fashionable parlors. The homespun, handwoven Shaker rag carpets, with their simple stripes, would have been considered plain, regardless of their bright colors, to a sophisticated visitor from the World. It is our late twentieth-century eyes that prefer quiet, self-toned carpets that coordinate with, rather than dominate, a room. Although in a Shaker dwelling of the mid-nineteenth century, one wouldn't find boldly patterned carpets, coverlets, or curtains, there was plenty of warmth and color in the surroundings. Shaker taste in furnishings has always been influenced by the changing customs of the time.

All textile production in the nineteenth century went through profound changes brought about by the Industrial Revolution. At the beginning of the century in America, weaving was still done by hand, both commercially and at home. Professional weavers, who were for the most part men, did their work for sale, while some women wove at home for their own family's use. Professional weavers more often wove on multiple-shaft, countermarch, dobby, or even jacquard looms with fly shuttles for speed and extra width. At home, most women used four-shaft, counterbalanced looms that wove cloth of simple pattern and a width of 40 to 45 inches. By the end of the nineteenth century, "weavers" were simply millworkers who tended several water- or steam-powered looms at one time. The increased speed of production brought more textiles to the average farmhouse and rendered most handweaving obsolete.

Inside the Shaker villages, the same changes were happening. Because of the Shaker doctrine of simplicity, the textiles that the Shakers produced were the sort typically made by women weaving for their families. Complex patterns would have been considered superfluous ornamentation, so there was no need for multiple-shaft looms. The looms that survive in Shaker collections are generally four-shaft (or fewer), counterbalanced looms. Early in the nineteenth century, weaving became (with a few exceptions) exclusively women's work in Shaker communities.

As in all other crafts and trades, the Shakers embraced current technological advances in the production of textiles. In 1809, the lead community at New Lebanon, New York, bought a carding machine and built a water-powered carding mill to prepare wool fibers for spinning. In 1812, they bought a 24-spindle spinning jenny, and by the 1830s, they were constructing water-powered spinning gins. In 1845, the village at Hancock built a woolen mill with three power looms and water- or steam-powered machinery for picking, carding, spinning, and fulling. Some nonwoolen cloth was still being woven

by hand, but often on fly-shuttle looms. One of the looms in the collection at Hancock Shaker Village, which was built in 1834 by Brother Henry DeWitt, was originally outfitted with a fly-shuttle apparatus.

In the middle of the nineteenth century, the cloth that was being woven on Shaker looms was utilitarian, vernacular weaving, not significantly different from other American textiles of the period. Shaker Sisters used the materials that were available in their region, and along with many other New England households in the late eighteenth century, they spun their own threads for weaving. Woolen and worsted came from their flocks of Merino sheep. Their linen and tow came from the flax cultivated on their farms. Ginned cotton fiber was purchased and hand spun until the early nineteenth century. The communities in Kentucky raised silkworms as well. Using skills that often had been learned before they joined the sect, they produced the necessary fabrics for blankets, sheets, towels, summer and winter clothing, grain sacks, flour bags, herb-gathering sheets, carpets, curtains, handkerchiefs, and so on. Although there were some restrictions concerning textiles in the Millennial Laws, specific dimensions, colors, weave structure, yarn size, and sett were determined by function, contemporary aesthetics, and "the way things were usually done," rather than by standard patterns and rules. In addition, the Shakers throughout their history have both purchased textiles that served their purposes and made use of textiles that were brought in by converts.

The weaving projects presented here are representative of the types of textiles that were produced in Shaker villages. The weaving draft for the linen towel was taken from a towel in the Hancock collection. Although there are towels in that collection that were probably purchased by the Shakers, the simple, four-shaft weave structure and the many treadling mistakes in the original lead me to believe that it was the work of a novice weaver, and not a purchased towel. Twisted-weft rag carpeting seems to demonstrate a uniquely Shaker technique. The project presented here is a reproduction of a carpet from the collection of Hancock Shaker Village. The carpet bag is inspired by a similar bag in another Shaker collection, although the tote-bag style itself is modern.

Don't feel bound by the instructions that follow. Unless you are making a reproduction for a museum exhibit to replace an original that is in bad condition, there is no reason to attempt to replicate exactly these textiles, unless they perfectly suit your needs and taste. Uniformity was important to the Shakers, but there were no prescribed patterns. It was technique, rather than specific weave pattern, that was uniform in most cases. The project instructions are presented as guidelines. Different colors, overall dimensions, yarn size, sett, and beat work just as well. As long as you use the colors available from the dye stuffs of the period, fibers available in the nineteenth century, and the simple weave structures that Shaker looms were capable of, your finished product will still look Shaker.

A Linen Towel

As commercially spun cotton yarn became cheaply available, fewer and fewer New Englanders felt the need to grow and process flax, for, compared to cotton, linen production is a very labor-intensive process. Despite the cheap cost and availability of cotton, however, the Shakers' communal economy and work-centered, religious lifestyle made the processing of linen practical for them, and some of the communities continued to grow flax and produce linen both for their own use and for sale at least until the end of the Civil War.

Part of the stalk of the flax plant, the linen fiber is outside the cambium layer of the stalk and inside the green layer that corresponds to the bark of a woody plant. For the best fiber, the seeds must be thickly sown so that the stalks crowd each other as they grow and are thus unable to branch. After the plants have flowered, but before the seeds ripen, the crop is harvested by pulling the stalks up by the roots in handfuls. After the stalks are dried, *retting* must take place before the fiber will separate from the stalk without breaking. Retting is a soaking process that starts the decomposition of the stalks. The Shakers practiced *dew retting*. The dried stalks were thinly laid out on the fields in September when the early autumn dews are heavy every night. The flax became soaked with dew every night and dried by the sun every day. It was turned frequently to prevent any part of the stalks from staying damp long enough to mildew. After approximately one month of this treatment, the fiber separated easily from the inner core, and the stalks were once again dried in preparation for *breaking*. Breaking was done in the winter or early spring, as the humidity of the warm months hinders the process of crushing the brittle inner core and scraping it away from the fibers. The Shakers used a trip-hammer to break the stalks and then a wooden blade against a wooden board to scrape, or *scutch*, the fibers. The final process is *hetcheling* — splitting the fibers into fine hairs by combing them on hetchels, which are brushes of long, sharpened iron spikes. The long fibers that remained in the hetcheler's hand were ready then to be wrapped onto a distaff and spun into the finer *line linen*. The shorter tow fibers that were split off and caught in the hetchels were spun into a coarser thread for grain sacks, kitchen towels, and work clothes.

The Shakers' reputation for quality and honesty created a demand for their all-linen diaper in a market where blends of cotton and linen were frequently being sold as "all linen." Shaker all-linen diaper, which was popular for toweling, was woven in any of a number of different patterns, including bird's-eye, goose-eye, m's and o's, herringbone, reversing twill, and huck. The towel presented here is a combination of goose-eye and straight twill alternating across the width of the towel. The treadling, too, alternates between goose-eye and straight twill to produce a "goose-eye check" pattern.

The treadling of the original towel is so inconsistent that an assumption had to be made about which treadling was correct. I decided to *tromp as writ* (follow the threading pattern for the treadling). The number of ends per inch in the Shaker original varies between 33 and 35. To weave the reproduction shown on page 80, I had an old reed with about 17 dents per inch on the average, so it was easy to achieve the same sett. If you don't have a 17-dent reed, you can triple sley a 12-dent reed, leaving one end out of every sixth dent to achieve 34 epi. The original Shaker towel is approximately 20 inches wide and 30 inches long, with hems at both ends.

WARP

For a single towel, 30 inches long, with a 3-inch take-up allowance, a 2-inch hem allowance, and about 30 inches of loom waste, you will need to wind a warp 65 inches long. I planned to weave using a temple and so made no allowance for drawing in. For a width of 20 inches, allowing for four doubled warp ends on either side, you will need 683 ends to balance the pattern on both sides. For one towel, you will need a total of 1,233 yards of 40/2 natural linen. (The reproductions were woven on a 9-yard warp, which was enough for eight towels, with a bit left over.)

WEFT

The reproduction towel has a weft of single-ply, hand-spun linen, approximately the same size as the warp thread. A commercially spun 10/1 linen will work just as well.

Some of the other towels woven on the same warp use 20/2 cotton in white or colors. (The ones pictured are natural and navy blue.)

With either weft, you will need approximately 660 yards of weft for each towel if you weave square (34 ppi).

THREADING

Because of the reversing twill threading, you will need to use a *floating selvedge* or be forever fiddling with the edge threads to catch them in. The first four ends (including the floating selvedges) are double threads. Do not thread the first double thread (the floating selvedge) through any heddle. Next, thread two threads through each heddle for the first three pattern ends. For the remainder, thread one end per heddle until you come to the other side, where you repeat the three doubled pattern ends and finish with a double thread not threaded through any heddle for the floating selvedge.

If you are using a 12-dent reed, thread the doubled floating selvedge *and* the first doubled pattern end through one dent. Thread the remaining two doubled pattern ends together through the next dent (four threads per dent). Then, continue across the towel width, threading

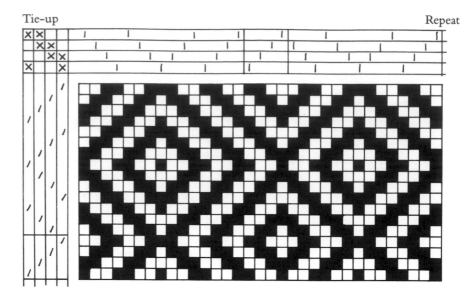

three ends through each dent for five dents, and two ends through every sixth dent. When you get to the last eight threads, thread two doubled pattern ends together in the next to last dent and the last doubled pattern end and the floating selvedge together in the last dent. If you have a 17-dent reed, just sley two ends per dent all the way across. (With doubled threads at the selvedges, you will have four threads per dent in the last two dents at each edge.)

The threading begins and ends with the goose-eye segment of the pattern, which should begin and end on the same shaft.

WEAVING TIPS

Despite the doubled ends at the selvedges, the linen might suffer abrasion and break at the edges if it is allowed to draw in. For this reason (and to protect your old reed if you have one), I recommend weaving with a temple (stretcher). Keeping a linen warp damp also strengthens it. As you weave, try spritzing the area from the shafts to the fell of the cloth with water from a plant mister.

To make use of the floating selvedge ends (the edge threads that weren't threaded through any heddle), the shuttle should always enter the shed on top of the floating ends, and be caught underneath the floating end on the other side. In this way, the edge thread is always caught by each weft pick.

RECOMMENDED FINISHING

Finish the towel by hemming both ends. The Shaker towels don't have any fancy pulled or wrapped thread hems. They are simply turned up twice and stitched down. (Zigzag the raw edges before turning the hems.) Some of the towels in the Shaker collections have fringe rather than hems. With a linen warp, however, fringe is not recommended as the linen threads tend to fray and disintegrate with use and washing.

Shaker Elders' Room Twisted-Weft Rag Carpet

Unlike the Shaker towels, which are so ubiquitous that it is difficult to tell which were made by the Shakers and which were purchased, the twisted-weft rag carpeting that was produced at many Shaker villages appears to be a uniquely Shaker textile. All of the examples of this carpet technique that I have seen were made in Shaker communities.

The warp of these carpets is purchased cotton rug warp. The Shakers used various colors, but usually one color in each rug. The weft consists of narrow strips of fulled woolen cloth and/or plied yarn. Sometimes cloth strips of two colors were plied together, as were several different yarns. Some carpets have only fabric strips for weft and some have only twisted yarns, but my favorites are finely woven of fabric strips alternating with plied yarns.

In these carpets, the picks of wool fabric appear in the finished weave as solid stripes of color. The yarn picks, composed of between five and twelve yarns of various colors, which have been plied (twisted) together, create diagonal dashes of colors across the width of the rug. Although the rugs are all woven in plain weave, the plied yarns create the illusion of a complicated twill or tapestry weave. In some of the Shaker carpets, the yarns were plied with a Z twist, and in others an S twist was used.

For a Z twist, the yarn is twisted clockwise by the spinning wheel. The term Z refers to the direction of the diagonal formed by the twisting of the yarns: The diagonal slants the same direction as the central section of the letter Z, when the yarn is held in a perpendicular position (Figure 21). No matter how you turn or flip the yarn, the slant will still appear the same. (Try turning the illustration upside down.) The S-twisted plies are spun counterclockwise by the spinning wheel, and the diagonal thus formed slants the same direction as the central section of the letter S.

In the woven rugs, the diagonal dashes of color formed by S-plied yarns will appear to slant uphill (reading left to right), and Z plies will slant downhill (Figure 22). They will appear the same if the rug is turned over. In some of the Shaker carpets, a herringbone pattern was created by alternating bands of S- and Z-twisted yarns.

The multicolored yarns and fabrics that were used for carpet weft were remnants and mill ends from the woolen mill at Hancock or such other Shaker industries as the manufacture of fulled wool cloaks at several communities.

The carpets were woven as yardage and cut to the various lengths needed. The cut ends were finished by first tying pairs of warp ends in square knots to secure the edge, and then sewing a binding tape over the knotted ends. Ten warp ends were usually double-sleyed at each edge, giving a very firm selvedge. The weft yarns not in use were usually carried up the sides, and the fabric strips were usually left hang-

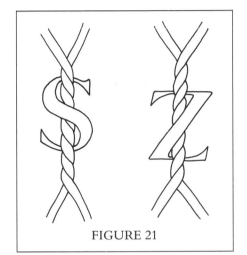

FIGURE 21

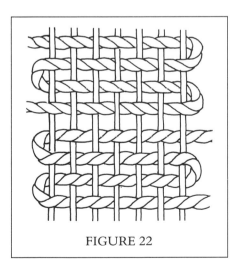

FIGURE 22

ing out and later stitched back against the edge by hand. Depending on the pattern of alternating wefts, this selvedge treatment can make a very messy edge. For this reason, some of the rugs were bound up the sides as well as across the ends. The early bindings were hand-woven, striped wool tapes, woven in a warp-faced tabby weave. In some cases, the wool tapes have worn out and cotton rug binding has been sewn over the original tape.

If the selvedges aren't bound, there is usually a twisted or braided cord of the weft yarns applied to the very edge of the carpet. The cord doesn't cover anything, but is attached to the very edge and visible on both sides of the rug. Several of the carpets I have seen have a four-strand, interlocked braid trimming the edges.

WARP

You will need 8/4 cotton carpet warp (see List of Suppliers, page 129). The Shaker rugs usually have a single, dark color for warp. Because a dark, neutral color doesn't interfere with the weft colors, it is possible to weave several rugs of widely varying colors on the same warp. A dark warp color will deepen and enrich the weft colors, furthermore, whereas a light warp visually washes out the weft colors. The Shaker reproduction rug pictured on page 81 has walnut-brown rug warp from Oriental Rug Co.

For a single 3' x 5' rug, allowing for a 15 percent take-up (these rugs take up more than other weaving) and a 30-inch loom waste, you will need to wind a warp of 99 inches (2¾ yards). The rug is sleyed at 10 epi with ten extra ends to double sley five dents on each side. You will thus need 370 ends, or a total of 1,018 yards of warp yarn; two half-pound tubes will be plenty.

WEFT

For the fabric strips, you will need well-fulled wool fabric in four colors. *Fulled* refers to the finishing process through which woolens are put to shrink and felt them, and give them their nap. When fabrics that are not well fulled are cut into narrow strips, they ravel, causing the surface of your rug to be shaggy. Weft from heavy (coat-weight) woolen fabric should be cut into ¼-inch wide strips; and from light (skirt-weight) woolen fabric, ½-inch wide strips. (For sources of well-fulled wool and wool-blend fabrics in the form of mill ends and factory remnants, see List of Suppliers, page 129.) For this carpet, the colors you will need are black; medium indigo (Canterbury blue); red (the original carpet uses two shades of red — one rusty, or madder, red; and one cranberry, or cochineal, red); and drab (anything from khaki to gray).

The weaving is easiest if the individual strips of each color are joined together into one continuous length before you begin to weave. Starting 1½ to 2 inches from the end, taper both ends of each strip to a

FIGURE 23

point. Apply glue (a glue stick makes this quite easy) to the tapered ends of two strips and overlap them as far as the beginning of the taper (Figure 23). Allow the glue to dry thoroughly before putting any strain on the joint. Although the strips can easily be pulled apart, even after the glue dries, the overlap holds them together in the weave. Join strips until you have 20-yard skeins in each of the four colors. Wrap joined strips on rag or ski shuttles for weaving.

As a general rule, the plied yarns that will alternate with the rag strips can be any weight of wool. Choose colors and mix yarns until the thickness of the combined yarns is roughly equivalent to the thickness of the rag strip. To compare the two, roll the thickness of the rag strip between your thumb and forefinger, and then roll the yarn combination in the same way.

You will need approximately 25 yards of weft for each square foot of finished rug. Depending on your warp tension and beat, and on the thickness of your weft, you may need more or less. When planning your pattern, be sure to alternate frequently between yarns and fabrics. Because of the difference in the way the yarns and the fabrics behave, too many consecutive picks of either will cause a scalloped edge on the finished piece. You can use up small bits of fabric or yarns if you plan your pattern to mix those judiciously with more plentiful materials. In the original Shaker carpets, it was normal for between one and three picks of rag to be alternated with one or two picks of yarn.

The Elders' Room rug has only one combination of yarns, which consists of twelve strands of a very fine, two-ply yarn. Two of the strands are cranberry red, two strands are dark moss-green, two strands are a color between turquoise and teal, two are drab gray, and four are white. Use more or fewer strands of the various colors to achieve the right thickness for your yarns. In the original carpet, the yarns are loosely plied (about one twist every two inches), making a Z twist. The twist in the reproduction pictured on page 81 is closer to one twist every inch. To ply the yarns, use a treadle spinning wheel with a large orifice, or a wool or spindle wheel. A good, big, heavy drop spindle is also adequate, but slower. For the Z twist, you will need to spin the yarns in a clockwise direction.

For a 3' x 5' rug, you will need approximately 50 yards each of black and blue fabric strips, and approximately 25 yards each of red and drab fabric strips. You will need approximately 300 yards of the Z-twisted yarns.

THREADING

The weave is tabby, so any threading that has a tabby treadling may be used. Use a 10-dent reed. When sleying the reed, thread two ends through each of the first and last five dents. These should be threaded singly in the heddles, however, and doubled only in the reed. Single sley the body of the rug.

WEAVING

After weaving a little heading to open the warp, begin the rug with three picks of doubled carpet warp. The repeating stripe pattern for the Elders' Room rug is as follows:

Number of Picks	Color
1	Black fabric
2	Twisted yarns
1	Red fabric
2	Twisted yarns
1	Black fabric
2	Twisted yarns
1	Blue fabric
2	Twisted yarns
1	Drab fabric
2	Twisted yarns
1	Blue fabric
2	Twisted yarns

Repeat

For this pattern, you will be changing shuttles constantly, and it will be much tidier if you cut rather than carry each of the various wefts after you have used it. When you cut the fabric strip or yarns, leave a tail of 1 to 1½ inches, taper it to a point, and weave it back into the *next* shed. Lay the tapered end of the next weft in, so that its tapered point overlaps the taper of the tail that has just been tucked in (Figure 24). The beginning of the new weft should come just to the edge of the carpet. Because of the tapered ends, the overlap shouldn't make any additional thickness at the edges; and the double-sleyed warp ends firmly hold the tucked-in tails.

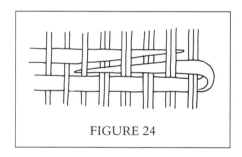

FIGURE 24

Allowing for the 15 percent take-up, and weaving under as much tension as your loom can muster, you will need to weave approximately 69 inches to achieve the 60-inch length of carpet. After the last pattern pick, weave in three more picks of doubled carpet warp, and then several picks of leftover rags or something else to hold the three doubled carpet warp picks in place until you can secure them.

FINISHING

Secure the three picks of doubled carpet warp at each end of the carpet by knotting the warp ends together or running the heading through the sewing machine set on a zigzag stitch. Trim the warp ends off close to the three warp picks and sew a binding over the ends. The reproduction carpet was bound with a commercial cotton rug binding, which shows on one side only. A more attractive, reversible binding can be achieved by using a 1½- to 2-inch-wide strip of one of the

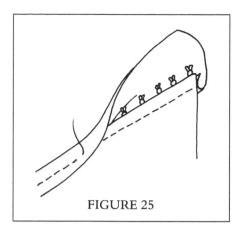

FIGURE 25

FIGURE 26

fabrics in the rug. Lay the strip under the end of the rug, right side toward the rug, edge even with the edge of the rug, and machine stitch along the last rag or yarn pick. Fold the binding strip back over the edge and machine topstitch it down on the other side (Figure 25). Very well-fulled wool won't even need to be folded under before being stitched down. The binding will show on both sides, but it will match the carpet nicely.

The final touch for most Shaker carpets was the addition of a braid of some of the yarns that were also used in the carpet. The reproduction carpet uses the twelve strands of yarn, divided into three groups of four strands and braided into a standard three-strand braid. The more common type of braid used by the Shakers is a four-strand interlocking braid (Figure 26). The braid is stitched by hand to the very edge of the carpet, making it, too, visible on both sides of the rug.

The final step is to steam the rug flat. Working right on the floor, use a mister to dampen the rug slightly, and then press it with a steam iron. Repeat the process on the other side. Let the rug dry thoroughly before rolling or folding it.

Note: If you are designing your own rug, it is helpful to prepare all your materials ahead of time. Cut and skein your fabric strips, and twist and skein your yarns before you start to weave, so that your pattern can be planned around the quantities of the various weft materials you have on hand. If you don't, you may find that you have underestimated one of your wefts, and run out before the rug is finished.

Twisted-Weft Carpet Bag

All of the original Shaker rugs made in this rag-and-yarns technique are rather thin in comparison with the rag rugs that are commonly made today. The carpet material is of sufficient density and drape, however, to be made into attractive and tough tote bags. Although the tote bag design is modern, the idea came from a Shaker bag that is made of carpeting and that is in the collection of the Shaker Museum at Old Chatham, New York. Our version is simply an updated bag style. Have fun with the colors. You, too, can shock people out of their misconceptions about Shaker textiles.

The warp and weft calculation and preparation for a tote bag are the same as for the carpet. Be sure to plan a pattern that alternates frequently between yarns and rags, or your bag will have a scalloped edge.

WARP

For the blue-and-black bag pictured on page 82, you will need black 8/4 cotton rug warp. For a single bag, one half-pound tube will be enough. Wind a warp of 270 ends, approximately 50 inches long. This allows for a loom waste of 29 inches.

WEFT

Cut and glue approximately 16 yards of blue and 24 yards of black fabric strips. The yarns are a combination of a natural dark gray heather, royal blue, navy blue, medium gray, grape, and black in various weights. You will need 24 yards of S-twisted and 24 yards of Z-twisted yarns.

THREADING

The 270 warp ends will make a warp 26 inches wide, with 10 ends per inch, and five double-sleyed reed dents at either side.

WEAVING

As with the carpet, after opening the warp with rags or something of the sort, begin the bag with three picks of doubled carpet warp. The order of picks for the bag pictured is as follows:

Number of Picks	Color
1	Blue fabric
1	Black fabric
1	Blue fabric
2	Z-twisted yarns
1	Black fabric
2	Z-twisted yarns
1	Black fabric
2	Z-twisted yarns
1	Blue fabric
1	Black fabric
1	Blue fabric
2	S-twisted yarns
1	Black fabric
2	S-twisted yarns
1	Black fabric
2	S-twisted yarns
	Repeat

Weave 20 to 21 inches of pattern (this allows for take-up), and end with three more picks of doubled warp thread.

MAKING THE BAG

Approx. 16" wide x 12" high

MATERIALS

21" x 36" broadcloth, in color
complementary to woven bag
90" cotton Shaker chair-seat tape
Sewing machine, scissors, thread
to match cloth
Velcro closure or snap

1. When the bag piece is cut off the loom, machine zigzag the cut edges along the three doubled warp picks, trim off any yarn or warp ends that are sticking out, and then steam iron the piece. Using this pressed bag piece as a pattern, cut a lining, the same size as the woven piece, out of the broadcloth. Set the lining aside.

2. The handles are sewn onto the still-flat bag before the side seams are sewn. Cotton Shaker chair-seat tape is ideal for handles. Cut a piece of tape twice the width of the woven piece, plus enough for two handles the length you like them — somewhere in the neighborhood of 90 inches. Sew the tape on in a big loop that crosses the bag piece selvedge to selvedge, parallel to the woven stripes, centered on the bag about 6 inches apart; the two handles will hang over the edges. Overlap the two cut ends of the tape near the

STEP 2

middle of the woven piece, so that when the bag is complete, the overlap will be at the bottom of the bag. Sew the handles on by stitching through bag and handle close to both edges of the tapes.

3. Fold the bag in half, right sides facing. With the handles on the inside of the bag, bring the two selvedges together, and sew up the side seams along the edges of the first pattern picks.

4. While the bag is still inside out, square the bottom by flattening the side seams and sewing across the corner points about an inch in from the point. Turn the bag right-side out.

5. If you want pockets in the bag, you can sew patch pockets onto the right side of the lining before sewing it into the bag. Fold the lining in half with the pockets inside, and sew up the side seams. Square the lining bottom in the same way as the bag.

STEP 4

6. Fold the top half-inch of the lining to the wrong side and press it down. Slip the lining into the finished bag and sew it in by top-stitching around the top of the bag. Sew on a Velcro closure or a snap, stitching through both lining and bag.

MODIFICATIONS FOR A NARROW LOOM

If your loom's weaving width is narrower than 26 inches, you can use the width of the loom for the width (rather than the height) of the bag. When planning the warp, calculate ten ends per inch, plus ten double-sleyed selvedge ends. The warp width should equal the width you want your bag to be; length should be twice the desired height of the bag, plus loom waste and take-up. When weaving the bag, begin and end with three picks of doubled carpet warp.

1. Attach the handles to the bag as described in Step 2 above, *except* sew the handles on at right angles to the pattern stripes — the stripes run horizontally on the finished bag rather than vertically. Stop the stitching on the handles at the first pattern

pick. Do not sew over the three doubled carpet warp picks.

2. Cut a lining piece using the pressed bag for a pattern, as before, and sew on pockets, if desired.

3. With right sides together, sew the lining to the bag along the top edges. Be careful to keep the handles out of the way between the two layers, and leave several inches along one edge unstitched for turning the bag right-side out later.

4. Fold both the bag and lining in half with both the outsides

STEP 3

facing in. Align the top edges of the bag (where the lining and bag are seamed), stitch the side seams.

5. Square the bottoms of both the bag and the lining as described in Step 4, page 97.

6. Turn the whole bag assembly right-side out by pulling everything through the opening you left in one top seam, and push the lining into the bag. Turn the seam allowances of the opening to the wrong side. Topstitch around the top opening of the bag; stitch through both bag and lining very close to the seam.

POPLARWARE

Galen Beale

Orders receive prompt attention, are nicely packed and sent by express, except small articles not liable to crush, which are sent by mail.

CATALOGUE OF FANCY GOODS
MADE AT SHAKER VILLAGE
ALFRED, MAINE, 1908

O f the Shaker Societies' almost 200-year-old history, the earlier years are the most well known. Their more recent story is equally interesting, however, for the Shakers continued to adapt to the world around them, and, at the same time, to maintain the tenets of their religion. By mid-nineteenth century, Shaker populations began to decline, and, consequently, the members had to evaluate how they could continue to maintain their communities. As their male numbers in particular decreased, the predominantly agricultural Shaker societies became increasingly difficult to manage. To support themselves, they turned to lighter industries, such as the sale of herbs, medicines, and what they called fancy goods — small, sewn articles that were extremely popular with Worldly Victorians. These items filled the Shaker stores and were marketed vigorously in catalogs and on sales trips. Over time, they provided an important source of income.

Poplarware, of all their fancy goods crafts, was probably unique to Shakers. The term applied to a variety of cardboard containers that were first covered with a cloth woven of narrow poplar strips, and then lined with brightly colored satins and brocades, and decorated with matching ribbons. Although not at all related to their tenet of simplicity, Shaker poplarware reflected their appreciation for color and exemplified both Shaker craftsmanship and Shaker practicality. The pieces required a high level of woodworking and sewing skills, and each item had a specific function.

The manufacture of poplarware began at the New Lebanon (New York) Shaker Village in the mid-nineteenth century. The complexity of this labor-intensive and highly skilled craft is substantiated by

the fact that no one else undertook to copy these poplarware containers. The Shaker woodworkers and weavers, however, often experimented with new weaving materials, and poplar, which was abundant in the Northeast, was a natural candidate. In their woodworking shops, the Shakers processed the wood into fine strips for weaving. Their collective skills in basketry, woodworking, and weaving enabled them to produce the poplar cloth, and their communal lifestyle made mass production possible and inexpensive. Shakers of all ages and skills worked at this craft. As the New Lebanon Shakers shared their technology, the industry spread throughout the New England Shaker villages and remained viable until production ceased in 1958 for lack of materials, manpower, and interest. Today, it is remembered with fondness by active Shakers as having been a pleasant occupation.

The poplarware containers came in an amazing variety of sizes and shapes, with equally varied ornamentation. In order to sell their product to the World, the Shaker Sisters took sales trips to their local and state fairs, fine retail stores such as Jordan Marsh in Boston, and large resort hotels along the New England coast and in the White Mountains. Additionally, they published catalogs of their fancy goods, listing such poplarware as handkerchief boxes, card trays, stud boxes, and jewel trays.

The poplar cloth itself was a masterpiece of Shaker technology. The Brothers played an important part in the process of preparing the wood to be made into strips. In the winter, the Brothers cut a supply of poplar trees, which they took to their sawmill to be cut into 2-foot lengths, 2 inches square. In a vertical plane of their own adaptation, the Brothers shaved the poplar blocks into paper-thin strips. These shavings, which fell in curls into baskets at the foot of the planer, were then taken by the Sisters to be hand straightened and laid to dry on specially built racks in a warm, dark place such as an attic in the village. Later, these strips were dampened and put through a gauging tool (another Shaker invention). This tool cut the pieces into $1/16$-inch weavers, which were then laid flat to dry.

The weaving of the poplar cloth was done by the Sisters on two-harness looms. The looms were warped with 10 yards of a fine (no. 30), white cotton thread. Because there was a right and wrong side to the strips, each one had to be examined individually before use. In addition, the strips were fragile, and, even though they were used damp, they often broke. When the cloth was taken from the loom, paper was glued to the back to stabilize the fragile wooden pieces.

The assembly of the boxes was done by several Sisters, working together on as many as 100 boxes at once. The work was done in the winter and was planned to be finished before the beginning of spring cleaning. The process involved stitching together layers of poplar,

cardboard, fabric, and batting, and then nailing these strips to wallpaper-covered wooden bases. Strips of kidskin were glued over the seams to hide them, and ribbons and buttons were used as fasteners. The end results were pure white, finely woven containers, lined with bright satins and brocades, or sometimes velvets and patterned fabrics; matching ribbons festooned the sides and tops.

The following directions are for two reproduction poplar-cloth sewing accessories: a needlebook and a tomato pincushion. Needlebooks with flannel leaves that serve as a neat storage case for sewing needles were often tied with ribbon to the inside of Shaker sewing boxes. The one described here is reproduced from an original made by the Canterbury Shakers. The second project, a tomato pincushion — so named by the Shakers because it resembled the top of a ripe tomato — is adapted from one made in the Alfred, Maine, community. The tomato pincushion, made of velvet and finished on top in a *spiderwork* embroidery stitch, sits in a poplar-cloth container. Not all tomato pincushions were embroidered in this manner; those that were tied inside the wooden oval boxes had spiderwork on both sides.

Woven Poplar Cloth

Most of the supplies that you will need to complete these projects are readily available. The poplar cloth may be purchased in sizes sufficient for these projects (see List of Suppliers, page 129), or you may weave your own in the following manner.

You will need a two-harness loom, capable of weaving a 22-inch width. The warp is no. 30 white cotton sewing thread. For the weft, use fine poplar strips (see List of Suppliers, page 129); the Shakers also sometimes used sweet grass, dyed ash, or oat straw to form patterns in the cloth.

Warp: No. 30 white cotton thread
Weft: Poplar strips and no. 30 white cotton thread
E.P.I.: 10
Width in reed: 22"
Total warp ends: 220
Warp length: 4 yards

Two tabby weave patterns alternate on this cloth — one consisting of all-poplar wefts, and the other consisting of a pick of poplar alternating with a pick of no. 30 thread. Be sure to keep the shiny side of the poplar strip up when weaving.

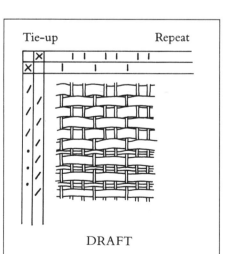

Tie-up Repeat

DRAFT

Poplar-Cloth Needlebook

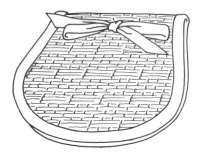

2½" x 3"

SUPPLIES

Cardboard, pencil, scissors

One piece of woven poplar cloth,
 5" long by 3½" wide

White paper or light-colored wall-
 paper or fabric for lining, 5"
 x 3½"

Quick-drying Elmer's and fabric
 glues, glue brush, toothpick

Kidskin, 15" x ³/₈"

Damp washcloth

Waxed paper

Lightweight white flannel, 7½"
 x 3½"

Pinking shears

¹/₈" leather hole punch

Double-sided satin ribbon, 10"
 x ¼"

Tapestry needle

CUTTING OUT
THE POPLAR CLOTH
AND LINING

1. To make a cardboard pattern, trace the needlebook on page 123, transfer the tracing to a piece of cardboard, and cut out the pattern.

2. Lay the pattern on the paper side of the poplar cloth *with the poplar strips running horizontally*, across the width of the needlebook. Trace around the pattern with your pencil, and cut out the needlebook.

3. Using the same cardboard pattern, trace the needlebook onto the lining material, and cut out the lining.

4. Glue the lining onto the back of the poplar cloth with either Elmer's or fabric glue.

5. Place the needlebook flat under a weight (such as a book), and allow the glue to dry for 30 minutes.

6. Fold the needlebook in half and trim the edges so that they are even.

COVERING THE RAW
EDGES WITH KIDSKIN

7. Cut each end of the kidskin on an angle.

8. Apply a thin coat of quick-drying glue to the wrong side of the kidskin for about half its length.

9. Beginning at the upper right-hand edge of the fold of the needlebook, glue half the width of the kidskin strip to the poplar-cloth side of the needlebook, and fold the other half to the reverse side. Work on a small section at a time, wiping off

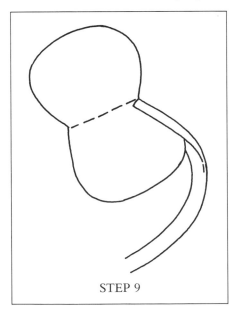

STEP 9

excess glue with a damp washcloth as you go. Continue around the edge of the needlebook, applying more glue as necessary, until the ends of the kidskin overlap.

10. Fold the needlebook in half and place it between two sheets of waxed paper. Weight it and allow it to dry for 20 minutes.

11. If there are spots that are not glued down, apply more glue with a toothpick, wipe off the excess glue, and again dry under a weight.

CUTTING OUT THE
FLANNEL LEAVES

12. Trace the patterns for the flannel leaves on page 123, transfer the tracing to a piece of cardboard, and cut out the patterns. Use the patterns to cut one small and two large leaves from the flannel. Cut the leaves with pinking shears, so that the edges won't fray.

13. Stack the three flannel leaves, with the smaller leaf sandwiched between the two larger ones and their top edges even.

14. On the front of the folded needlebook, ¼ inch down from the fold and centered on the piece, make two pencil marks, ½ inch apart.

15. Place the three flannel leaves in the fold of the needlebook.

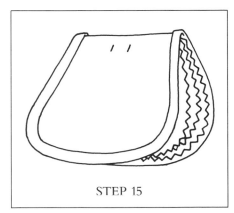

STEP 15

Fold the top of the needlebook over the flannel, and hold all the layers together firmly.

16. At the two pencil marks, make holes with the leather punch. Be sure you go through all layers of the fabric. It may be necessary to twist the hole punch slightly.

TYING THE RIBBON

17. Thread the ribbon on a tapestry needle. With the front of the needlebook facing you, draw the ribbon from front to back through the right-hand hole, across the back of the needlebook, and then from back to front through the left-hand hole. Even the lengths of the ribbon, making sure that it lies flat across the back of the needlebook, and tie it into a bow. Cut the ends at an angle.

Tomato Pincushion in Poplar-Cloth Container

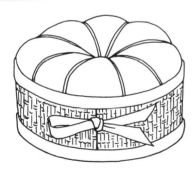

Approx. 2½" diameter x 1½" high

The round, velvet pincushion is filled with unwashed wool fleece or cotton batting (but see also page 57 for advice on unwashed wool fleece), then shaped and decorated with embroidery floss in a spiderwork pattern. The wooden container in which the pincushion rests is covered with cardboard-backed poplar cloth.

SUPPLIES

4" x 8" piece of cardboard (for pattern), compass, pencil, scissors
4" x 8" piece of velvet fabric
Straight pins
Chalk
Sewing thread to match the velvet
Sewing and tapestry needles
Sewing machine (optional)
Unwashed wool fleece or cotton batting
Embroidery floss in a color complementary to the velvet
9" length of 1½" wide poplar cloth
8" x 8" piece of lightweight cardboard (for container side)
Quick-drying glue, toothpick, wet washcloth
2⅜" diameter wooden disc, ⅜" thick
3" x 3" piece of wallpaper in a color complementary to the velvet
18" length of ⅜" wide kidskin
10" length of ¼", double-sided, satin ribbon, to match velvet
⅛" leather hole punch

MAKING THE PINCUSHION

1. On the 4" x 8" cardboard, draw a 3¾-inch diameter circle with your compass, and cut it out.

2. Fold the piece of velvet in half, with right sides together. Pin it to keep it from sliding.

3. Place the cardboard pattern on the folded velvet, and outline it with chalk.

4. Cut out the velvet circles, and pin them together with right sides facing.

5. On a sewing machine (or by hand), sew around the circles, ¼ inch from the edge; leave a 2-inch opening to allow for stuffing.

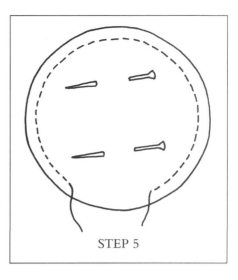

STEP 5

6. Turn the piece right side out. Fill it firmly with the stuffing material. Slip-stitch the opening closed.

SPIDERWORK EMBROIDERY

7. Cut a piece of embroidery floss 2 yards long. Divide this length into three parts, each containing two strands of floss. Thread the floss through a tapestry needle, and knot the end.

8. Push the needle directly through the center of the cushion from bottom to top. Pull tightly. Next, push the needle through the center of the cushion from top to bottom, then again from bottom to top. End with the thread coming from the top of the cushion.

9. Take the floss over the outside of the cushion and back through the center of the cushion from bottom to top.

10. Take the floss over the exact opposite side of the cushion, again pushing the needle through from the bottom to the top. The floss should now divide the cushion in half.

11. Repeat these steps two more times, running the floss at right angles to the line created in Steps 11 and 12. The floss should now divide the cushion into quarters.

12. Secure the thread by drawing it through the center from top to bottom and back again, and pull fairly tightly. End with the thread again coming from the top of the cushion.

13. In the same manner, divide the cushion four more times so that the cushion has eight equal segments.

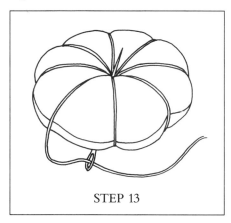

STEP 13

14. To cover the seam of the cushion, with your needle go down through the center and come up on the seam edge, near where a strand of floss crosses the seam. Loop the needle and floss once around the divider floss, and pull snugly. Con-

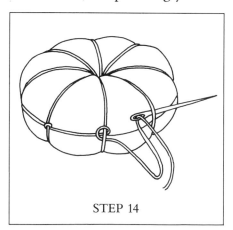

STEP 14

tinue in a clockwise direction, looping and pulling the floss tightly around each divider floss. You do not need to go through the fabric itself. When you have completed the circle and the seam is entirely covered, push the needle through the cushion and out through the center top of the cushion.

15. To weave the spiderweb, slide the needle under two sections of floss. Pull the floss until it is snug; push the floss down to the center of the spiderweb. Place the needle behind the nearer of the two floss dividers just taken, slide under it and the next one. Pull tight, and push the floss toward the center again. Continue in this way, inserting the needle back one and under two, until you have formed a tightly woven spiderweb, once around the circle.

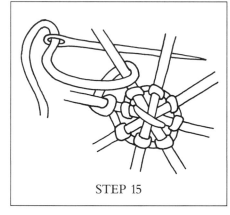

STEP 15

16. Go around the spiderweb about four more times.

17. To finish, draw the floss through the center to the bottom of the cushion. Tie securely and cut the floss.

THE POPLAR-CLOTH CONTAINER

18. Lay the piece of poplar cloth flat with the poplar strips vertical. Measure and cut it to 8" x 1".

19. Bend the 8" x 8" piece of cardboard gently to determine the direction it bends most easily without cracking; the grain of the cardboard must be vertical in order to wrap smoothly into a circle. Measure and cut the cardboard to 7½" x 1".

20. Apply quick-drying glue to the back of the cardboard, and place the poplar cloth on the cardboard with the left and bottom edges even. One-half inch of excess poplar cloth will extend on the right side.

STEP 20

21. Apply glue to the back of the ½-inch poplar-cloth extension. Fold this piece over onto itself, wrong sides together, and press with your fingers until the glue holds. Be sure that the edge of the fold is straight. You will have a ¼-inch tab of doubled poplar cloth extending on the right side of the strip.

22. Sand the edges and bottom of the wooden disc until they are smooth.

23. Apply quick-drying glue to the edge of the wooden base. Beginning with the *left* side of your

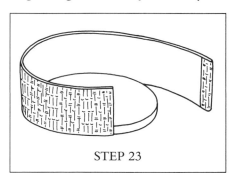

STEP 23

poplar-cloth strip and going clockwise, wrap the strip around the glued edge of the base. The cardboard ends should butt together, and the tab of poplar cloth overlap the side. The bottom of the poplar cloth should be even with the bottom of the base. Hold the piece in place until the glue is dry.

24. Making sure that the fold on the tab is straight up and down, glue it onto the container side.

25. Cut a circle of wallpaper the diameter of the base, and glue it to the outside of the base.

APPLYING THE KIDSKIN

26. Cut a strip of kidskin 9 inches long. Trim the ends on an angle.

27. Apply a thin coat of quick-drying glue to the wrong side of the kidskin strip for about half its length. Beginning to the left of the seam on the container side, and working an inch at a time, glue half the width of the kidskin to the container side; the kidskin will overlap the poplar cloth approximately 1/8 inch. Glue the kidskin all the way around the container, adding more glue as needed; keep the kidskin overlap as consistent as possible. Overlap the ends 1/4 inch (trim if nec-

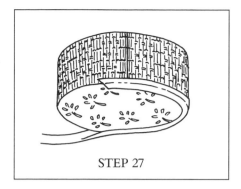

STEP 27

essary). If the glue becomes messy, clean with a damp washcloth.

28. Smooth the remaining half of the kidskin strip over to the bottom of the container, on top of the wallpaper. Use a straight pin to smooth out the wrinkles.

29. Using the same technique, apply the remaining length of kidskin to the top edge of the container side. Start on the right side of the seam, and apply the kidskin to the poplar-cloth side first; then fold

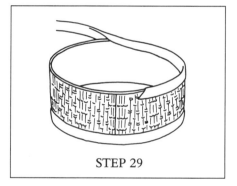

STEP 29

the remaining kidskin over the top edge of the container and smooth it in place on the inside.

RIBBON DECORATION

30. With a pencil, make two marks in the center of the poplar cloth, 1/4 inch on either side of the seam. Push the hole punch through the side at these marks.

31. Thread the ribbon through a tapestry needle, and starting on the front of the container, thread the ribbon into the right-hand hole. Bring the ribbon across the inside of the container and out the left-hand hole.

32. Even the ends of the ribbon, and tie it into a half bow, with the loop going toward the left. Trim the ends of the ribbon on opposite angles.

FINISHING

33. Fit the cushion into the container with the spiderwork up. The seam edge of the cushion should be just below the top edge of the container. Remove the cushion. Apply glue to the inside walls of the container. Fit the cushion into the container, and set it aside until the glue is dry.

HERBS

Galen Beale

It was strongly impressed upon us that a rose was useful, not ornamental. It was not intended to please us by its color or its odor; its mission was to be made into rosewater.

SISTER MARCIA BULLARD, 1906

Throughout the nineteenth century many of the Shaker Societies ran large and profitable businesses growing herbs and manufacturing herbal medicines, extracts, and oils for the pharmaceutical market. At the height of the industry, in the third quarter of the century, Shakers were supplying the World with 421 varieties of herbs, roots, and barks. That the Shakers should enter this field was logical. Like many other eighteenth-century country people, the members of the newly formed Shaker Societies relied on herbs in their domestic lives, not only for medicinal purposes, but also for cooking and making cosmetics. Their neighbors, including local Native Americans, supplemented the Shakers' basic herbal knowledge by teaching them the uses of indigenous plants.

The Shakers at first intended to provide medicines only for members of their own communities, but they soon began selling excess herbs to the World in order to buy medicines and products they could not produce for themselves. Their reputation for reliable, high-quality herbs quickly spread, and by 1836, the New Lebanon, New York, community was issuing a catalog mentioning 164 different kinds of herbs for sale; other villages, in New Hampshire, Maine, Ohio, and New York, were also rapidly expanding their businesses.

The industry actually became so successful that the Shakers were unable to produce enough herbs on their own land to supply market demand and had to purchase herbs wholesale from growers in the World. Thirty or forty herbs were purchased from suppliers in the U.S. South and West, as well as from Europe and South America. It soon became necessary for some of the villages to erect distilleries, drying houses, and kilns devoted solely to the processing and storing of herbs.

The Shakers eventually marketed their herbal products throughout the United States and Europe. At the peak of their business, New

Lebanon Shaker Village had fifty acres of herbs under cultivation; and the combined acreage devoted to herbs in all the societies was about 200 acres. The 240 varieties of herbs being grown for the pharmaceutical market included tansy, yarrow, yellow dock, fleabane, rue, wormwood, cranesbill, clary, and pleurisy root, as well as indigenous plants collected in the wild, such as goldthread (*Coptis trifolia*), motherwort (*Leonurus cardiaca*), sarsaparilla (*Aralia nudicaulis*), and various ferns.

The first organized set of rules governing Shaker Societies established an Order of Physicians to ensure the ongoing health of their limited numbers. The early Shaker doctors based their medicines on herbs, which were at first gathered in the wild, but were soon grown in "physic," or medicinal herb gardens. These physic gardens contained such herbs as henbane, dandelion, lettuce, sage, summer savory, marjoram, dock, burdock, valerian, and horehound. To identify the wild specimens, the doctors used the accepted botanical manuals of the day, *Eaton's Manual of Botany* and *Rafinesque's Medical Flora*, and they set up an orderly system for collecting, harvesting, and processing the herbs. This scientific approach enabled the Shakers to produce reliable and highly potent herbal medicines.

The Shakers were not immune from the sensual pleasures of working in herb gardens, and among the delightful recorded memories is Marcia Bullard's account of harvesting at the New Lebanon community in the 1860s:

> Forty years ago it was contrary to the orders which governed our lives to cultivate useless flowers, but fortunately for those of us who loved them, there are many plants which are beautiful as well as useful. We always had extensive poppy beds and early in the morning, before the sun had risen, the white-caped sisters could be seen stooping among the scarlet blossoms to slit those pods from which the petals had just fallen. Again after sundown they came out with little knives to scrape off the dried juice. This crude opium was sold at a large price and its production was one of the most lucrative as well as the most picturesque of our industries.
>
> *Good Housekeeping* [July 1906]: 33-37

In addition to establishing the herb gardens, Shaker doctors traveled among the villages to assist each other in their work, supervised infirmaries where they cared for and operated on the sick, and practiced embalming. In order to provide complete medical care, their remedies contained many potentially dangerous herbs, such as mandrake root (*Podophyllum peltatum*), thorn apple (*Datura stramonium*), lobelia or Indian tobacco (*Lobelia inflata*), opium poppy (*Papaver somniferum*), and deadly nightshade (*Atropa belladonna*), all of which possess narcotic properties. It was essential, therefore, that the doctors be able to rely on the consistency of their medicines, which they formulated and manufactured themselves, often working out herbal for-

mulas in consultation with leading doctors of the day. Many of the villages became well known for their herbal medicines. Canterbury's Corbett's Shakers' Compound Concentrated Syrup of Sarsaparilla, a well-known blood purifier, was recommended for use in cases of asthma, diarrhea, and "for the complicated diseases of females so apt to end in consumption"; it was also recommended for "Mothers When Worn Out" and as a restorative for "Good Appetite and Rich Blood." Made in 100-gallon lots in the Syrup Shop, the mixture contained large quantities of sarsaparilla root, princess pine, yellow dock root, dandelion root, black cohosh, mandrake root, juniper berries, and Indian hemp. Norwood's Tincture of Veratrum Viride, introduced in New Lebanon in 1858, was another popular Shaker medicine, which was sold for eighty years. Made from the root of white hellebore, its narcotic properties were recommended for typhoid fever, acute rheumatism, measles, and yellow fever.

In addition to seeking outside advice for their herbal formulas, the Shaker doctors often consulted with the World's doctors in order to increase their skill and knowledge in other areas of their practice. The success of the early Shaker doctors was noted by contemporary visitors, who commented on the health and longevity of the community members.

The Shakers saw medicinal, as well as culinary, value in many of the herbs that we now use primarily in cooking. The culinary, or "sweet," herbs, which were pulverized and sold in cans, included sage, sweet marjoram, summer savory, and thyme. Sage, a major crop in many villages, was thought to be valuable to combat coughs, colds, and worms; it was also used as a diaphoretic — a substance that has the ability to promote moderate perspiration. Thyme and sweet marjoram were given as tonics, and savory for nervous headaches, colds, and colic.

The Shakers also used herbs to dye fibers and to make cosmetics. Fragrant waters, such as rose and lavender, were distilled and sold by the gallon. The large quantity of roses necessary to produce rosewater came primarily from red roses (*Rosa gallica officinalis*), as well as from damask roses (*Rosa damascena*), cabbage roses (*Rosa centifolia*), and white roses (*Rosa alba*). Marcia Bullard recalls the New Lebanon rose beds:

> The rose bushes were planted along the sides of the road which ran through our village and were greatly admired by the passerby, but it was strongly impressed upon us that a rose was useful, not ornamental. It was not intended to please us by its color or its odor; its mission was to be made into rosewater, and if we thought of it in any other way we were making an idol of it and thereby imperiling our souls. In order that we might not be tempted to fasten a rose upon our dress or to put it into water to keep, the rule was that the flowers should be plucked with no stem at all. We had only crimson roses, as they were supposed to make stronger rosewater than the paler varieties. This rosewater was

sold, of course, and was used in the community to flavor apple pies. It was also kept in store at the infirmary, and although in those days no sick person was allowed to have a fresh flower to cheer him, he was welcome to a liberal supply of rosewater with which to bathe his aching head.

Good Housekeeping [July 1906]: 33-37

The herbs that were marketed for pharmaceutical use were compressed into bricks, or small cakes weighing from one ounce to one pound and were wrapped in colored papers. In 1853, the New Lebanon Shakers pressed 42,000 pounds of herbs. By 1860, this village had three double presses capable of pressing 100 pounds daily.

The distribution of Shaker herbs and medicines throughout the United States and Europe reflected a sophisticated understanding of a competitive market, one flooded with many exotic elixirs and cures for every ailment. The Shakers advertised their medicines in aggressive campaign literature containing endorsements from doctors, druggists, and chemists, as well as many satisfied users. Professor C. S. Rafinesque, a nationally known botanist, gave the following testimony: "The best medical gardens in the United States are those established by the communities of the Shakers, or modern Essenians, who cultivate and collect a great variety of medical plants. They sell them cheap, fresh and genuine" (from *A Catalogue of Medicinal Plants and Vegetable Medicines*, published by the New Lebanon community in 1848, and now in the American Antiquarian Society in Worcester, Mass.). It was the Shakers' emphasis on the purity of their product and their reputation for honesty that made them successful in the marketplace.

The Recipes

The following herbal recipes are taken directly from Shaker originals; the measurements have been converted to their modern-day equivalents. A medical syringe or an eyedropper can be used for the smaller measurements. The various fats and oils in these recipes can be bought at most drugstores. Health food shops, homeopathic drugstores, and perfumeries are additional sources of dried herbs, oils, and mixtures. Most herbs can be easily grown in the home garden, for their requirements are simple and many excellent books on herb culture are available. See pages 129-30 for sources of plants and seeds, as well as mail-order herbal suppliers.

Rosewater and Lavender Water

An unusual and delicious flavoring, rosewater is used in many different Shaker dishes, as well as for its mild medicinal properties and for its scent in cosmetic preparations. Many Shaker villages grew their own roses and operated distilleries in which they processed fragrant

waters, as well as medicines. Before distillation, the rose petals were salted in order to both enhance and prolong their fragrance. A recipe book from Canterbury Village (now in a private collection) gives these directions for preparing "rose flowers" for distilling:

> Gather the flowers in full bloom and to every pound of Roses add 4 ounces of salt, put them all together in a clean tub or earthenware vessel, and let them remain until thoroughly saturated with the salt.

To obtain rosewater, you can steep the petals in a solution of distilled water, vodka, and an essential oil, or you can distill it using a simple still made with two jars and some copper tubing (Figure 27). For the still, you will need one large (about 1 gallon) and one small (about 2 quarts) jar. Make a hole in the lid of each in which you can insert a piece of ¼-inch diameter, flexible copper tubing. (A cork lid is easier to pierce, but a tight-fitting, screw-on lid will work, too.) Set the larger jar in a pan of water on the stove. In it, place two quarts of distilled water, one quart of pure alcohol, and two quarts of flower blossoms. Cover the jar, and place a length of copper tubing through the lid, reaching about one-third of the way down inside this jar; make sure the end of the tube is *above* the jar's contents. Wrap the smaller jar in a damp dish towel, cover it, and place it in a pan of cool water. Put the other end of the copper tubing through the hole in the lid into the small jar. Heat the pan of water on the stove, and when the water and alcohol in the jar barely begin to move, reduce the heat. Keep the liquid at a constant, very low simmer. At the end of several hours, about two-thirds of the liquid will have transferred to the smaller jar — this is your flower water. Store it in a clean, tightly closed bottle in a cool, dark place.

In *The Scented Room*, Barbara Ohrbach describes an easier method of making rosewater: Mix together 2 cups distilled water, ¼ cup vodka, 10 drops rose oil, and ½ cup fresh, deep-red rose petals. Place the mixture in a sealed jar, and let it age in a dark place for eight days.

Rose oil may now be purchased (see List of Suppliers, pages 129-30). A recipe in the Shaker Collection of the Western Reserve Historical Society describes the Hancock Shakers' tedious method of obtaining the oil:

> Take a large jar and fill it [with] clean flowers of roses. Cover them with pure water and set it in the sun in the day time and take in at night for 7 days when the oil will float on the top. Take this off with some cotton tied on a stick and squeeze in a phial and stop it up close.

Other forms of roses — the petals and the hips — were also used in Shaker cooking. Do not cook with any roses (or other flowers) that have been sprayed with pesticides or fungicides.

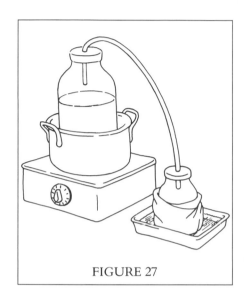

FIGURE 27

Lavender water was made and used in much the same way as rosewater. A recipe book from Canterbury Village, now in a private collection, recommends using 1 quart of water for every 1 pound of lavender blossoms (either the flowering tops, or the whole herb of Lavandula vera De Condolle). Distill as for rosewater. Pour into bottles, and cork the lavender water tightly.

ROSEWATER CREAM FROSTING

YIELD: ENOUGH FOR TWO
8-INCH LAYERS

4 tablespoons butter
¼ cup heavy cream
Confectioners' sugar, sifted
 (about 4 cups)
1 teaspoon rosewater (or more,
 to taste)
1 egg yolk (optional)

Melt the butter in a heavy pan. Remove from the heat, and add the heavy cream. Beat in enough confectioners' sugar to make a mixture that is thick enough to spread.

Flavor with the rosewater. To make a smoother consistency, add an egg yolk.

Amy Bess Miller and Percis Fuller
The Best of Shaker Cooking

ROSE HAW PRESERVES

NORTH UNION, OHIO
YIELD: 1-2 PINTS

The rose haw, which is the fruit of the briar rose, forms in the fall after bloom. It looks much like a cranberry. Because the haws are rare, this preserve is a true confection — never-to-be-forgotten.

2 cups rose haws
½ cup seedless raisins
1 cup sugar
1 cup water
½ teaspoon rosewater

Clip off the blossom end of the rose haws, and with a very sharp knife, remove the seeds. Stuff each haw with several raisins.

Place the sugar and water in a medium-sized saucepan and bring to a boil. Drop the haws into the boiling sugar and water. Cook gently until the mixture becomes syrupy, about 20 minutes.

Add the rosewater. Pour into very small, sterilized glass containers, seal, and process in a boiling water bath for 10 minutes.

Caroline Piercy and Arthur Tolve
The Shaker Cookbook

ROSE PETAL SWEETMEAT

NORTH UNION, OHIO
YIELD: ABOUT 2 CUPS

4 cups rose petals, freshly plucked
 and tightly packed
4 cups water
1½ cups sugar
4 tablespoons strained honey
1 teaspoon lemon juice
Dash of pink food coloring

Cut off the hard base of the rose petals. Pack the petals tightly when measuring. Place the petals in a medium-sized saucepan with the water, and cook 10 minutes. Drain off the water and save it.

Measure 1 cup of this rose liquid. Add the drained rose petals and the sugar and honey. Cook until the liquid threads from a spoon.

Add the lemon juice and cook until the rose petals are transparent. Add just a dash of pink coloring. Pour into small, sterilized glass containers, seal, and process in a boiling water bath (pints, 10 minutes; quarts, 15 minutes).

Caroline Piercy and Arthur Tolve
The Shaker Cookbook

SHAKER ROSEWATER APPLE PIE

CANTERBURY, NEW HAMPSHIRE
YIELD: ONE 9-INCH PIE

Of all the Shaker recipes that called for rosewater, one of the most popular was Rosewater Apple Pie.

3 cups peeled, sliced sour apples
⅔ cup maple or white sugar
1 tablespoon heavy cream
1 tablespoon rosewater
Pastry for two 9-inch piecrusts

Preheat oven to 350 degrees F. Slice the apples into a medium-sized mixing bowl. Add the sugar, cream, and rosewater. Mix thoroughly to distribute the rosewater evenly.

Line a 9-inch pie plate with half the pastry. Fill with the apple mixture, and cover with the remaining pastry. Slash with vents for the steam to escape, and flute the edges so the juice won't escape. Bake in a 350 degrees F. oven for 50 minutes.

Eldress Bertha Lindsay
Canterbury Village

Colognes

In addition to making fragrant waters, the Shakers made many colognes. The oils used in many of these recipes came from flowers that were growing in their gardens, but more exotic oils were purchased. For sources of essences and oils, see the List of Suppliers on pages 129-30. Store colognes in pretty, stoppered glass bottles.

KISS-ME-QUICK COLOGNE

SABBATHDAY LAKE, MAINE
YIELD: 8 PINTS

This is Sister Mary Ann Hill's cologne receipt.

1 gallon spirits
¼ ounce essence of thyme
2 ounces essence of orange flowers
½ ounce essence of neroli
30 drops attar of roses
1 ounce essence of jasmine
1 ounce essence of balm mint
20 drops oil of lemon
½ ounce *Calamus aromaticus* (calamus root)

Combine all ingredients.

The Shaker Herbalist, No. 1
Sabbathday Lake, Maine

COLOGNE

NEW LEBANON, NEW YORK

1½ teaspoon oil of neroli
15 drops oil of rose
¾ teaspoon oil of nutmeg
1 teaspoon oil of lemon
1 teaspoon oil of lavender
1½ teaspoons oil of bergamot
3 drops oil of musk
1 gallon pure alcohol

Combine all ingredients. Store in tightly covered bottles.

Recipe Book
Canterbury, New Hampshire
Private Collection

Creams, Lotions, and Mixtures

The Shakers made many of their own cosmetics. Because much of their time was spent out-of-doors, recipes for creams and lotions abound. Store creams and lotions in porcelain jars.

WITCH HAZEL AND ROSEWATER TONIC

CANTERBURY, NEW HAMPSHIRE

Stimulating and refreshing, tonics are used to remove excess oil from the skin and to tone up the complexion. Eldress Bertha Lindsay of Canterbury Village gives this formula: "Mix 2 parts rosewater to 1 part witch hazel." Because witch hazel is a drying agent, Eldress Bertha suggests adjusting these proportions to make a mixture best suited to your own skin.

GERANIUM WATER

YIELD: ABOUT 2½ CUPS

2 pints pure alcohol or vodka
4 ounces rosewater
5 drops tincture of musk
1 ounce tincture of orrisroot
1 ounce oil of geranium

Combine all ingredients. Bottle and allow to age.

Ann T. Fettner
Potpourri

LOTION FOR CHAPPED FACE

CANTERBURY, NEW HAMPSHIRE
YIELD: ABOUT 1 CUP

4 ounces rosewater
1½ teaspoons glycerine
1½ teaspoons sodium borate
2 ounces geranium water
2 ounces camphor water

Combine all ingredients. Store in a tightly covered, wide-mouthed, opaque jar.

Recipe Book
Canterbury, New Hampshire
Private Collection

HEALOLENE

NEW LEBANON, NEW YORK
YIELD: 1 QUART

Healolene, made from the seeds of the quince tree, was a hand cream manufactured and sold by the New Lebanon Shakers. It was scented by a variety of oils and essences. The original recipe noted that "Some prefer oil of bergamot but the majority like Rose Geranium for perfume."

1 cup quince seeds
Water
2 ounces pure alcohol or vodka
1½ ounces glycerine
Oils or extracts of perfume, as desired

Cover the quince seeds with tepid water, and soak until the gluten parts from the seeds. Stir once in awhile, carefully, to avoid discoloration.

Strain the liquid through a fine sieve or cloth, but do not squeeze it. Add the alcohol, glycerine, and oils or extracts of perfume according to liking. If oil is used, mix the oil and alcohol together before adding them to the other ingredients or the oil will not combine with the gluten.

Thin with water if the mixture is too thick. Beat well. Bottle and seal tightly.

<div align="right">Recipe Book
Canterbury, New Hampshire
Private Collection</div>

PERFUME AND PREVENTATIVE OF MOTHS

YIELD: 12 OUNCES

1 ounce whole cloves
1 ounce caraway seeds
1 ounce whole nutmeg (about 8)
1 ounce shredded mace
1 ounce stick cinnamon
 (about seven 3-inch sticks)
1 ounce tonquin beans (about 20)
6 ounces Florentine orris root

Mix all of the ingredients together and grind them until they are powder. Fill sachets with the mixture, and place them among your clothes.

<div align="right">Shaker Collection
Western Reserve Historical Society</div>

Candies

During the first half of the twentieth century, many villages sold herbal candies such as candied sweet flag, lovage root, ginger, and candied flower petals. Store candies in airtight containers.

HOREHOUND CANDY

NORTH UNION, OHIO
YIELD: ABOUT 8 DOZEN

Horehound candy remains a popular candy today, but it was also used by the Shakers as a cough remedy. When made at home with fresh herbs, it is much better than commercially available varieties.

3 cups water
3 ounces horehound leaves
6 cups packed dark brown sugar
1 teaspoon cream of tartar
1 teaspoon butter
1 teaspoon lemon juice

Bring the water to a boil, and pour it over the chopped horehound leaves. Let the mixture steep 20 minutes.

Strain off the tea and add to it the sugar, cream of tartar, and butter. Cook this mixture until the syrup forms a hard ball when dropped into cold water.

Add the lemon juice, and remove from the heat. Pour the candy into a greased candy mold and allow it to harden, or pour it onto a buttered plate and cut it into small squares before it becomes too hard.

<div align="right">Caroline Piercy and Arthur Tolve
The Shaker Cookbook</div>

SHAKER MINTS

NORTH UNION, OHIO
YIELD: ABOUT 6½ DOZEN

2 cups sugar
½ cup light corn syrup
½ cup water
1 egg white
2 drops oil of peppermint
3 drops green food coloring

In a large saucepan, combine the sugar, corn syrup, and water, and cook to the hard ball stage (260 degrees F.), or until the mixture forms a hard ball when dropped into cold water.

While the mixture is still hot, beat the egg white until stiff peaks form.

Gradually pour the hot syrup into the beaten egg white in a thin stream, beating constantly until smooth and creamy. Beat in the flavoring and coloring. Using a buttered rubber scraper, quickly drop small spoonfuls of the mixture onto lightly buttered waxed paper, and allow the candies to set until completely cool.

If the mixture stiffens too much to drop easily, place it in the top of a double boiler over hot water until it softens slightly. When cooled, store candies in a covered container in a cool, dry place.

<div align="right">Caroline Piercy
*The Shaker Cookbook:
Not By Bread Alone*</div>

CANDIED VIOLETS

Eldress Bertha Lindsay, of Canterbury Village, gives the following rule for candied violets:

Candied rose leaves and violets can be made at home by anyone who can make a good fondant. To make the syrup, use a pound of sugar to half a pint of water, and boil until it will form a ball when a little is dropped in cold water. Remove from fire. Drop selected rose leaves and violets (be sure they are free from moisture) into the syrup, pressing down without stirring. Bring the syrup to boil again. Pour the mixture into a bowl and set it aside. The next day, drain the flowers into a fine sieve and save the syrup. Add ½ cup water to the syrup, and boil it again until it reaches the hard ball stage. Put the flowers into the syrup again, bring to the boiling point, and then pour the mixture into a bowl and set it aside. Repeat the process on the third day, but this time when the syrup comes to a boil after the flowers have been added, continue to boil gently until the syrup granulates. Pour the candy upon sheets of waxed paper. Breakage can best be avoided by separating the flowers with a silver fork after they have cooled.

Beverages

Herbs also found their way into Shaker beverages. There were both cool, summer drinks, such as herbades, switchel, and gingerade, and hot teas, made from many herbs including wintergreen, hardhack, and meadowsweet.

SWITCHEL, OR SHAKER HAYING WATER

NORTH UNION, OHIO
YIELD: ABOUT 30 SERVINGS

The Shaker sisters carried this thirst-quenching drink to the Brothers when they were working in the fields. Before ice houses were built, jugs of it were kept cool by hanging them in the spring house or the well.

4 cups sugar *or* 3 cups maple syrup
2 cups molasses
2 teaspoons powdered ginger
2 gallons cold water

Combine all ingredients, and stir until thoroughly blended. Pour into a large container and chill.

Caroline Piercy
The Shaker Cookbook:
Not By Bread Alone

SHAKER GINGERADE

UNION VILLAGE, OHIO
YIELD: ABOUT 8 SERVINGS

4 ounces fresh gingerroot
4 lemons, cut in half lengthwise
2 quarts water
2 cups lemon juice
Simple Syrup, to taste
Ice
Mint sprigs

Using the shredding plate of a four-sided grater, shred the ginger root. Cut the lemons into paper-thin slices, and mix them with the ginger root in a medium-sized bowl. Bring the water to a boil, and pour it over the ginger and lemon mixture. Cover, and let the mixture stand for 5 minutes.

Strain off the fruit and chill the liquid. Add the lemon juice, and sweeten with Simple Syrup to taste. Pour over shaved, chipped, or crushed ice in tall glasses. Serve garnished with sprigs of mint.

SIMPLE SYRUP

3 cups sugar
2 cups water
Dash of cream of tartar

Bring the water to a boil. Place all the ingredients in a quart jar, and stir well to dissolve the sugar. Refrigerate until needed.

Caroline Piercy
The Shaker Cookbook:
Not By Bread Alone

HERBADE

CANTERBURY, NEW HAMPSHIRE
YIELD: ABOUT 12 SERVINGS

2 cups water
4 tea bags
1 cup mint leaves
1 cup lemon balm leaves
1 cup borage leaves
Juice of 6 lemons
Juice of 4 oranges
6 12-ounce cans ginger ale
1 quart white grape juice

Boil the water. Remove it from the heat, pour it over the herbs and tea, and steep for 1 hour.

Add the remaining ingredients. Chill.

Eldress Bertha Lindsay
Canterbury Shaker Village

Sharpening Woodworking Tools

D. Clifford Myers and Seth M. Reed

Of all the woodworking skills that a craftsperson needs to master early on, none is as important, yet so often missed, as sharpening. Plain and simple, *dull tools do not work*. Regardless of the brand or type of tools that you choose to work with, you will be happier and the tools will do their jobs better if they are sharpened before use and kept sharp as you work. Sharp tools cut with less effort and are less likely to slip and cause an accident.

Sharpening is not a difficult skill, although there are many variations of the basic sharpening techniques. The following methods require very few tools, and thus eliminate the need for gadgets and honing jigs. Practice is the key to mastering the skill of sharpening.

Scrapers

Sharpening a scraper is a simple, straightforward process if you take it one step at a time, first, removing the old burr, then polishing the edge of the scraper, and, finally, turning a new burr.

1. To remove the old edge (or true the edge of a factory-fresh blade) lock the scraper in a vise, and file off a small amount of the surface. A 10-inch, fine-cut or mill bastard-cut file works well for this job. Clamp the scraper into the vise so that the surface to be filed is about ¾ inch above the jaws and parallel to the floor. Stand by the side of the vise so that you are standing at right angles to the face of the scraper. Place the front 2 inches or so of the file onto the edge of the scraper closer to you and hold the file tightly against the scraper surface with your left thumb. Allow the remaining fingers of the left hand to ride against the wide face of the scraper to stabilize the file. Carefully turn the file with the right hand until it is as close as possible to a right angle with the edge of the scraper (parallel with the floor), and brace it at that angle with the fingers of the left hand. Keeping most of the downward pressure on the file coming from your left thumb, push the file forward along the edge until it reaches the back end of the edge. Then, as you continue to push the file forward, slowly shift the pressure to your right hand so that the file is being pressed onto the edge uniformly throughout its length. Repeat this process until all traces of the old edge are gone and the edge of the

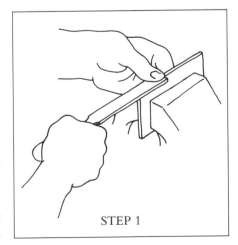

STEP 1

scraper is absolutely flat and true. If either the front or the back end of the scraper edge becomes rounded, you are pressing too hard on that end of the file. The solution is to take a few more strokes, while pressing a little harder on the other end of the file. There is no need to press down hard on the file; in fact, to do so is likely to cause the file to chatter and skid off the edge. Easy does it.

2. When you have filed both edges of the scraper flat, you will notice that it has already developed a burr. This coarse burr is ideal if you are scraping old paint off a surface, but it will not leave a smooth finish on a piece of wood. You must now remove this coarse burr and prepare the edge to take a fine, very sharp burr. The question that most people have at this stage is how to remove the coarse burr without rounding over the right angle that they have filed onto the edge. This problem is overcome by using a short block of hardwood as a guide. Cut a piece of 2-inch thick hardwood 3 or 4 inches long and a few inches wide (the size

is not critical). Put a small amount of oil (see page 117) on a fine India stone, put the wooden block onto the middle of the stone, and then put one of the edges of the scraper onto the stone and press the face of the scraper up against the edge of the wooden block. This rudimentary jig will keep the edge of the scraper at right angles to the stone while you hone off the coarse burr left by the file. Slide the scraper back and forth along the stone until the edge is smooth. To avoid wearing a groove in the stone, keep moving the wooden block as you hone, and turn the stone around, end-for-end, each time you sharpen an edge. When the edge of the scraper is as smooth as the India stone will make it, turn the scraper over and hone the other side.

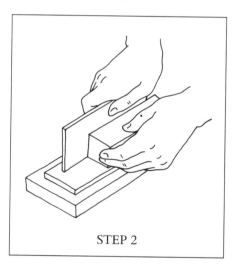

STEP 2

3. Remove the block, turn the scraper onto its face, and hone off all of the burrs that have formed while you were honing the edges. This will give you four smooth, sharp, right-angled edges on the scraper. For an even sharper edge, which will result in an even sharper final burr, repeat the process on a soft Arkansas stone. Make sure that you wipe off all of the oil and abrasive particles when you switch stones, or you will have difficulty polishing all of the scratches off the edges.

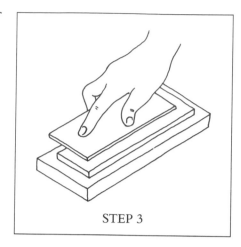

STEP 3

4. In preparation for turning the burrs, again thoroughly wipe the blade clean and lightly oil the edges. The burrs are turned on the edges by rubbing a smooth, hardened piece of steel along the edges. You can use anything from a commercial round, triangular, or elliptical burnisher to an automobile engine valve stem for this task. The flat back of a wood chisel works as well as anything. Place the scraper on a workbench, with about ¼ inch sticking out over the edge of the bench. Rub a little bit of oil onto the back of the chisel, and put it flat up against the edge of the scraper furthest away from you. Put the fingers of your left hand onto the flat of the

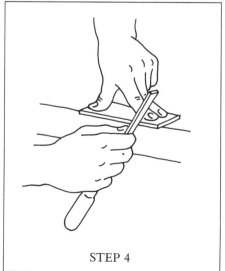

STEP 4

scraper and push down to hold the scraper in place. Hold the chisel by the tang end of its blade, near the handle, so that the flat of the chisel is exactly parallel with the scraper edge. Carefully roll the chisel counterclockwise about 2 or 3 degrees from vertical, at the same time maintaining contact with the scraper edge. Twist your hand so that the chisel edge closest to you comes just off the scraper edge. Make sure that the front edge of the chisel is still on the scraper and pull the chisel back toward you. The more lightly you push against the scraper edge, the smaller the burr will be and the smoother it will cut. If the scraper skids across the workbench when you turn the burr, you are pushing too hard. Repeat the single stroke on the other three edges. With a rag or a paper towel, wipe the entire scraper clean and free from oil.

The scraper is now ready to use. Handle it with care, for it will cut you as easily as any other edged tool. Give it the respect that it deserves, and it will serve you long and well.

Note: Take care to dispose of the oily wiper properly to avoid a fire from spontaneous combustion.

Chisels

The three main steps in sharpening chisels are grinding, honing, and stropping. You can grind nearly all of your chisels and plane irons to about 25 degrees, although some authorities recommend angles of 25 degrees for softwoods and 30 degrees for hardwoods. A hollow grind makes honing quicker and leaves you with a better edge. An electric grinder with a 6- or 7-inch white (or pink) aluminum oxide wheel creates considerably less friction than do gray wheels. Friction is undesirable because it causes your tools to heat up, thus destroying their heat treatment.

1. Set the grinder's tool rest approximately 25 degrees off of the face of the stone. Grind the chisel square across at the edge.

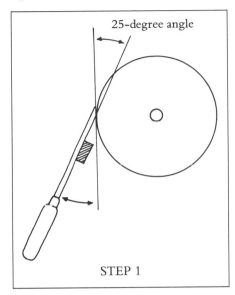

25-degree angle

STEP 1

2. Grind the bevel by laying the front face of the tool flat on the tool rest, and slowly advancing it until the left side of the tool comes in contact with the right side of the wheel. Your right index finger should butt up against the base of the tool rest. Using extremely light pressure, slowly move the tool from left to right, grinding the entire width of the tool. Remove the tool from the wheel, and take it back to the left, where you started, and make another pass. Throughout this process, be careful to keep the tool pointed straight toward the grinder; do not angle the tool to the right or left. Continue making the passes until you have created a nice, even hollow bevel from the front face of the chisel to the back face. The bevel will be roughly twice as long as the tool is thick. If you have trouble making a smooth, even pass, practice with the grinder off until you get a comfortable, fluid move.

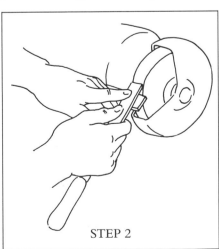

STEP 2

3. For honing, use a medium-grit, manmade stone, followed by a fine-grit, natural mineral stone. If you have a used stone (which you may be able to find at a flea market), you must first flatten its face. Take a sheet of silicon carbide sandpaper, place it on a flat surface, and work the stone back and forth on the paper until its face is even and *flat*. Lubricate the stone before using it to prevent steel particles from clogging it. I use kerosene for this, although most people use motor oil, 3-in-1 oil, or WD-40. Whatever you choose, keep the stone wet during use, and wipe off the face when done. *Always dispose of oily rags properly.*

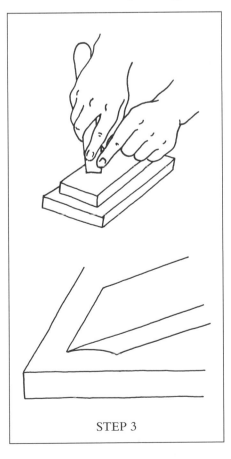

STEP 3

4. Begin to hone by holding the blade in your right hand and laying the ground bevel flat on a medium-grit, lubricated stone. Apply pressure on the very end of the blade with your left index finger until you feel the chisel rest flat on the bevel. Using very little pressure, move the chisel back and forth the full length of the stone, in either a straight line or a figure-eight pattern. *Be sure to keep the bevel flat.* After three or four passes, you'll be able to feel a slight burr on the back side of the cutting edge. At this point, lay the chisel flat on its back and take one or two passes to remove the burr. Next, oil a fine-grit stone and repeat the last two steps.

5. Rub a small amount of buffing compound into the surface of your strop, and pass the chisel over it in the same manner as on the bench stones until that small burr on the edge has been worked off.

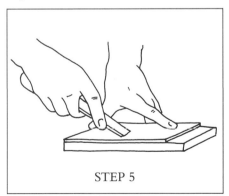

STEP 5

Your chisel should now be quite sharp. Test it by lightly paring a small piece off the end grain of a block of pine. With very little pressure, a sharp chisel will leave a smooth, shiny surface. If it doesn't, go back to your stones and try again. You can use these same techniques to sharpen your plane.

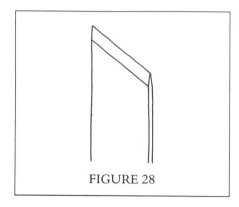

FIGURE 28

FIGURE 29

FIGURE 30

Turning Tools

Turning tools are sharpened in much the same way as chisels and planes, except that the angles vary slightly. Also, a fine stone or strop is not necessarily needed for turning tools.

Turning skews, rather than being ground square across the end, are angled anywhere from 10 to 20 degrees off of square (Figure 28). A grind of 15 degrees, with a hollow bevel of about 25 degrees on both sides works well. After grinding, stand the tool up on its handle, and use a small, medium-grit stone to hone the bevels on both faces (Figure 29). Be sure to keep the stone wet, and hold it flat on each bevel. Some folks use a fine stone and strop after this, but the tool works wonderfully right off the medium stone. Try both ways for yourself and develop your own preference.

Most turning gouges are ground straight across, much as you grind your chisel, except that rather than being moved across the grinding wheel from left to right, they are rolled from side to side on their convex back sides. Gouges can be given a stubbier bevel — about 40 to 45 degrees. If you hone your gouges with a rounded slip stone, you will be able to hone the inside of the tool as well as the outside.

One other gouge that is often used is a thumbnail gouge — so-called because it has a rounded profile on its cutting end. To begin sharpening a thumbnail gouge, first grind its profile into a roughly semicircular shape. For a 3/8-inch gouge, for example, visualize an arc with a radius of about 3/8 inch, and grind the end to that shape. Once the cutting end has been shaped, its angle can be ground. Place the left edge of the gouge on the center of your grinding wheel. Because of the rounded profile, you must not only roll the gouge on its back side, but also ease the tool back toward you as you approach the point, and then ease it back toward the wheel as you near the other outside edge. This can be tricky at first, so practice with the grinder off. After the tool is ground, finish it off with a medium stone, working across the entire half-round cutting edge.

The last commonly used lathe tool is the parting tool, used mainly for setting dimensions on turnings. Grind parting tools to a point of about 60 degrees, and finish them up with a light honing on a medium stone. It should be noted that many parting tools are somewhat diamond-shaped in cross section (Figure 30). If yours is of this variety, be careful when grinding to ensure that the cutting edge is centered on the median ridges located on both sides of the tool. Failure to do so can cause the tool to bind and prematurely heat up from friction during use.

Patterns

Please note that patterns that are printed on a grid must be enlarged according to the scale indicated. Those patterns printed without a grid behind them are actual size and may be traced or photocopied and used without adjustment. (Check to be sure that a photocopy is an exact replica; some machines do not make uniform copies or enlargements.)

To enlarge patterns, make a grid containing 1-inch squares. Beginning at the lower left corner of the pattern, count up the number of squares to the first horizontal intersection of the pattern with a vertical grid line and make a mark. Continue moving up and marking the horizontal intersections on vertical grid lines until you reach the top of the pattern. Next, move to the right, and mark intersections. When you reach the farthest right portion of the pattern, move down to the bottom, marking intersections as you go. Finally, mark intersections along the bottom of the pattern. When all intersections are marked, complete the drawing by connecting the points.

Please note: Some marks on the patterns are indications for placement only. Do not make any cuts until you refer to the directions with the project.

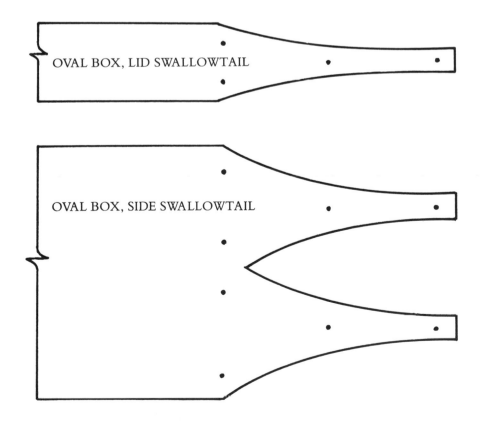

T

T

T

T

SHAKER-STYLE TRAY, BOTTOM

To get full oval, place center line on fold of tracing paper.

Center line

T

T indicates location of tacks

T

T

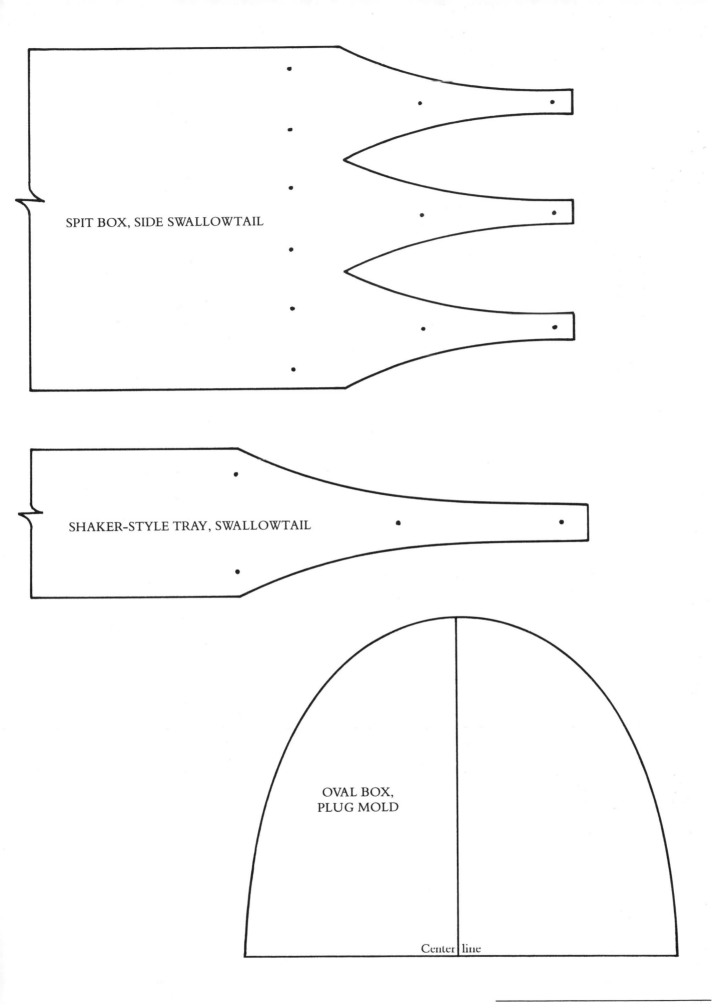

SPIT BOX, SIDE SWALLOWTAIL

SHAKER-STYLE TRAY, SWALLOWTAIL

OVAL BOX,
PLUG MOLD

Center line

MINIATURE SETTEE, BRACE

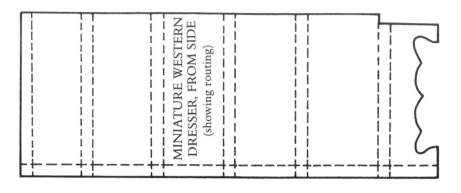

MINIATURE WESTERN
DRESSER, FROM SIDE
(showing routing)

MINIATURE
WESTERN DRESSER,
DUSTBOARD
(showing routing)

MINIATURE WESTERN DRESSER,
FRONT MOLDING

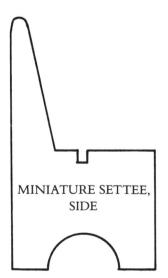

MINIATURE SETTEE,
SIDE

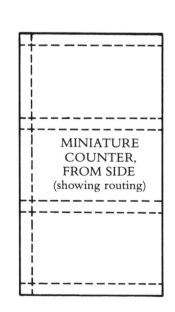

MINIATURE
COUNTER,
FROM SIDE
(showing routing)

PASTRY CUTTER, BODY

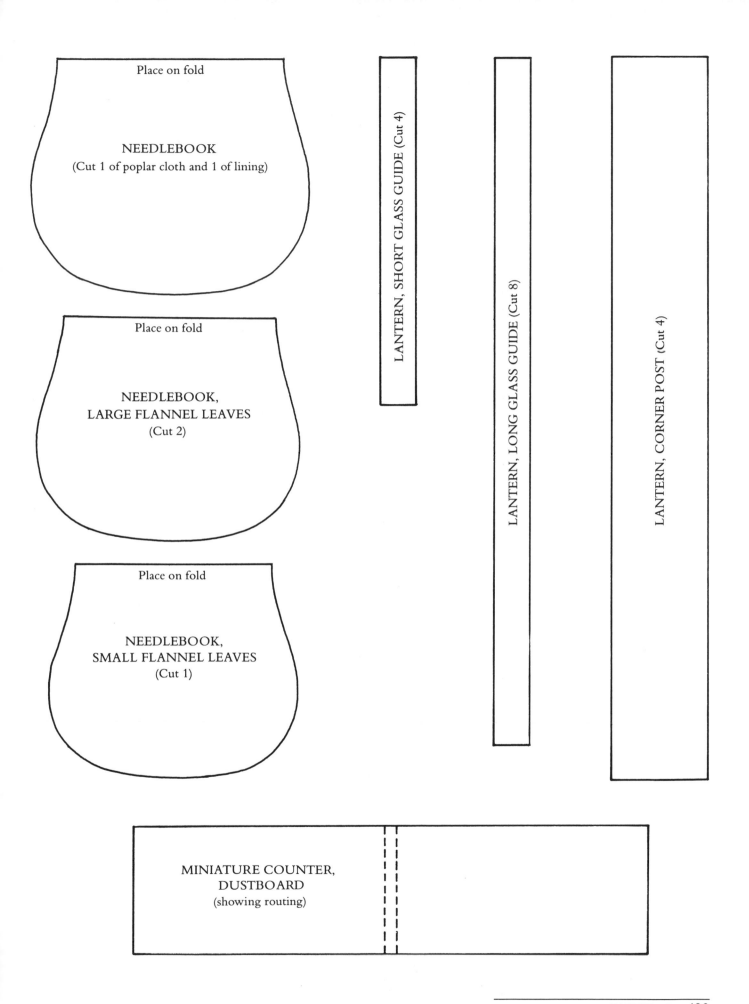

Place on fold

NEEDLEBOOK
(Cut 1 of poplar cloth and 1 of lining)

Place on fold

NEEDLEBOOK,
LARGE FLANNEL LEAVES
(Cut 2)

Place on fold

NEEDLEBOOK,
SMALL FLANNEL LEAVES
(Cut 1)

LANTERN, SHORT GLASS GUIDE (Cut 4)

LANTERN, LONG GLASS GUIDE (Cut 8)

LANTERN, CORNER POST (Cut 4)

MINIATURE COUNTER,
DUSTBOARD
(showing routing)

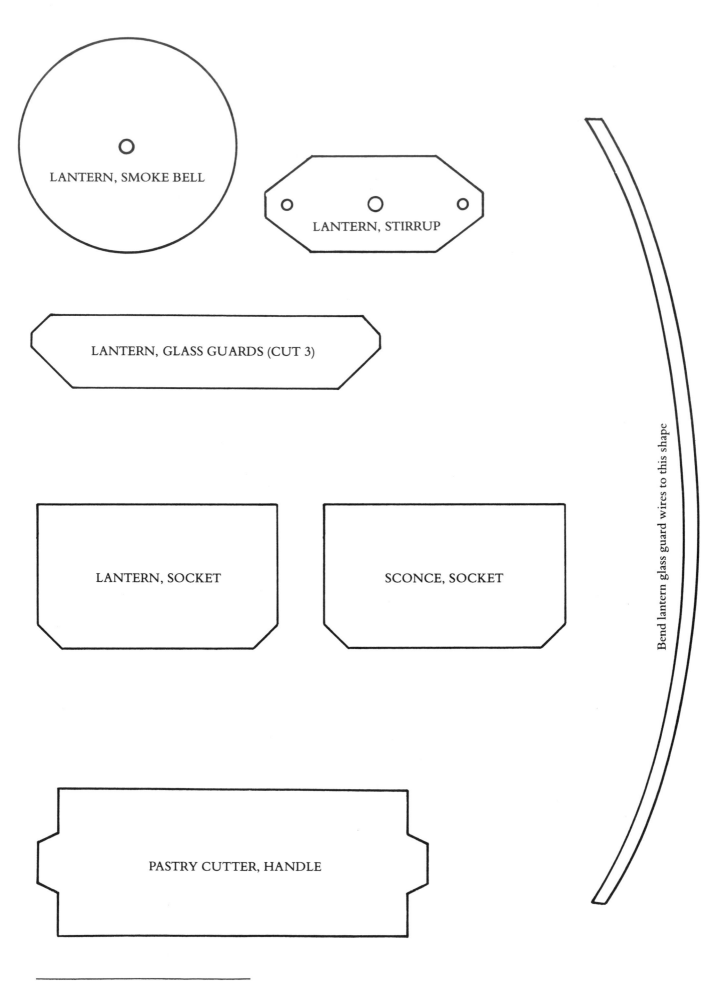

LANTERN, SMOKE BELL

LANTERN, STIRRUP

LANTERN, GLASS GUARDS (CUT 3)

LANTERN, SOCKET

SCONCE, SOCKET

Bend lantern glass guard wires to this shape

PASTRY CUTTER, HANDLE

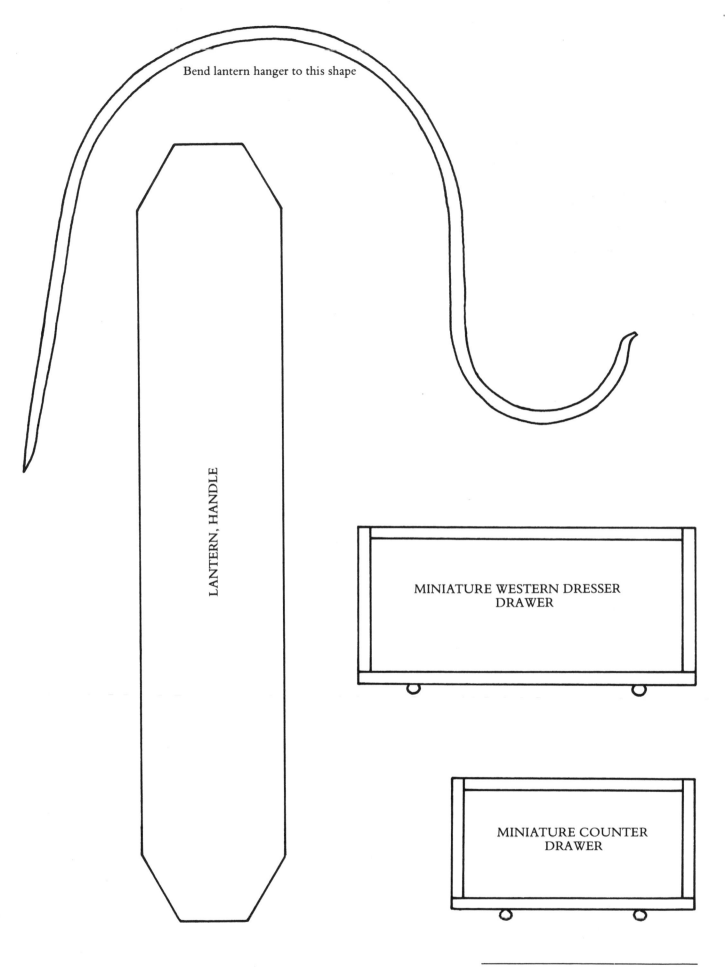

Bend lantern hanger to this shape

LANTERN, HANDLE

MINIATURE WESTERN DRESSER
DRAWER

MINIATURE COUNTER
DRAWER

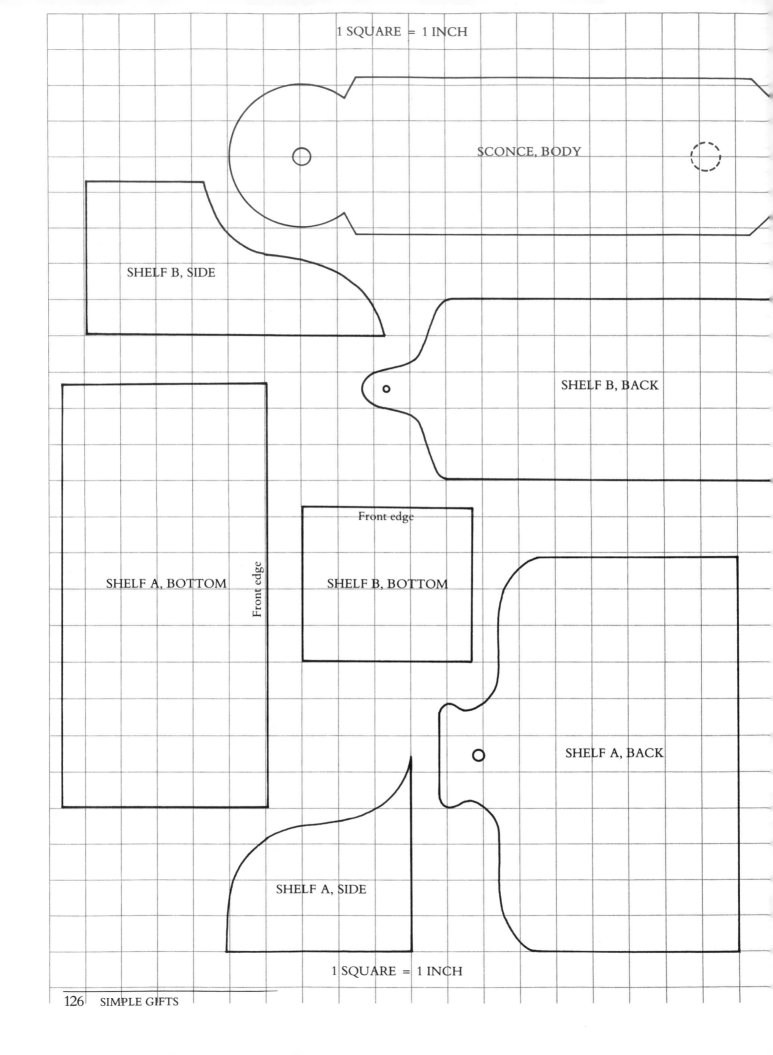

1 SQUARE = 1 INCH

SCONCE, BODY

SHELF B, SIDE

SHELF B, BACK

Front edge

SHELF A, BOTTOM

Front edge

SHELF B, BOTTOM

SHELF A, BACK

SHELF A, SIDE

1 SQUARE = 1 INCH

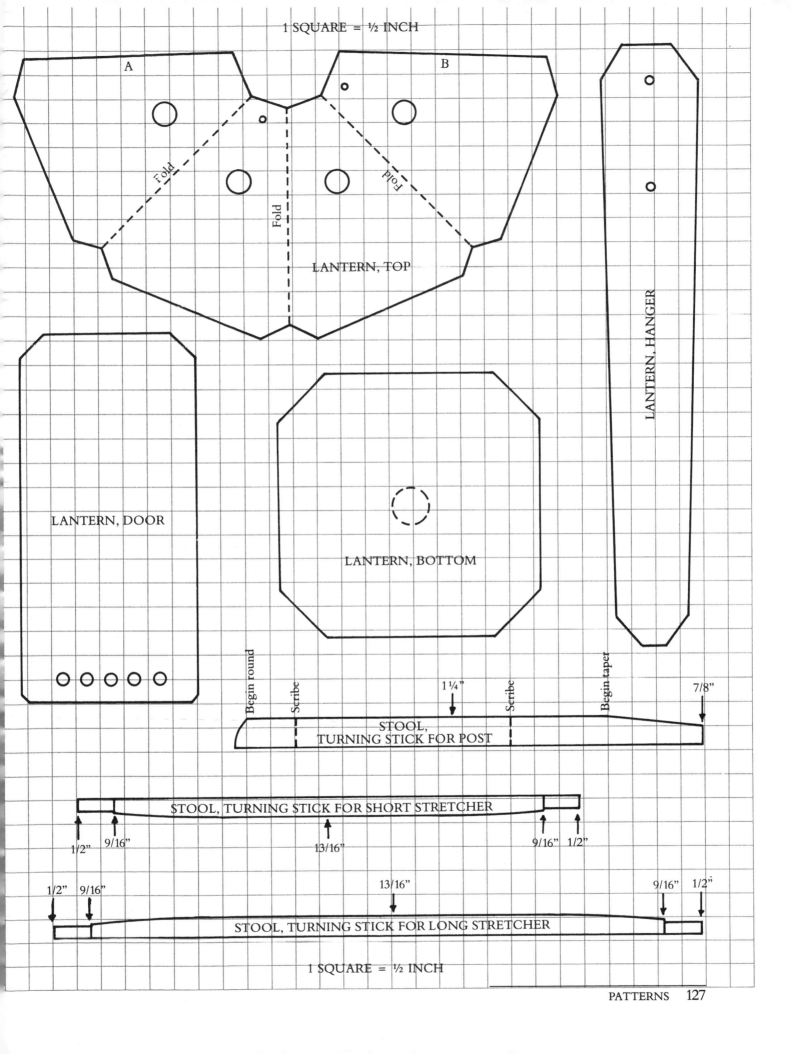

1 SQUARE = ½ INCH

A B

Fold

Fold

Fold

LANTERN, TOP

LANTERN, HANGER

LANTERN, DOOR

LANTERN, BOTTOM

Begin round

Scribe

1 ¼"

Scribe

Begin taper

7/8"

STOOL,
TURNING STICK FOR POST

STOOL, TURNING STICK FOR SHORT STRETCHER

1/2" 9/16"

13/16"

9/16" 1/2"

1/2" 9/16"

13/16"

9/16" 1/2"

STOOL, TURNING STICK FOR LONG STRETCHER

1 SQUARE = ½ INCH

List of Suppliers

If materials for the project that you wish to make are unavailable locally, the following mail-order suppliers offer equipment and/or supplies.

OVAL BOXES

Craftsman Wood Services
1735 West Cortland Court
Addison, IL 60101
800-543-9367 or 708-629-3100
Tools, glues, varnishes, rare and common woods
Catalog, $1

Constantine's
2050 Eastchester Road
Bronx, NY 10461
800-223-8087
Tools, glues, varnishes, rare and common woods
Free catalog

W. W. Cross Division
PCI Group, Inc.
77 Webster Street
Jaffrey, NH 03452
603-532-8332
Copper tacks (1 pound and up)

D. Clifford Myers
106 Main Street
Stephentown, NY 12168
518-733-5566
Copper tacks in small quantities

The Stulb Co.
East Allen and Graham Streets
Allentown, PA 18105
800-221-8444
For information on where to purchase Williamsburg Buttermilk Paint Colors, Old Village Paint Colors, and Old Sturbridge Village Special Color Edition

Trend-lines
375 Beacham Street
Chelsea, MA 02150
Orders: 800-343-3248
Catalog: 800-866-6966
Old-Fashioned Milk Paint
Catalog, $2

Woodworkers Dream
Division of Martin Guitar
10 West North Street
Nazareth, PA 18064
800-247-6931 or 215-759-2837
Exotic and domestic hardwoods
Free catalog

Monsey Products Co.
P.O. Box 340
Waterford, NY 12188
518-235-0890
Village Collection Colors

WOODWORKING

Tremont Nail Co.
Elm Street at Route 28
P.O. Box 111
Wareham, MA 02571
508-295-0038
Reproduction nails
Free catalog

MINIATURE FURNITURE

Trend-Lines
375 Beacham St.
Chelsea, MA 02150
Orders: 800-343-3248
Catalog: 800-366-6966
Tools, glues, varnishes
Catalog, $2

Woodworker's Supply
5604 Alameda Place NE
Albuquerque, NM 87113
505-821-1511
Tools, glues, varnishes
Free catalog

Craftsman Wood Services
1735 West Cortland Court
Addison, IL 60101
800-543-9367 or 708-629-3100
Tools, glues, varnishes, rare and common woods
Catalog, $1

Constantine's
2050 Eastchester Road
Bronx, NY 10461
800-223-8087
Tools, glues, varnishes, rare and common woods
Free catalog

TINWARE

Elmont International Steel Co.
10 Industrial Road
Carlstadt, NJ 07072
201-933-4050
Tinplate

Charles Hartwell
Pioneer Arizona Museum
Pioneer Road
Phoenix, AZ 85027
602-993-0212
Tinplate

Northern Co.
P.O. Box 1219
Burnsville, MN 55337
800-533-5545 or 612-894-9510
Brake

Silvo Hardware Co.
611 North Broadway
P.O. Box 92069
Milwaukee, WI 53202
800-331-1261 or 414-272-6080
Hemostats, tin snips, dividers, scratch awls, round-nose and needle-nose pliers
Free catalog

Harbor Freight Salvage Co.
P.O. Box 6010
3491 Mission Oaks Boulevard
Camarillo, CA 93011-6010
805-388-1000
Hole punches, Roper Whitney 5 Jr.-type punch, shears, tin snips
Free catalog

BASKETRY

Gerrie Kennedy
Berkshire Basketry
P.O. 85
Worthington, MA 01098
413-238-5816
Black ash splint, basket molds, and tools

Basketworks
510 North Earl Avenue
Lafayette, IN 47904
317-447-2646
Black ash splint, basket molds, and tools
Price list

Connecticut Cane and Reed Co.
Box 762
Manchester, CT 06040
203-646-6586
Basket molds and tools
Free catalog

H.H. Perkens Co.
10 South Bradley Road
Woodbridge, CT 06525
203-389-9501
Basket molds and tools
Free catalog

John E. McGuire Basket Supplies
398 South Main Street
Geneva, NY 14456
315-781-1251

Black ash splint, basket molds, and tools
Send SASE for catalog

Martha Wetherbee Basket Shop
Box 116 HCR69
Sanbornton, NH 03269
603-286-8927
Black ash splint, handle and rim supplies, basket molds, and tools
Catalog, $2

TAPE WEAVING

Hancock Shaker Village
P.O. Box 898
Pittsfield, MA 01202
413-443-0560
Woven tape

Shaker Workshops
P.O. Box 1028
Concord, MA 01742
617-646-8985
Woven tape, Shaker reproduction furniture and furniture kits
Catalog, $1

Connecticut Cane and Reed Co.
P.O. Box 762
Manchester, CT 06040
203-646-6586
Woven tape
Free catalog

Shaker Accents
P.O. Box 425
Lee, MA 01238
413-243-3088
Woven tape

HANDWEAVING

Braid-Aid
466 Washington Street
Pembroke, MA 02359
617-826-6091
Wool fabric mill ends

The Oriental Rug Co.
Dept. 5969
Lima, OH 45802
419-225-6731
Rug warp and other yarns

Harry Frascr and Co.
192 Hartford Road
Manchester, CT 06040
203-649-2304
Wool fabric mill ends by the pound
Catalog, $2.50; price list, no charge

Webs
P.O. Box 349
18 Kellogg Avenue
Amherst, MA 01004
413-253-2580
Rug warp, linen, and wool yarns and mill ends
Free catalog

Frederick J. Fawcett, Inc.
1304 Scott Street, Dept. I
Petaluma, CA 94952
800-289-9276
Linen, cotton, and worsted yarns; flax fibre

Edgemont Yarn Service, Inc.
Box 240, Edgemont
Maysville, KY 41056
800-446-5977
Rug warp and other yarns

Halcyon
12 School Street
Bath, ME 04530
800-341-0282 or 207-442-7909
Rug warp, linen, and wool yarns
Free catalog

POPLARWARE

Gibbs and Beale
Shaw Road, RFD 8
Concord, NH 03301
603-267-6482
Poplar cloth, kidskin

HERBS

Crabtree & Evelyn
30 East 67th Street
New York, NY 10021
203-928-2766
Dried botanicals, herb products, oils

Gilbertie's Herb Garden
7 Sylvan Avenue
Westport, CT 06880
203-227-4175
Live plants
No mail order

Sandy Mush Herb Nursery
Route 2, Surrett Cove Road
Leicester, NC 28748
704-683-2014
Live plants and seeds
Catalog, $4, deductible from order

Shady Hill Gardens
821 Walnut Street
Batavia, IL 60510
708-879-5665
Live plants and seeds
Catalog, $2

Hové Parfumeur, Ltd.
824 Royal Street
New Orleans, LA 70116
504-525-7827
Oils
Free catalog

High Country Rosarium
1717 Downing Street
Denver, CO 80218
303-832-4026
Roses
Free catalog

Roses of Yesterday and Today
802 Browns Valley Road
Watsonville, CA 95076
408-724-3537 or 408-724-2755
Roses
Catalog, $3

Aphrodisia
282 Bleecker Street
New York, NY 10014
212-989-6440
Dried botanicals, herb products, oils

Lorann Oils, Inc.
P.O. Box 22009
Lansing, MI 48909
517-882-0215
Flavorings and essential oils
Free catalog

Caprilands Herb Farm
534 Silver Street
North Coventry, CT 06238
203-742-7244
Live plants (in April only) and seeds
Send SASE for catalog

Meadowbrook Herb Garden
Route 138
Wyoming, RI 02898
401-539-7603
Live plants at the greenhouse; seeds
and essential oils by mail
Catalog, $1

Caswell-Massey, Co., Ltd.
Catalogue-Order Department
111 Eighth Avenue
New York, NY 10011
212-620-0900
Herb products, oils
Catalog, $2

Index

Page numbers in italics indicate that a color photograph appears on that page.